EROS IN POMPEII

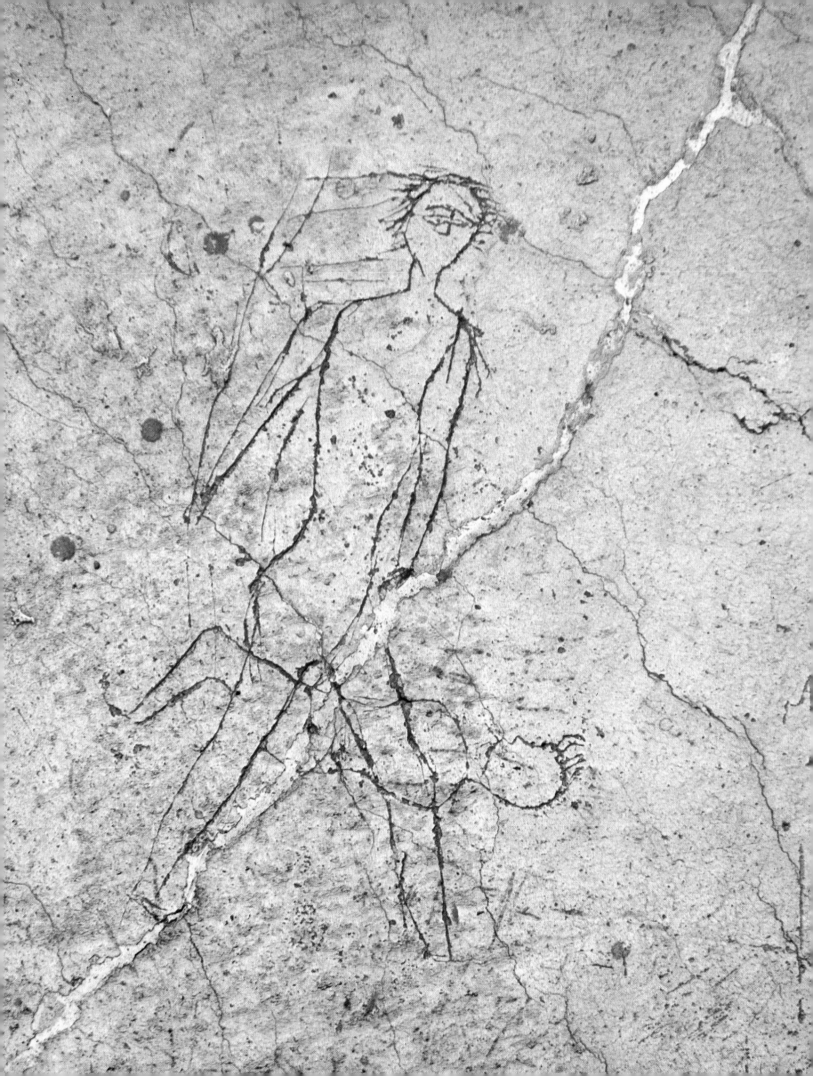

EROS IN POMPEII

The Secret Rooms of the National Museum of Naples

by Michael Grant
with photographs by Antonia Mulas
and a description of the collection
by Antonio De Simone and Maria Teresa Merella

William Morrow & Company, Inc., New York 1975

Printed in Italy by Arnoldo Mondadori Editore, Verona
1 2 3 4 5 79 78 77 76 75
Library of Congress Catalog Card Number 75-4118

ISBN 0-688-02916-7

CONTENTS

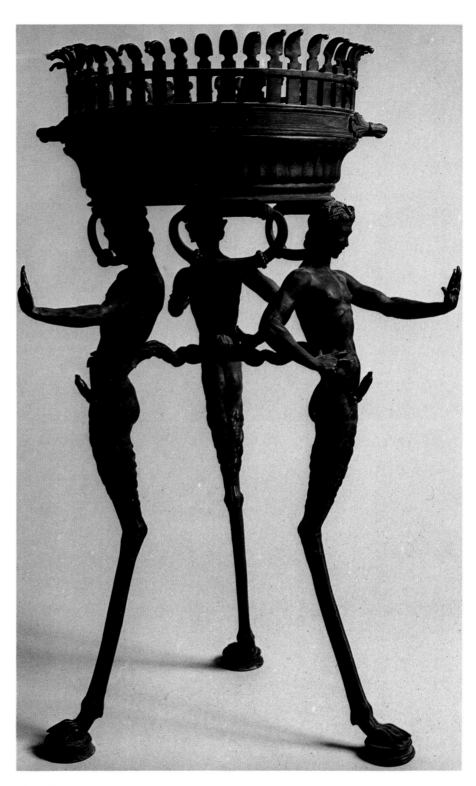

Page 6:
EROTIC SCENE
Graffito on plaster; 26 cm × 34 cm
From Pompeii
RP (Raccolta Pornografica), Inv. no.
27706
See page 86

TRIPOD WITH
ITHYPHALLIC YOUNG PANS
Bronze; height 90 cm, diameter 45 cm
From Pompeii
(15 June 1755)
RP. Inv. no. 27874
See page 84

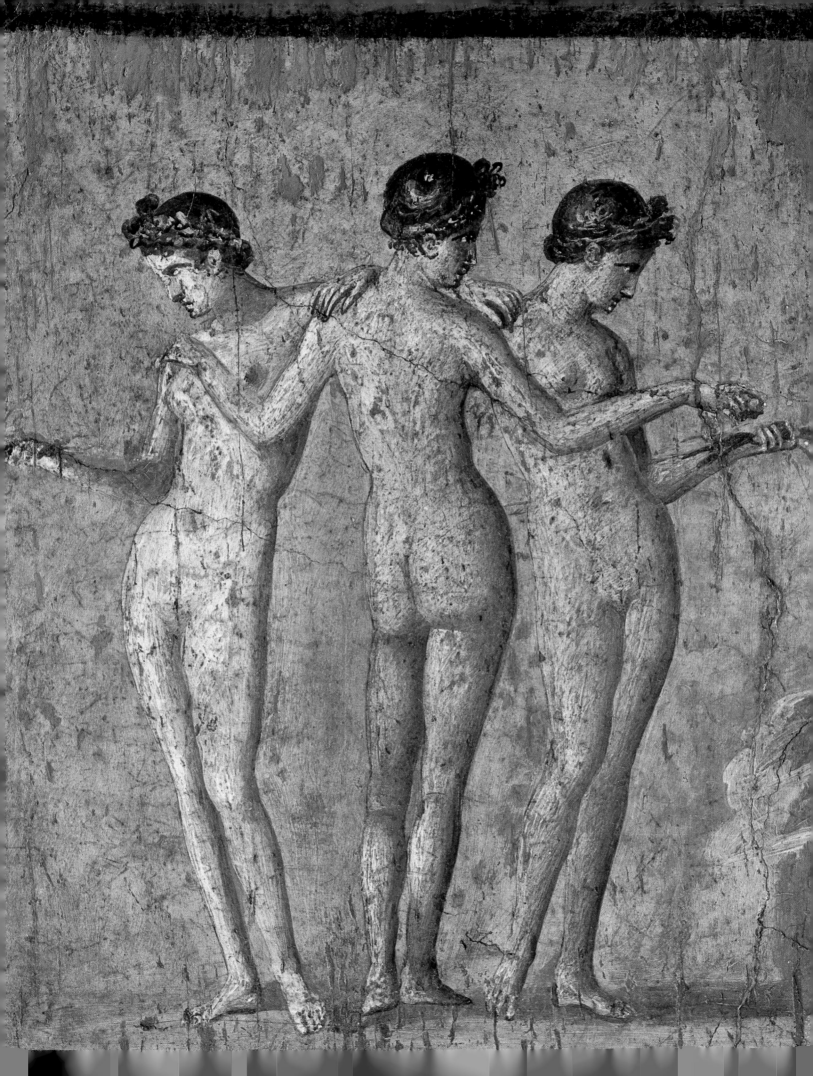

Pompeii: its history and life

Michael Grant

The three Graces. *Fresco in the Fourth Style (see page 144), removed from a Pompeian house. The motif is freely derived from Hellenistic prototypes.*

In 1970 the inhabitants of the coastal area of the Bay of Naples became alarmed because of the phenomenon known as 'bradyseism'—slow volcanic earthquake. The ground on which the town of Pozzuoli, beside the bay, is built had risen more than $\frac{3}{4}$ metre above the sea in the previous six months. Simultaneously the coastline of the island of Ischia, off the north-western end of the Bay, had substantially sunk. Earth tremors were felt, and the communities which lived so close to Vesuvius and to the thirteen bubbling, steaming craters behind the northern part of the bay—the Phelegraean Fields (Campi Flegrei)—wondered if history might be going to repeat itself. The ancient inhabitants of the area, at least until the time of the disaster approached, saw no such cause for alarm. Although expert observers, notably the geographer Strabo, could detect that the crater of Vesuvius—then enclosed within a single peak, the present Monte Somma, 11 kilometres across—was volcanic in origin, it had been extinct since before the beginning of historical record. Once its slopes had been covered by a thick forest famous for its wild boars, but by the beginning of our era, as Virgil reports, it was transformed into smiling vineyards, olive groves, ploughlands and pastures. But then on a brilliantly sunny winter day of Nero's reign, 5 February 62 A.D., the whole region was convulsed by a serious earthquake. Pompeii and Herculaneum were partly demolished, and neighbouring villas were hastily evacuated. Two marble reliefs erected by a local banker, Lucius Caecilius Jucundus, show the heaving of the ground, the reeling and collapsing of temples, arches and statues, and the breaching of one of the city reservoirs. The philosopher Seneca also describes the scene; a whole flock of six hundred sheep were killed by the fumes.

Undiscouraged, the cities went ahead with vigorous programmes of reconstruction. Yet the earthquake had been a sinister warning, because it represented an attempt by Vesuvius to blast an opening in its long unbroken carapace. The attempt was abortive, but the mountain was not to be frustrated. Seventeen years later, at the height of summer in the year 79 A.D., the crust was forced open, and the catastrophe had come. At Pompeii and the town nearby, there had been earthquake shocks for four days past. Moreover, all the springs and fountains in the region had mysteriously run dry. Then, on August 24th, came the eruption.

We owe an astonishing description of what happened to the younger Pliny—future writer and lawyer, and provincial governor—who was about eighteen years old at the time. He was staying at Misenum, at the north-western end of the Bay, with his uncle the elder Pliny, a distinguished scientist and historian who was the admiral in command of the Misenum naval base. Later on, a greater historian, Tacitus, asked the younger Pliny to let him know what had happened. And this is what Pliny reported:

My uncle was stationed at Misenum, in active command of the fleet. On 24th August, in the early afternoon, my mother drew his attention to a cloud of unusual size and appearance. He had been out in the sun, had taken a cold bath, and lunched while lying down, and was then working at his books. He called for his shoes and climbed up to a place which would give him the best view of the phenomenon. It was not clear at that distance from which mountain the cloud was rising (it was afterwards known to be Vesuvius); its general appearance can best be expressed as being like a pine rather than any sort of trunk and then split off into branches. I imagine because it was thrust upwards by the first blast and then left unsupported as the pressure subsided, or else it was borne down by its own weight so that it spread out and gradually

The House of Epidius Sabinus. *Detail of the atrium with Corinthian columns. At the far end is the shrine of the household gods* (lararium), *with an inscription dedicated by his freedmen to Epidius Sabinus.*

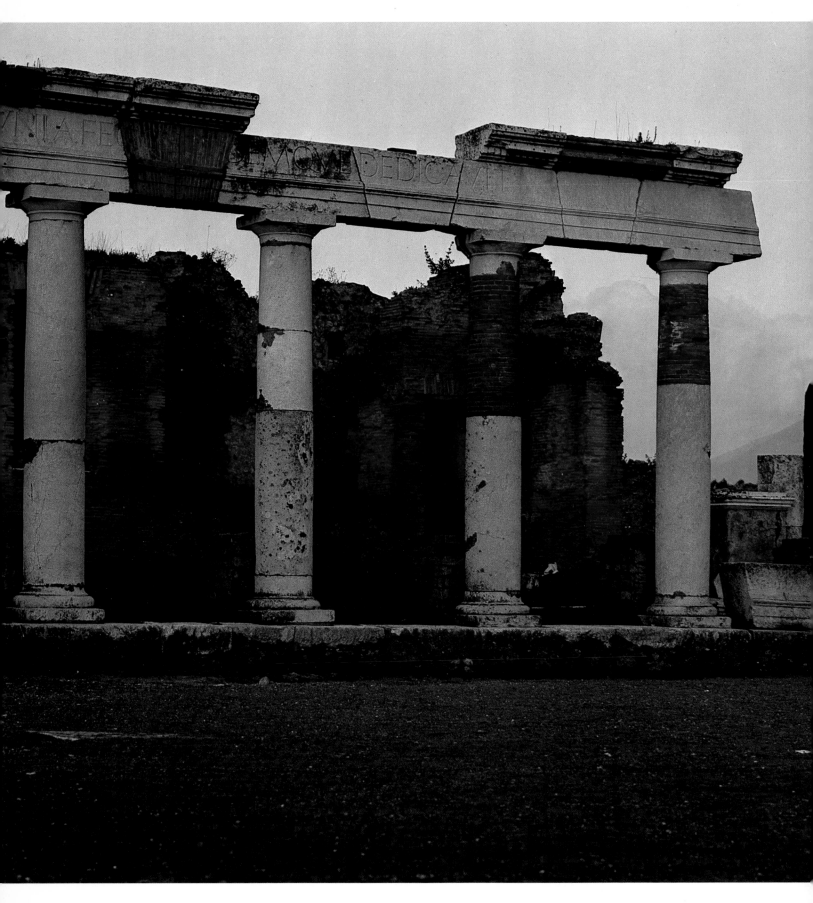

dispersed. Sometimes it looked white, sometimes blotched and dirty, according to the amount of soil and ashes it carried with it. My uncle's scholarly acumen saw at once that it was important enough for closer inspection, and he ordered a boat to be made ready, telling me I could come with him if I wished. I replied that I preferred to go on with my studies, and as it happened he had himself given me some writing to do.

As he was leaving the house he was handed a message from Rectina, wife of Tascus, whose house was at the foot of the mountain, so that escape was impossible except by boat. She was terrified by the danger threatening her and implored him to rescue her from her fate. He changed his plans, and what he had begun in a spirit of inquiry he completed as a hero. He gave orders for the warships to be launched and went on board himself with the intention of bringing help to many more people besides Rectina, for this lovely stretch of coast was thickly populated. He hurried to the place which everyone was hastily leaving, steering his course straight for the danger zone. He was entirely fearless, describing each new movement and phase of the portent to be noted down exactly as he observed them. Ashes were already falling, hotter and thicker as the ships drew near, followed by bits of pumice and blackened stones, charred and cracked by the flames: then suddenly they were in shallow water, and the shore was blocked by the debris from the mountain. For a moment my uncle wondered whether to turn back, but when the helmsman advised this he refused, telling him that Fortune stood by the courageous and they must make for Pomponianus at Stabiae (Castellamare di Stabia). He was cut off there by the breadth of the bay (for the shore gradually curves round a basin filled by the sea) so that he was not as yet in danger, though it was clear that this would come nearer as it spread. Pomponianus had therefore already put his belongings on board ship, intending to escape if the contrary wind fell. This wind was of course full in my uncle's favour, and he was able to bring his ship in. He embraced his terrified friend, cheered and encouraged him, and thinking he could calm his fears by showing his own composure, gave orders that he was to be carried to the bathroom. After his bath he lay down and dined; he was quite cheerful, or at any rate he pretended he was, which was no less courageous.

Meanwhile on Mount Vesuvius broad sheets of fire and leaping flames blazed at several points, their bright glare emphasized by the darkness of night. My uncle tried to allay the fears of his companions by repeatedly declaring that these were nothing but bonfires left by the peasants in their terror, or else empty houses on fire in the districts they had abandoned. Then he went to rest and certainly slept, for as he was a stout man his breathing was rather loud and heavy and could be heard by people coming and going outside his door. By this time the courtyard giving access to his room was full of ashes mixed with pumice-stones, so that its level had risen, and if he had stayed in the room any longer he would never have got out. He was wakened, came out and joined Pomponianus and the rest of the household who had sat up all night. They debated whether to stay indoors or take their chance in the open, for the buildings were now shaking with violent shocks, and seemed to be swaying to and fro as if they were torn from their foundations. Outside, on the other hand, there was the danger of falling pumice-stones, even though these were light and porous; however, after comparing the risks they chose the latter. In my uncle's case one reason outweighed the other, but for the others it was a choice of fears. As a protection against falling objects they put pillows on their heads tied down with cloths.

Elsewhere there was daylight by this time, but they were still in darkness, blacker and denser than any night that ever was, which they relieved by

Portico of the Forum. *Dating to the period after the earthquake of 62* A.D., *it was still being constructed at the moment of eruption in 79* A.D. *The columns are of travertine, while those of the earlier Republican period (end of the second century* B.C.*) are of Nocera tufa.*

The Stabian Baths at Pompeii. *The palaestra, or sports area. The columns were resurfaced with stucco in imperial times, and under the plasterwork are the old columns of Nocera tufa belonging to the original building of the end of the second century* B.C.

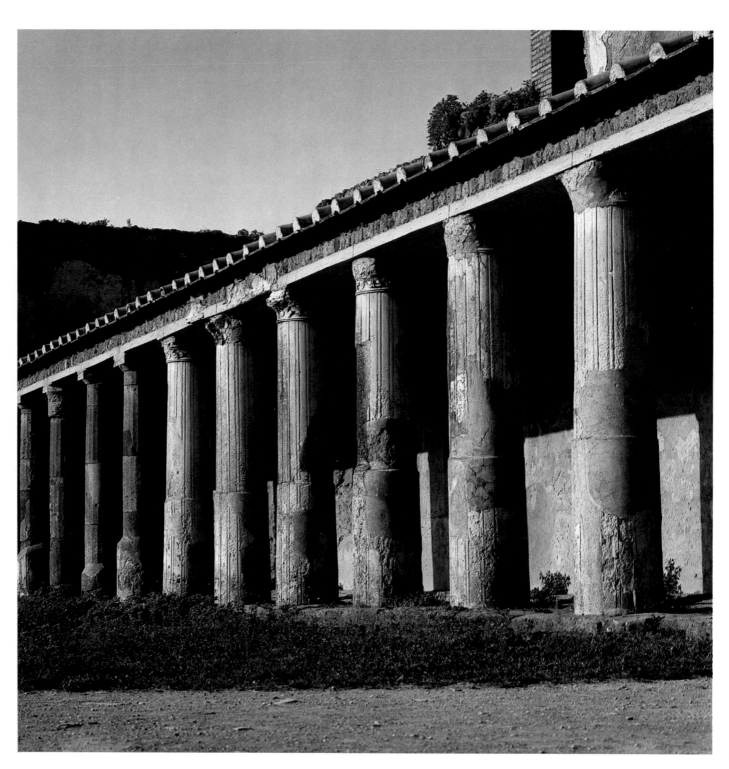

Covered Theatre (Odeon). *Constructed by the municipal officials (duoviri)* M.Porcius *and* Quintus Valgius *(c. 80–70* B.C.*). This odeon is one of the best-preserved examples of a Hellenistic Theatre.*

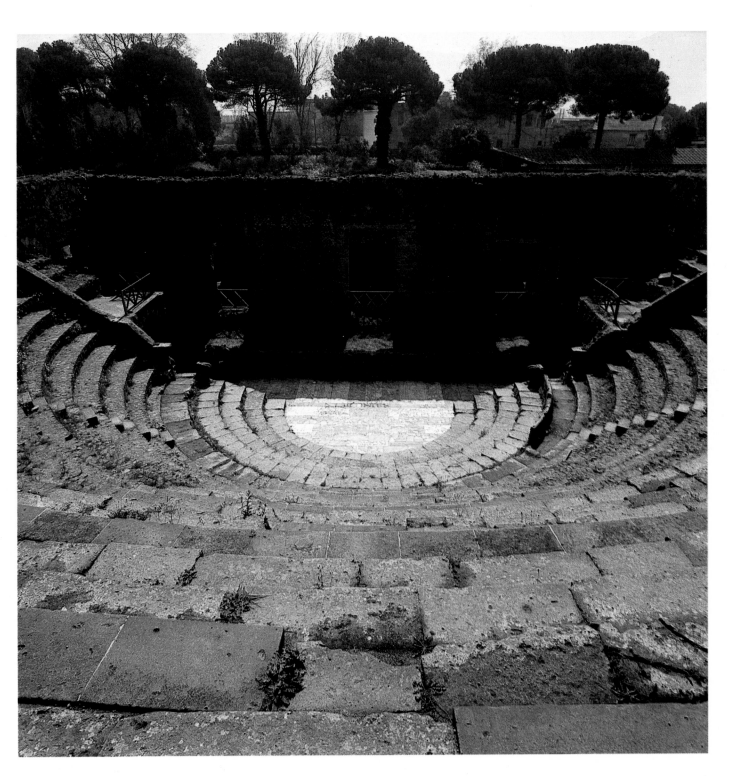

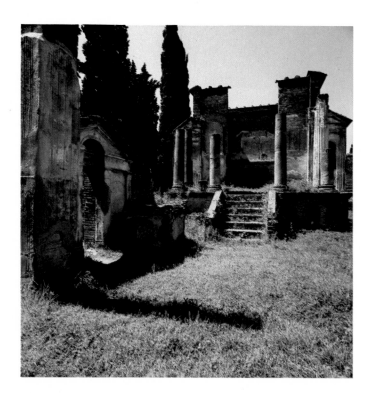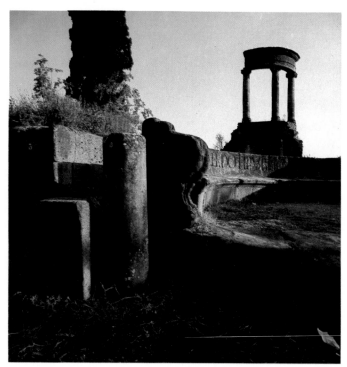

lighting torches and various kinds of lamp. My uncle decided to go down to the shore and investigate on the spot the possibility of any escape by sea, but he found the waves still wild and dangerous. A sheet was spread on the ground for him to lie down, and he repeatedly asked for cold water to drink. Then the flames and smell of sulphur which gave warning of the approaching fire drove the others to take flight and roused him to stand up. He stood leaning on two slaves and then suddenly collapsed, I imagine because the dense fumes choked his breathing by blocking his windpipe which was constitutionally weak and narrow and often inflamed. When daylight returned on the 26th—two days after the last day he had been seen—his body was found intact and uninjured, still fully clothed and looking more like sleep than death.

The electrical storms to which the younger Pliny referred were noted again when Vesuvius erupted seventeen hundred years later, and a century later still the mineralogist Arcangelo Scacchi pointed to five locations in Pompeii that had been struck by lightning during the eruption of 79 A.D. The lethal fumes by which the corpulent elder Pliny had been asphyxiated were a frequent cause of death during this eruption, as the twisted position of many of the victims confirms. These fumes, it appears, were at first of a sulphureous nature, followed by gases impregnated with hydrochloric acid and other chlorides.

Two other writers, the contemporary poet Valerius Flaccus and the third-century historian Dio Cassius, record that the eruption had begun with a terrifying noise, the tremendous crash of the mountain as it split apart. Dio adds other details too:

There were frequent rumblings, some of them subterranean, that resembled thunder, and some on the surface, that sounded like bellowings; the sea also

Top left:
Temple of Isis. *The original building was constructed at the end of the second century* B.C., *and the sanctuary is the oldest in Italy dedicated to the Egyptian goddess. The temple was completely rebuilt after the earthquake of 62* A.D.

Top right:
The Street of the Tombs, *in front of the Herculaneum Gate. In front is the funerary chamber of the priestess Mammia. The mausoleum of the Pompeian family of the Istacidii (c. 50–40* B.C.*) can be seen in the distance.*

Opposite page:
A typical corner at the intersection of two secondary roads. The large stepping-stones in the middle of the street allowed pedestrians to cross without getting their feet wet, and permitted wheeled traffic to pass unimpeded.

Pages 20–1:
One of the main roads of Pompeii. The numerals on the walls of the buildings refer to the dividing up of the city into regions and insulae, *which was the work of the archaeologist Giuseppe Fiorelli, director of excavations, 1861–72.*

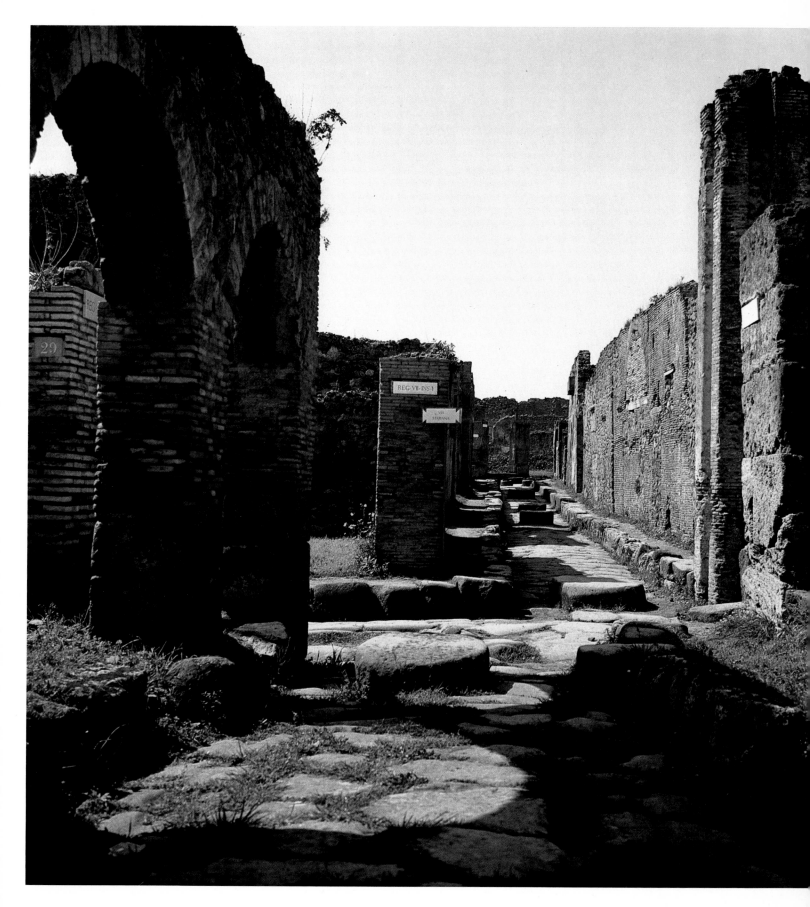

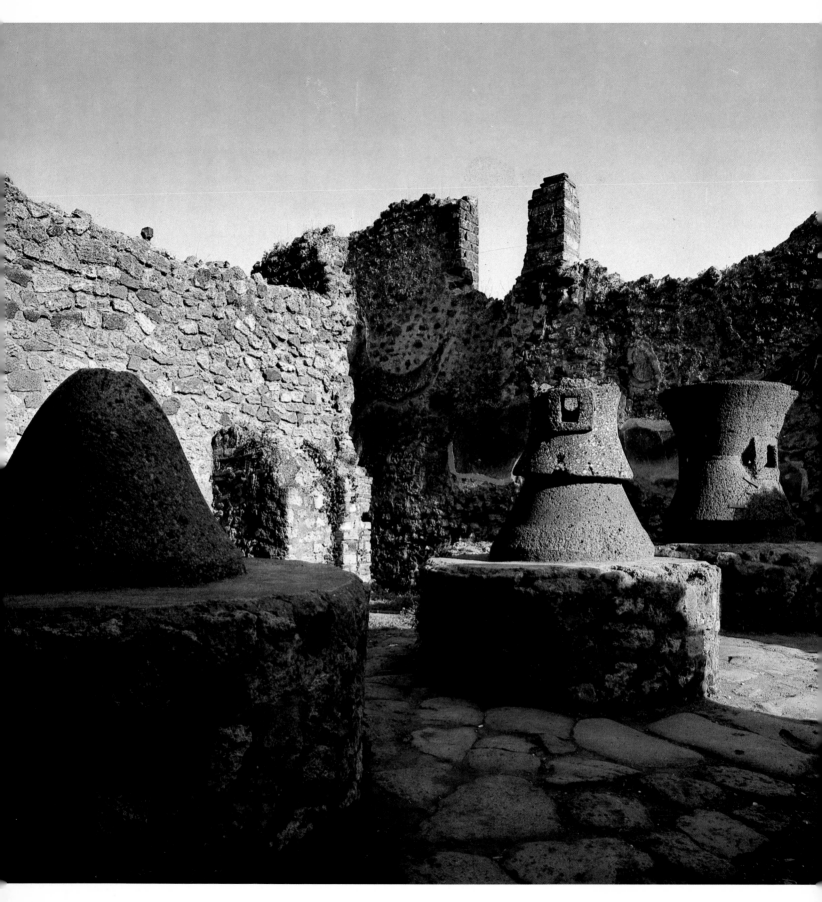

Left:
A baker's shop (pistrinum). *The bakers also ground the grain, and the large stone mills shown here could be powered by donkeys or workmen. The grain was poured in at the top, and the outer biconical stone was turned around the fixed inner core, to make the flour.*

Right:
Fountain at the intersection of two streets. Such fountains were placed along the length of the streets at every crossroads. Most were of local Vesuvian stone, but a few survive in travertine and marble. The rectangular basin is usually surmounted by a sculptured stone mask which pours out the water.

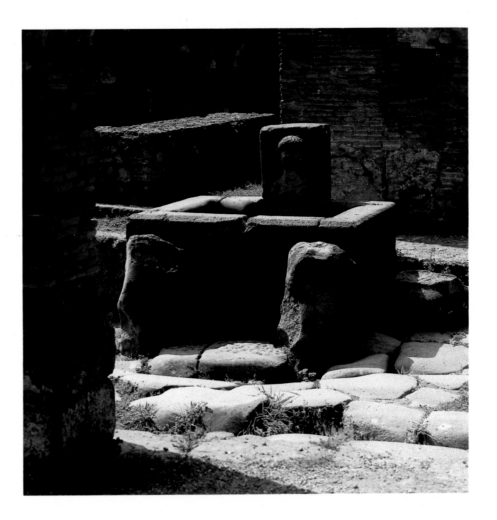

joined in the roar and the sky re-echoed it. Then suddenly a portentous crash was heard, as if the mountains were tumbling in ruins; and first huge stones were hurled aloft, rising as high as the very summits, then came a great quantity of fire and endless smoke, so that the whole atmosphere was obscured and the sun was entirely hidden, as if eclipsed. Thus day was turned into night and light into darkness. Some thought that the Giants were rising again in revolt (for at this time also many of their forms could be discerned in the smoke and, moreover, a sound as of trumpets was heard), while others believed that the whole universe was being resolved into chaos or fire.

Therefore they fled, some from the houses into the streets, others from outside into the houses, now from the sea to the land and now from the land to the sea; for in their excitement they regarded any place where they were not as safer than where they were. While this was going on, an inconceivable quantity of ashes was blown out, which covered both sea and land and filled all the air. It wrought much injury of various kinds, as chance befell, to men and farms and cattle, and in particular it destroyed all fish and birds. Furthermore, it buried two entire cities, Herculaneum and Pompeii, the latter place while its populace was seated in the theatre.* Indeed, the amount of dust, taken all together, was so great that some of it reached Africa and Syria and Egypt, and it also reached Rome, filling the air overhead and darkening the sun. There, too, no little fear was occasioned, that lasted for several days, since the people

*This detail is probably legendary.

23

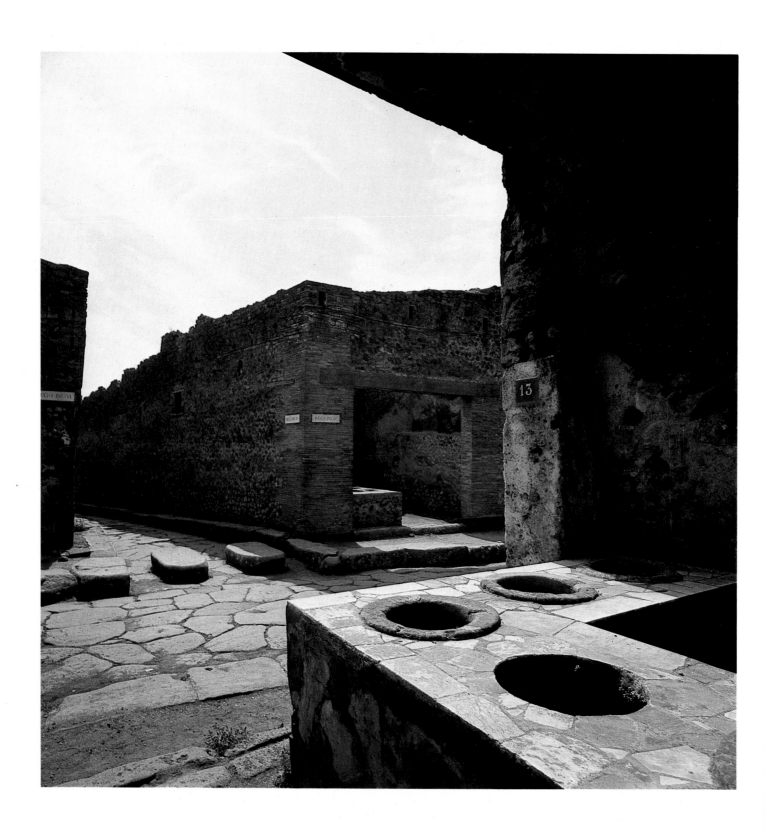

Above:
A wine shop (thermopolium), *with its corner bar where wine was served from large earthenware containers* (dolia) *sunk into the counter.*

Right:
A thermopolium *in the Via dell'Abbondanza, in the area of the recent excavations, with its serving counter and amphorae of wine stacked up behind. On the wall is a painting of the* genius *(guardian spirit) of the proprietor, flanked by the guardian deities of the establishment with Bacchus on one side and Mercury on the other.*

24

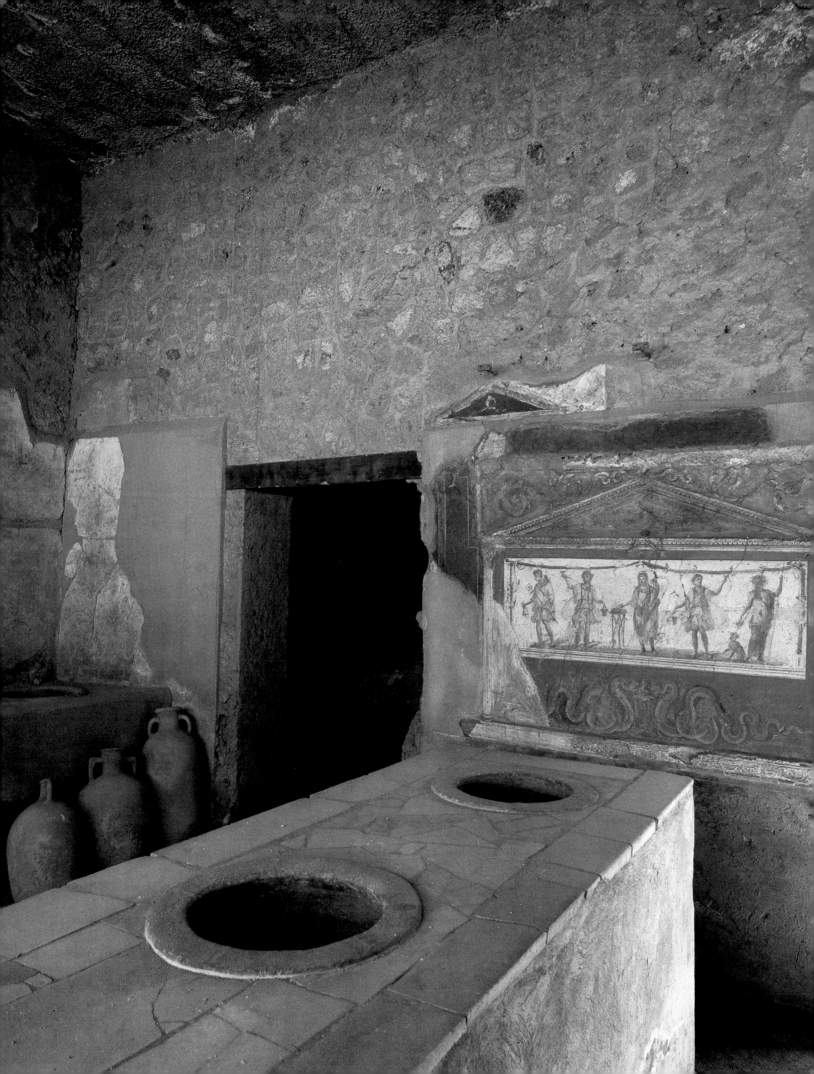

did not know and could not imagine what had happened, but, like those close at hand, believed that the whole world was being turned upside down, that the sun was disappearing into the earth and that the earth was being lifted to the sky.

Alexandre Dumas *père*, who, for political services, became the more or less honorary director of the Naples Museum and of Pompeii in 1860 and was given a residence by Garibaldi, expressed his awe of this achievement of Vesuvius in his *Impressions de Voyages* (1845):

It must be admitted that it revealed itself to the world by a master stroke. To cover land and sea with a black cloud; to send its ashes as far afield as Africa, Syria and Egypt; to bury two cities like Pompeii and Herculaneum; to asphyxiate, over a distance of a mile, a philosopher like Pliny, and to have his nephew record the catastrophe by means of an immortal letter—you will grant that this is not bad at all for a volcano that is only just setting out on its career.

Apart from Dio's passing reference, no ancient literacy record of the destruction of Pompeii exists. By the time when the elder Pliny had reached Stabiae —about 4 p.m.—its neighbour Pompeii had already been buried for several hours. First the redhot boulders, vomited forth by the mountain and hurled up thousands of metres into the air, had rained down onto the city, causing fearful damage and considerable loss of life. Then followed a rain of pumice-stone fragments which covered the ground to a height of between 2–3 metres. Next came a warm, suffocating, silent rain of ash, to about the same height. It was a remorseless, snowy fall, yet so delicately light that even eggs and fish were preserved on dining tables, and eighty-one loaves, put into an oven a few seconds earlier, were still to be seen there eighteen hundred years later, carbonized but otherwise intact. 'See at every turn', wrote the novelist Charles Dickens, 'the little familiar tokens of human habitation and everyday pursuits...all rendering the solitude and deadly lonesomeness of the place ten thousand times more solemn than if the volcano, in its fury, had swept the city from the earth and sunk it in the bottom of the sea.'
The fate of Herculaneum, too, was just as crushingly final. But it came in a very different fashion. For this little luxurious town was invaded not by rocks and ashes from on high, but along the ground by a boiling tidal wave of mud. That, too, moved with a gentle delicacy which preserved what it engulfed. It was slow-moving, moreover, and gave warning of its coming; so that at Herculaneum only some thirty skeletons have been found, for people had time to get out of the town—even though later many of them were struck down in the countryside, or failed to get away on the turbulent, boiling sea. At Pompeii, on the other hand, inside the town itself, at least 2000 men and women died—about one-tenth of the population. Countless signs have been noted of people who were taken by surprise, and whose

The main part of the Via dell'Abbondanza seen from the Forum. In the foreground are the stone barriers preventing the access of wheeled traffic to the Forum area. The building of Eumachia flanks the road on the left, and adjoining it is the travertine fountain with its representation of Fortuna and her cornucopia, which gives the street its name.

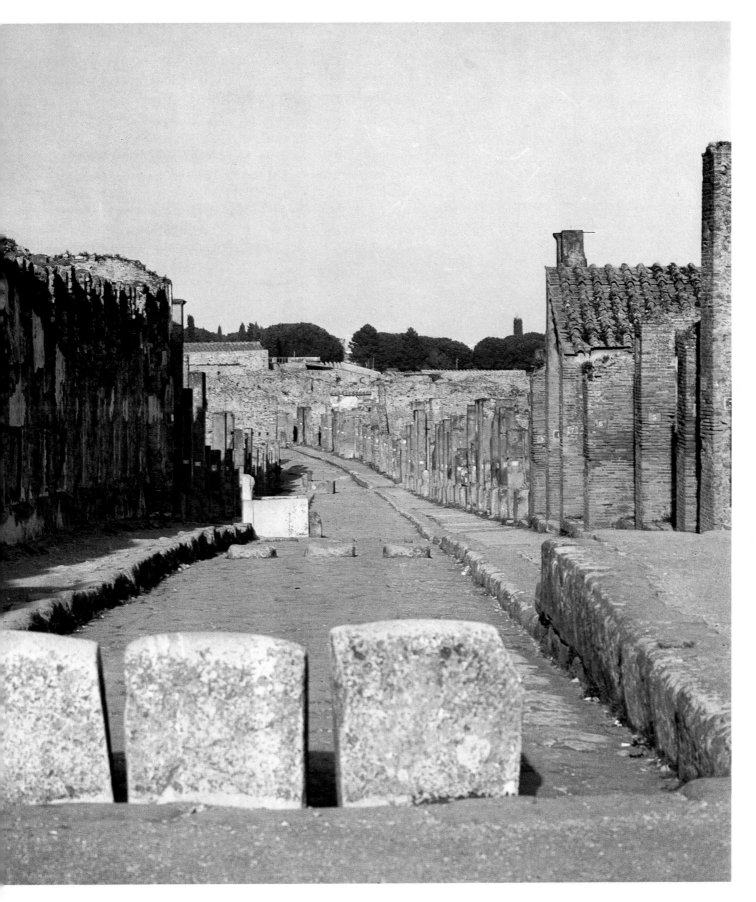

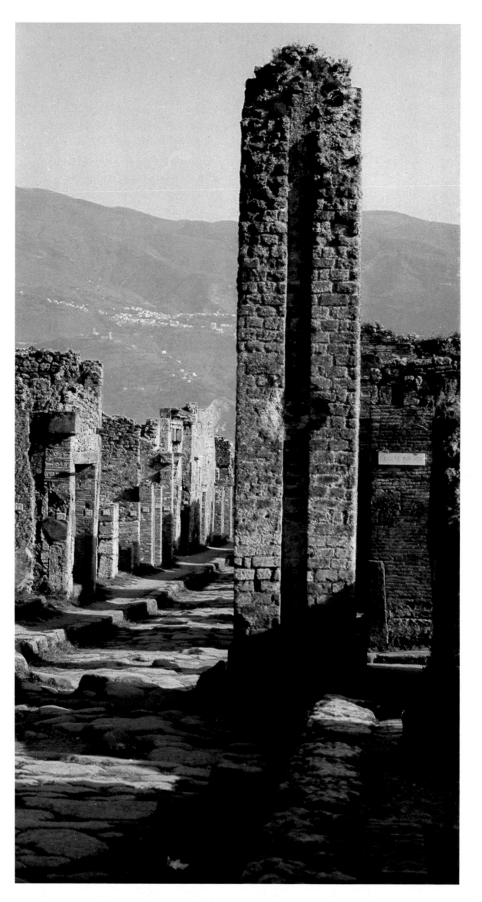

Left:
A view of the city below the Lactarii mountains.

Right:
A winding street in the ancient part of the city near the Forum.

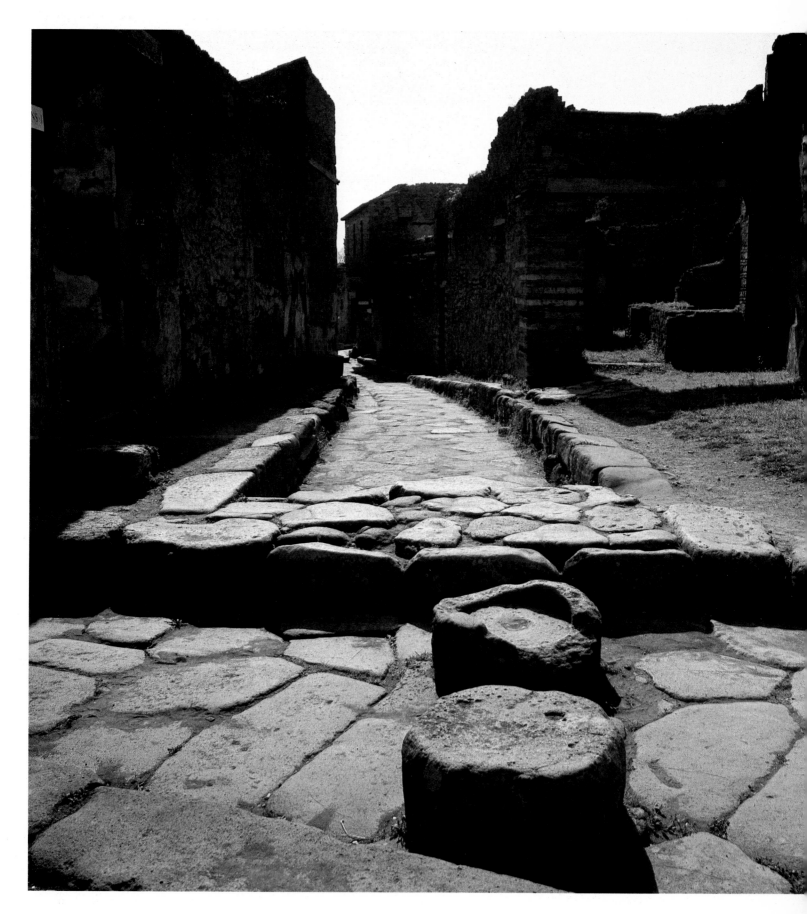

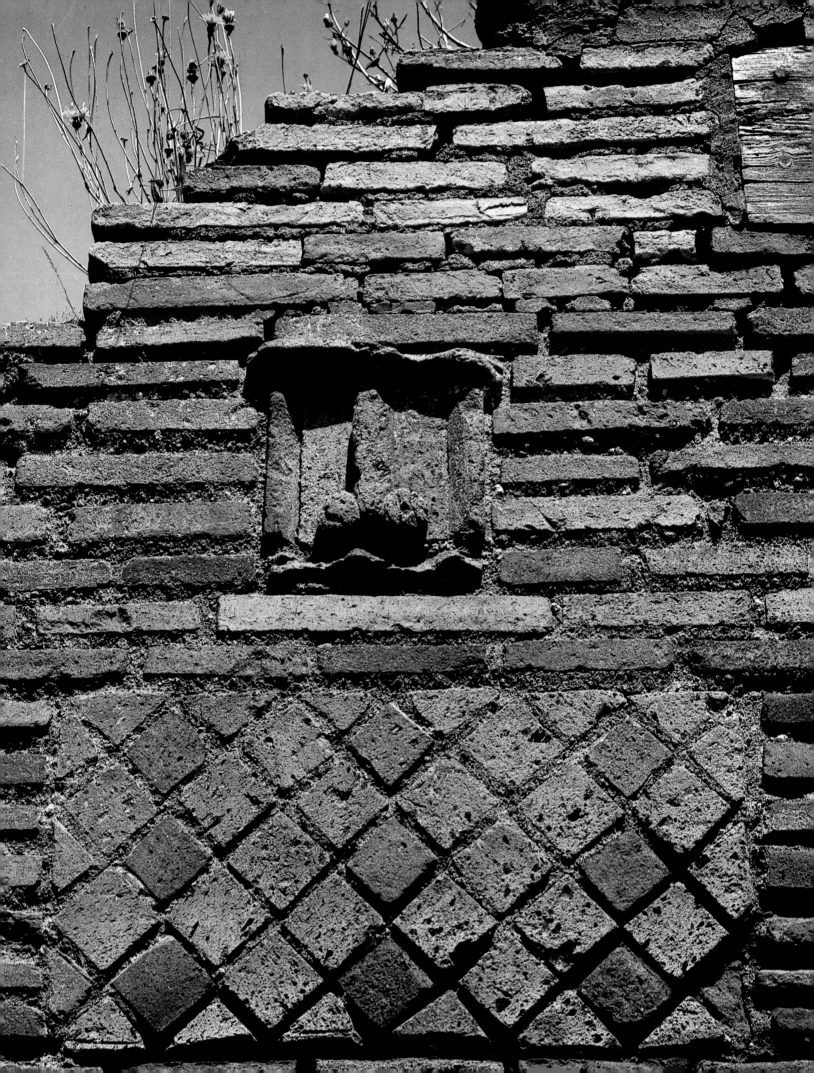

pathetic attempts to save themselves and their families and property ended in disaster.

Our most dramatic evidence of their fates is owed to one of Italy's outstanding archaeologists, Giuseppe Fiorelli, who was appointed in 1864 to the chair of archaeology in the University of Naples and then given general charge of the excavations. Fiorelli discovered an almost perfect way of recapturing the appearance, first of ancient trees, plants and other objects, and then of the human beings (as well as the animals) who died in the eruption. He noted that the rain of ash had often hardened so closely around the corpses that, although in the course of time they had decomposed, their exact outline was still perfectly preserved round the hollow space. When, therefore, such a hollow was discovered, Fiorelli first removed the bones from inside—a perilous task, owing to the lethal gas, the *mofeta*, which still lurked in these spaces—and then introduced into the hollow a tube through which he poured a special solution of liquid plaster. This, as it solidified during the course of the next few days, exactly reproduced the shape of the body. The results are startling, as vivid as any remains that archaeology has bequeathed to us anywhere in the world. Even the outlines of clothing and sandals are preserved. The tormented poses and facial expressions tell their own terrible story.

In the second millennium B.C., the island of Santorin (Thera) in the Aegean had suffered a fearful eruption, of which archaeologists are now discovering the consequences. At that time there were no historians to leave records, but

31

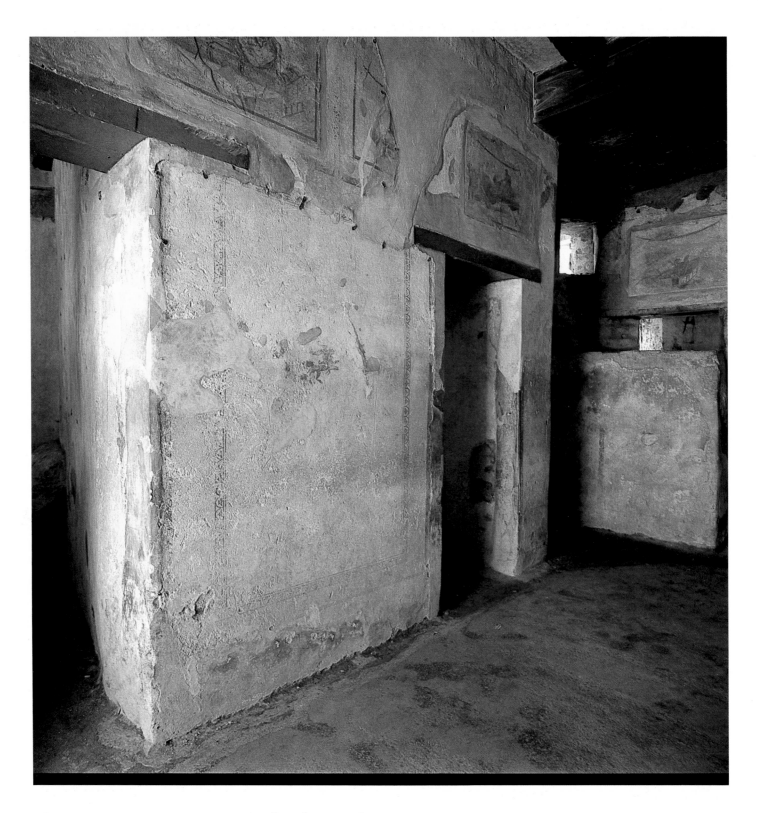

Above:
Interior of the brothel showing the entrances to the cubicles used by customers. Numerous frescoes advertise the specialité *de la maison, whose praises are also sung in the graffiti left by the occasional client.*

Opposite page, above:
A fresco from the brothel showing an erotic encounter.

Opposite page, below:
Another fresco from the brothel with an ithyphallic portrait, probably that of Priapus.

Pages 34–5:
Fresco in the Fourth Style, from a Pompeian house. It shows the elegant pavilions of a seaside villa, with its backdrop of hills and small boats passing by.

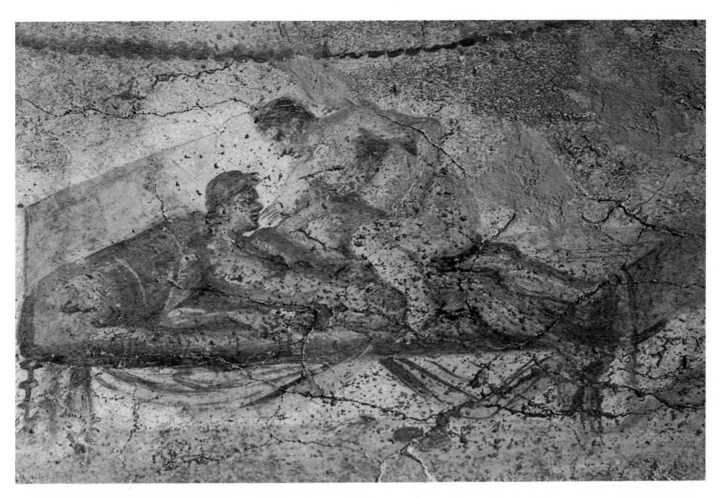

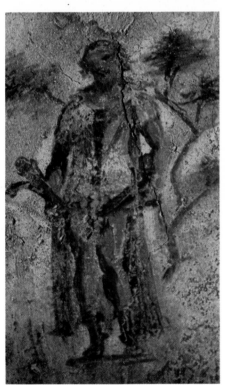

during the subsequent centuries after written history began, the Mediterranean area has never experienced a more destructive volcanic upheaval than the disaster caused by Vesuvius in 79 A.D. It was probably during this eruption that the mountain split, at just over half its height, into its present two peaks: to the ancient, eroded Monte Somma was added the new active cone of Monte Vesuvio.

Since then, there have been more than seventy further eruptions. None was as bad as the first; but the explosion in 1631 caused great loss of life, and made the crater of Monte Vesuvio three times larger than it had been before. In 1845 the Osservatorio Vesuviano was founded, to provide exact seismographical analyses. The last eruption was in March 1944, during the Second World War. In the following month, the crater closed up. It is still closed and let us fervently hope that that is how it will remain!

Goethe saw Vesuvius as a peak of hell, rising out of paradise. The death-dealing mountain, and its destruction of Pompeii, also inspired Giacomo Leopardi's great poem *La Ginestra (The Broom)*, written in 1836. Compared to the destructive force of the volcano he saw human life as a paltry thing; nineteenth-century doctrines of progress left him unimpressed. Hearing of the eruption of 1817 from an old man who had witnessed it (and was still so terror-struck that he would never turn his back to the mountain), the poet compares our life to an ant-heap which is as quickly destroyed by a falling apple as Pompeii was wiped out by Vesuvius. Yet our existence, he points out, which is perpetually threatened by the mountain, is also perpetually regen-

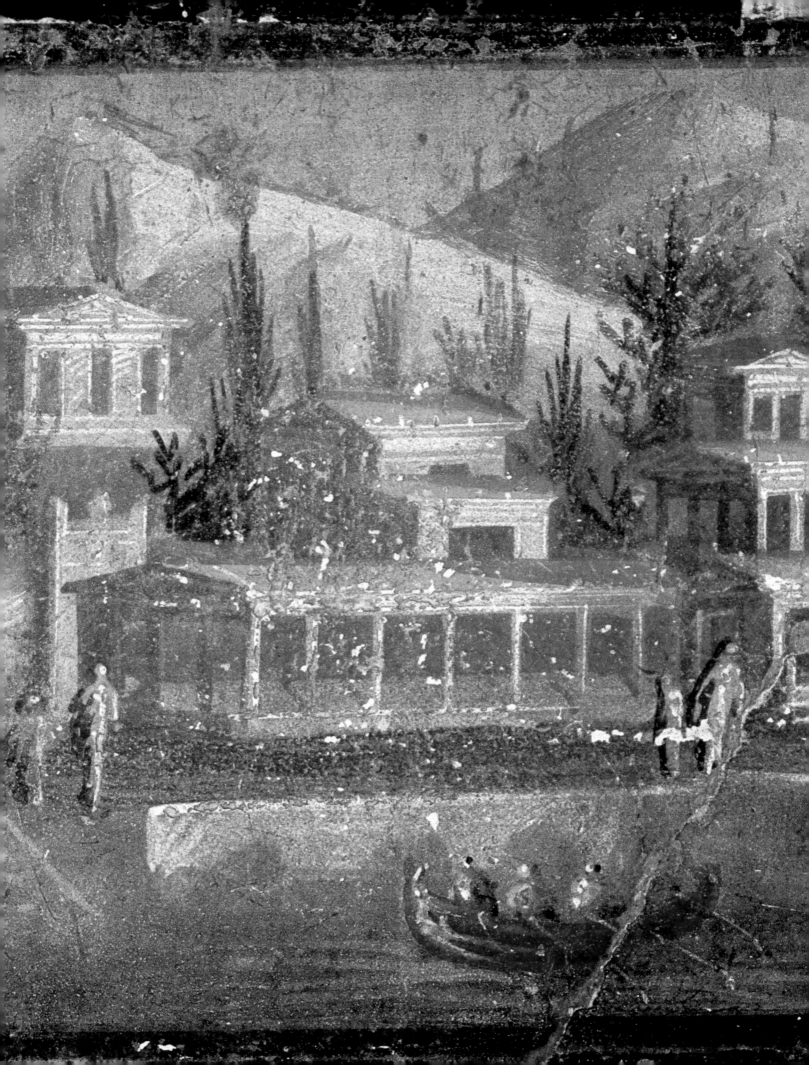

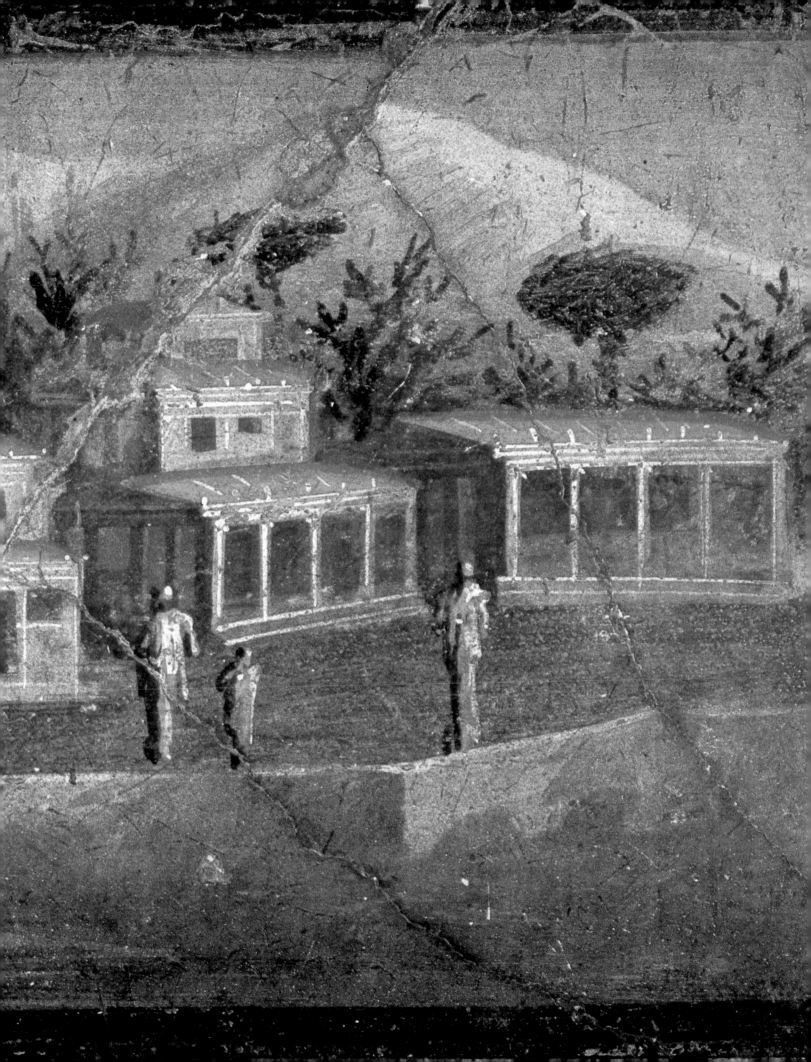

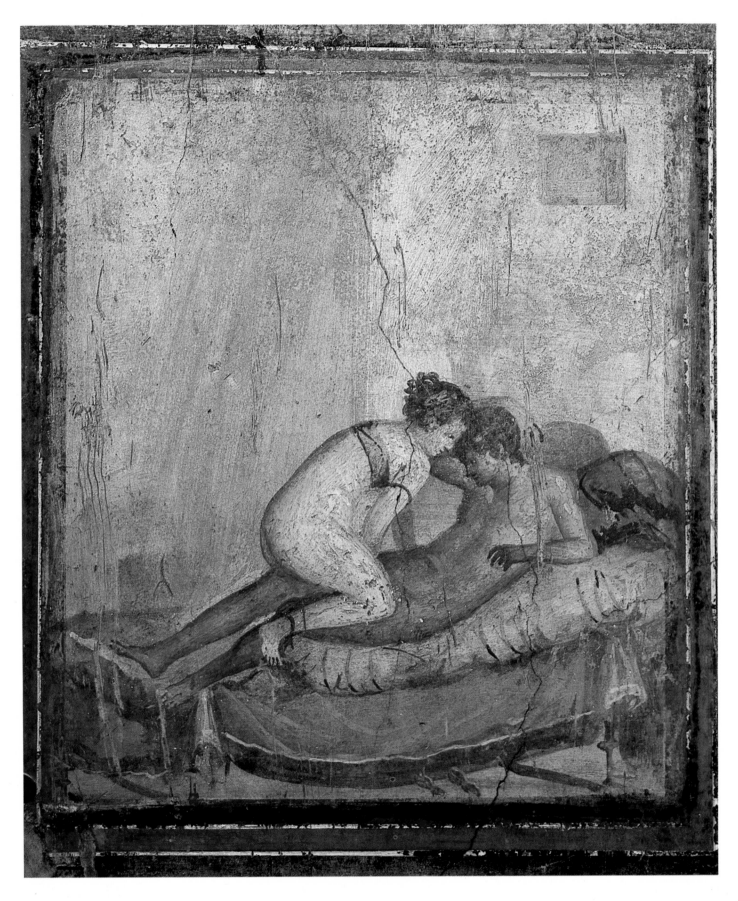

The House of the Centenary *(so-called because it was discovered on the hundredth anniversary of the excavations at Pompeii). A wall-painting showing an erotic scene.*

erated in its shade. The phenomenon is symbolized by the humble broom, growing on the lava fields where a new cataclysm will one day blot it out. Unlike man, it claims no immortality, but lives humbly and wisely for the day.

The busy life of Pompeii, thus devastatingly terminated in 79 A.D., had lasted for not far short of a millennium.

Long before the Romans were known, the inviting coastland of Campania had received successive waves of immigrants and attackers. In the eighth century B.C. the Greeks chose Cumae, just beyond the north-western extremity of the fertile Bay of Naples, for their earliest settlement on the Italian mainland. Then came the turn of the coast and of the Bay itself, described by Boccaccio as the most beautiful corner of all Italy. Before 650 B.C., Naples itself was settled, and a hundred and fifty years later Pozzuoli was founded; under the name of Dicaearchia, and later Puteoli, it outstripped Naples in commercial importance for centuries.

Pompeii lies not very far from the coast, 22 kilometres south-east of Naples. First of all, there had probably been a native Italian (Oscan) fishing and farming village on the site; and then came the Greeks. On the location now known as the Triangular Forum, they constructed a temple with Doric columns, of which the sparse surviving fragments go back to a date before 500 B.C. The temple stood on a southward-facing spur of the isolated volcanic ridge, about 40 metres above the level of the sea, on which the town of Pompeii later expanded. The ridge was created by a prehistoric flow of lava down the slopes of Mount Vesuvius, which dominates the scene some 8 kilometres away. At the southern end of the escarpment this lava flow had stopped abruptly, creating a cliff-like boundary which overlooked the little river Sarnus. This stream, now much diminished but at that time navigable by shallow-draught vessels of reasonable size, gave Pompeii the role of a minor sea-port serving the road-centre of Nuceria Alfaterna (Nocera), 11 kilometres inland. The Greeks also settled to the south of Pompeii at Stabiae, to the west at Oplontiae (Torre Annunziata), and farther to the north-west at Herculaneum.

But in due course these little Greek communities became subordinated to the major peninsular power of Italy, consisting of the city-states of the Etruscans, who came south from their homeland in what is now Tuscany and by the middle of the seventh century B.C. had established themselves at Capua (S. Maria Capua Vetere) in Campania. Before 500 B.C., they had extended their control over the greater part of the Campanian territory, including Pompeii where their black vases bearing Etruscan inscriptions have been discovered.

Yet they could not capture Cumae, the most formidable town of the area. On two occasions, in 524 B.C. and again in 474 B.C., they tried and failed; and within the decades that followed they gradually had to yield up the control of Campania and the Bay of Naples to the tough Samnite hill-folk from the interior. Cumae fell to the Samnites in about 420 B.C., and before long it was the turn of the coastal towns, including Pompeii, where the Samnites' Latin-related language, named Oscan after the people they had superseded, and written down in an adapted version of the Greek alphabet, slowly supplanted the Greek language that had been previously implanted in this area. Yet Samnite Pompeii retained its autonomous Republican government, directed by an Assembly under the chairmanship of an official known as the *meddix tuticus*.

In the late fourth century B.C. the Samnites became locked in warfare with the growing power of Rome. As a preliminary to the suppression of Samnium

Page 38:
House of the Ceii. *Detail of the tetrastyle* atrium. *In the foreground is the marble rim of the tank for catching the water (stored underground in a cistern) which came through the opening in the roof* (expluvium).

Page 39:
House of the Silver Wedding. *The great tetrastyle* atrium *of one of the most interesting of the older houses in Pompeii. It was built before the settlement of the military colony by Sulla (end of the second century B.C.).*

Pages 40–1:
House of the Silver Wedding. *Another view of the* atrium, *seen from the enclosed courtyard (peristyle).*

37

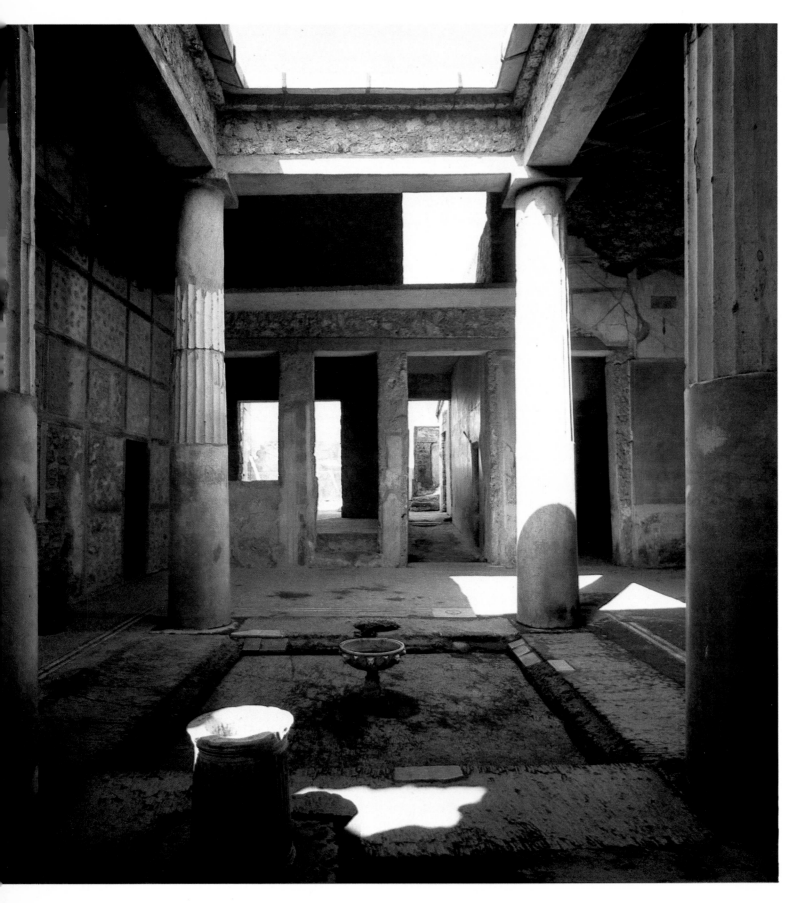

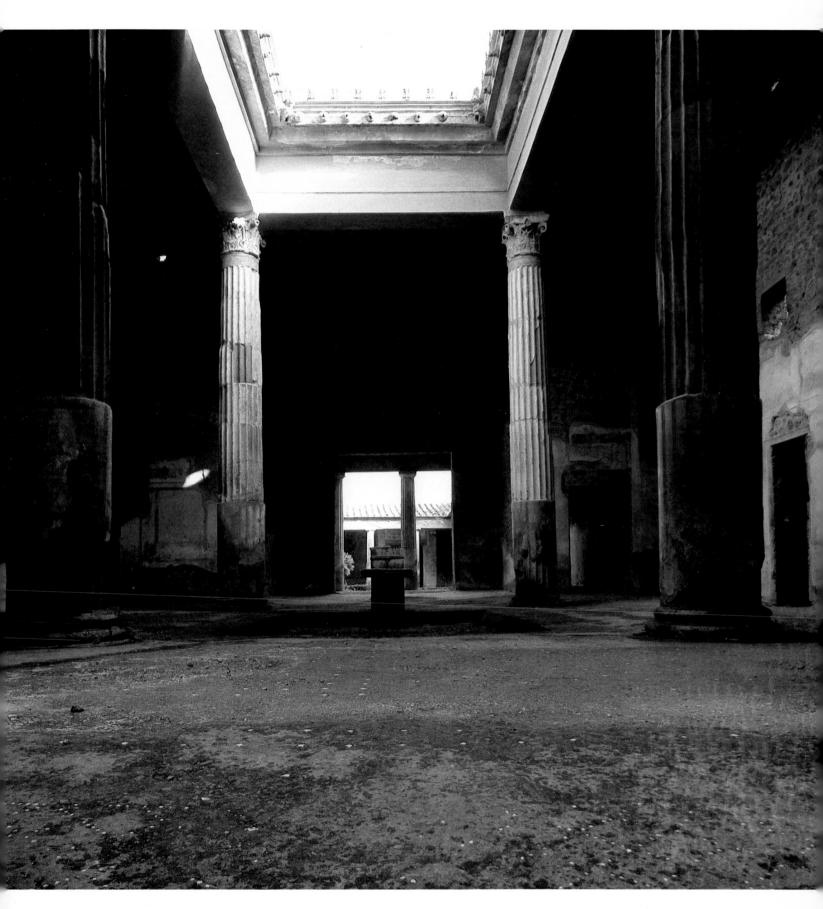

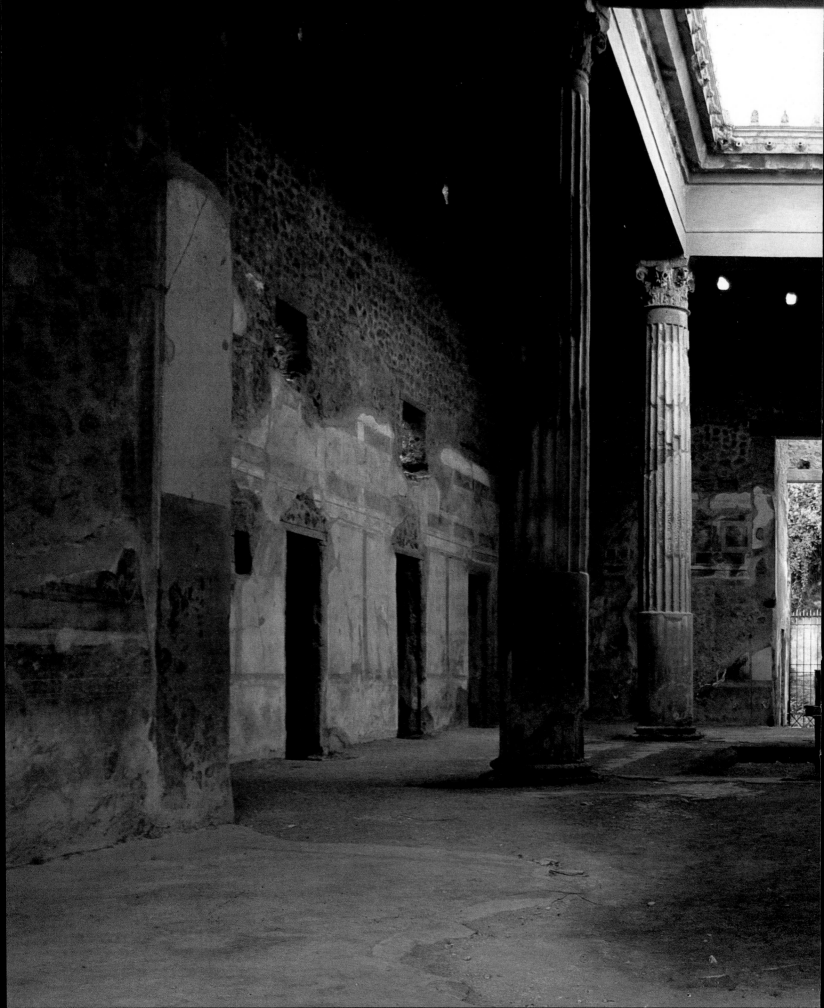

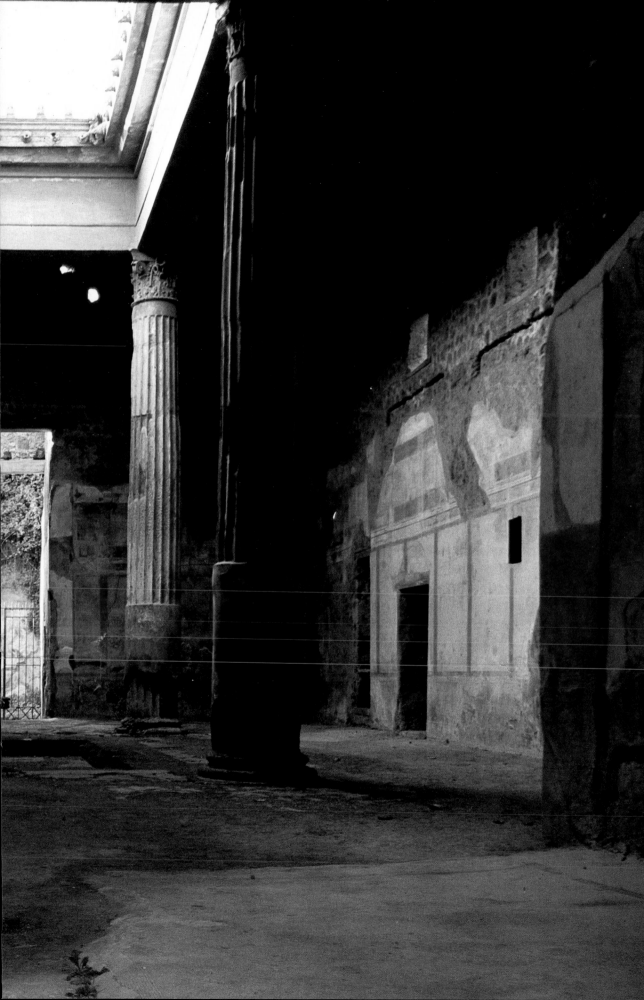

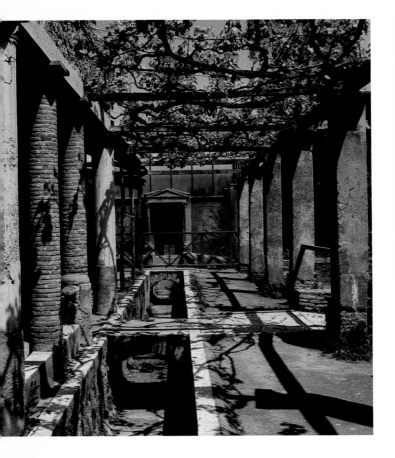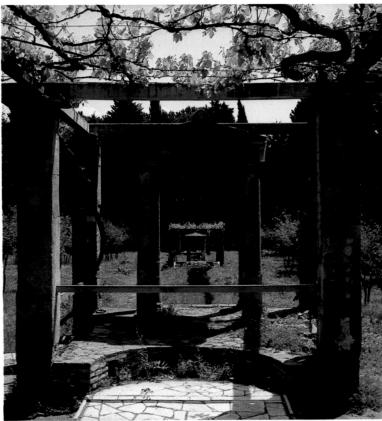

itself, the Romans gradually launched a comprehensive conquest of Campania, in the course of which they landed at the mouth of the Sarnus and took Pompeii, which passed under their control. Nearly a century later, during the invasion of Italy by Hannibal in the Second Punic War (218–201 B.C.), Capua temporarily went over to the Carthaginians, but Pompeii remained loyal to Rome. When, on the other hand, the Italians revolted against the Romans in the Social or Marsian War (91–87 B.C.), Pompeii and its neighbours joined the rebels. They were overcome by Sulla, Rome's future dictator, whose successful siege of Pompeii is illustrated to this day by holes in the town walls made by the stones shot from his siege-engines and by lead missiles found outside one of the gates: and Sulla's own name is found scratched on the plaster wall of a tower. After the war Pompeii became a Roman colony, and a large batch of Roman colonists moved in. According to Cicero, their relations with the former citizens were in the first instance very strained.

But in the end the place resumed its peaceful existence and, in its fairly modest way, prospered as never before. Distinguished men from Rome and elsewhere, as well as local residents who had enriched themselves, constructed costly villas in the surrounding countryside. Happy is the country without a history, and at Pompeii there was a happy uneventfulness until 59 A.D., when a serious riot between Pompeians and Nucenians in the amphitheatre resulted in its official closure for ten years. Three years later came the ominous earthquake: then in 79 A.D., Vesuvius performed its dreadful task of obliteration, and all the seething life around the mountainside was shattered and entombed.

Above:
House of Octavius Quartio, *also called (incorrectly) the House of Loreius Tiburtinus. Two views of the great* nymphaeum *with its water channels, fountains and ornamental pictures. The one at the far end, in the illustration on the left, is a scene from mythology.*

Opposite page:
Peristyle in the House of Julia Felix. *The marble pilasters are rectangular in cross-section, a comparatively rare form which appears later in Hadrian's Villa at Tivoli.*

Page 44:
The peristyle of the House of the Marine Venus. *Traces of painting in the Fourth Style of Pompeii (Julio-Claudian period) still decorate the walls of the building.*

Page 45:
Wall-painting showing a villa of semicircular plan, with colonnaded buildings arranged on three levels.

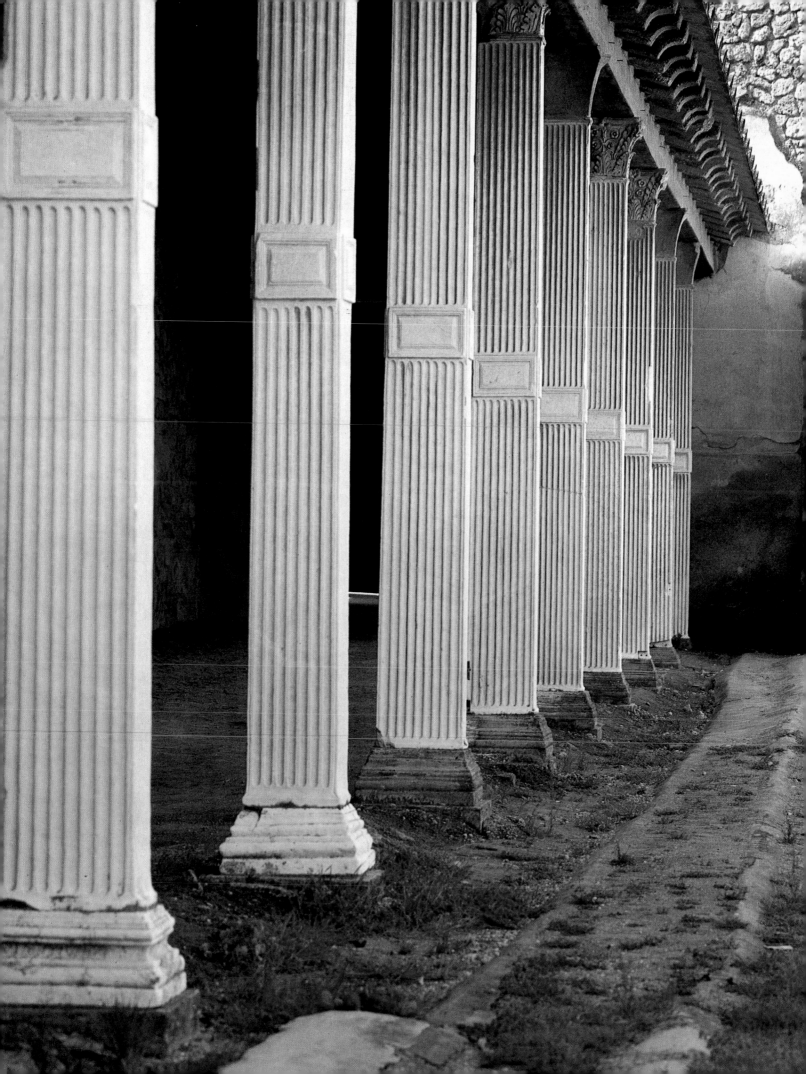

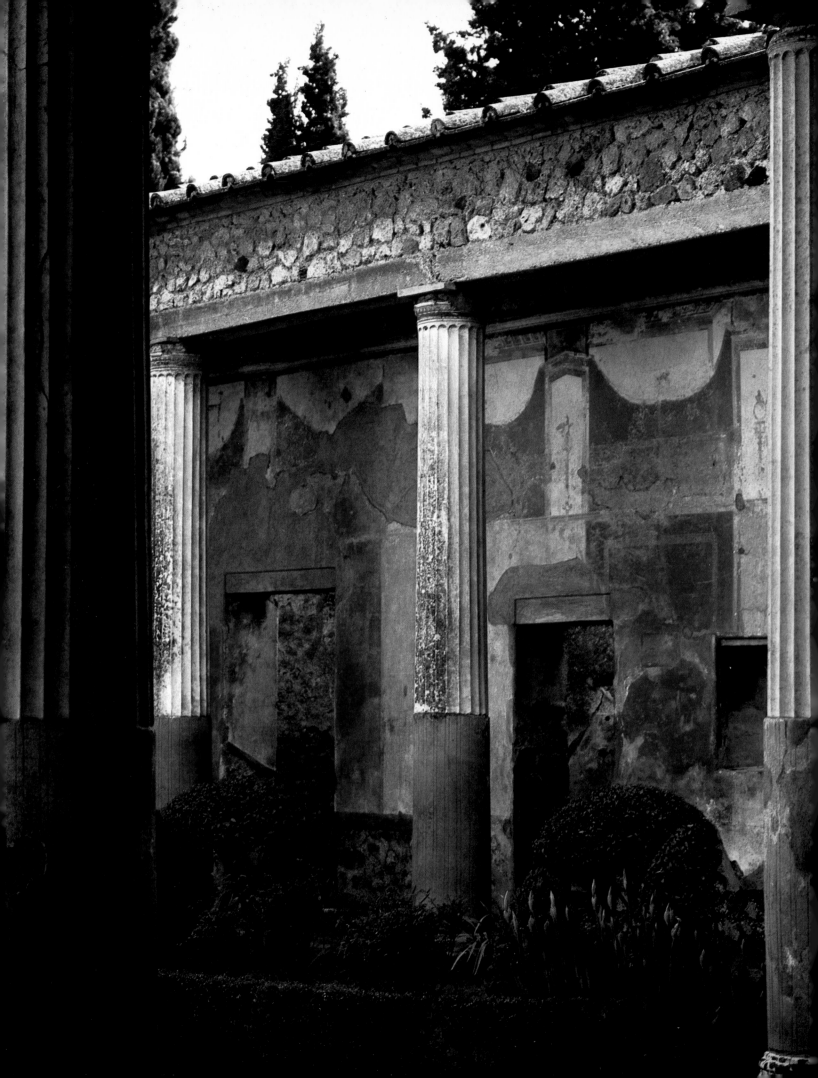

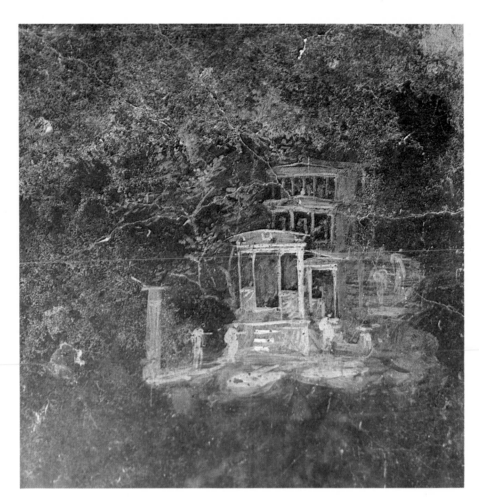

What sort of a place was the little city of Pompeii which had thus been so suddenly removed from the face of the earth?

To walk round its circumference took about half an hour. The population of the town, about 20,000, was four times the size of Herculaneum, and about the average for an Italian town of its time. In its earliest days Pompeii had just been an irregular huddle of buildings, but already in the fifth century B.C. orderly geometric town-planning on the Greek model had been introduced. Thereafter, expansion gradually followed. Sulla and Augustus added their quotas of buildings and adornments, and the biggest construction boom was under Nero, as a result of the earthquake which occurred in the year 62 A.D..

The streets, by modern standards, are extremely narrow; but this narrowness at least meant that there was some shade during the very hot summers, and so did the overhanging balconies of many of the houses and shops. These thoroughfares are paved with large slabs of grey Vesuvian lava, and one can still see the deep ruts scored in their surfaces by the wheels of ancient chariots and carriages. But as the streets were sometimes piled high with refuse, or were awash with water, large stepping stones were placed to enable pedestrians to cross from one sidewalk to the other.

The crossroads of the excavated, uninhabited city caused distress to Madame de Stael, whose romance travelogue *Corinne ou l' Italie* (1807) registered the tense feelings these spaces aroused in her:

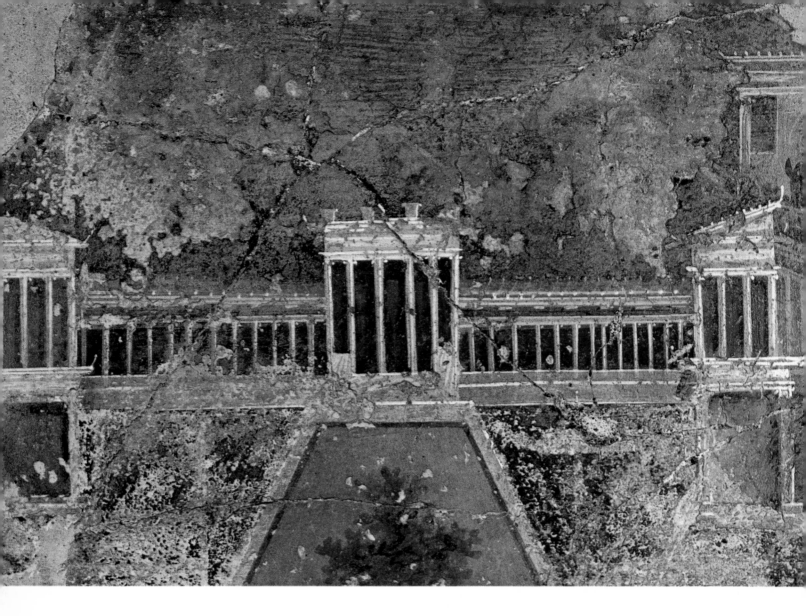

When you stand in the middle of one of these crossroads, from which one sees on every side the city which still survives almost in its entirety, it seems that you are waiting for someone, that the master is ready to make his appearance: and the very semblance of life that one's presence at this spot provides makes the eternal silence all around felt all the more poignantly.

At many of these crossroads there were fountains with sculptured headstones and troughs. Like the spacious public lavatories, they were served from reservoirs fed by a local offshoot of a 26 kilometre long aqueduct from the interior.

The walls of Pompeii are important to students of ancient Italian fortification. Four successive phases of construction can be traced. First there was just a palisaded earthwork. Then, in the mid-fifth century B.C., a facing of tufa and Sarnus limestone was added. The second century witnessed further reinforcement, and in about 100 B.C. twelve towers were added. There were seven gates, of varying elaboration and impressiveness—some of them originally surmounted by statues of Minerva, the patron of commerce. Just outside the walls were cemeteries containing rows of box-like but varied mausolea. When these were excavated, they were found to have fine internal mural paintings, and to contain valuable jewellery and other objects. For the dead must be allowed to enjoy some of their pleasant possessions; and their living relatives not only visited their tombs, but banqueted in them

Two frescoes from Pompeii in the Fourth Style, now in the Naples Museum. They show two great villas which bear a striking resemblance to houses which actually existed, such as that of San Marco at Stabiae.

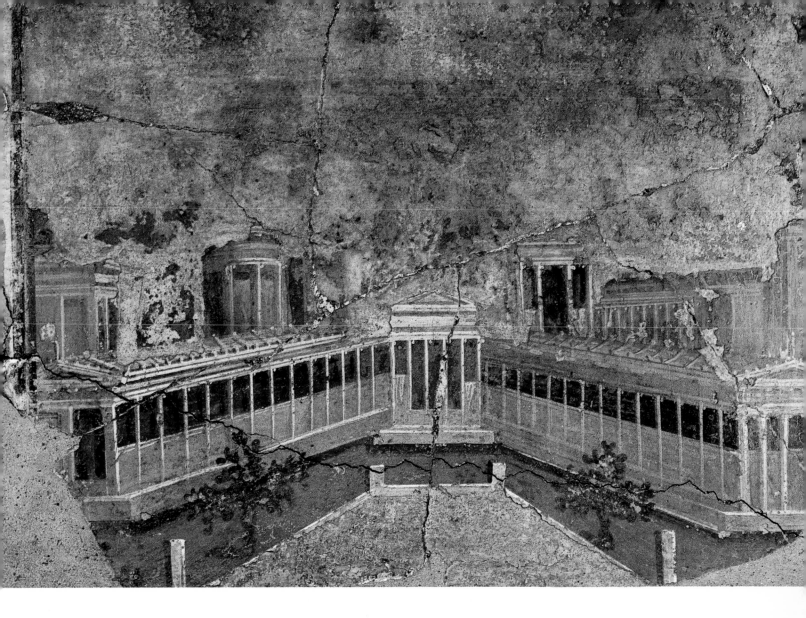

every year—and took refuge in them during the eruption, which meant that many of them were entombed in their turn. The relation between dead and living is always intimate and intricate at Pompeii.

The public buildings compare favourably with those of any town of the same size today—even in Italy, where there are so many small Renaissance towns with fine piazzas and town halls. After the small Triangular Forum of the original Greek Pompeii, the main rectangular Forum, later constructed in another part of the town, on one of its few tracts of level ground, was a splendidly conceived composition with a two-storeyed plastered and painted colonnade—almost a predecessor of the Piazza San Marco in Venice. On its west side stood the noble Basilica. This building, with its internal colonnades, was a rendezvous of legal, commercial and social life, the ancestor of church basilicas and lawcourts and stock exchanges and the covered meeting places, *gallerie*, in which Italian city-dwellers congregate today.

Pompeii also displays a stone amphitheatre large enough to seat almost the entire population—far older than any amphitheatre in Rome, and indeed the oldest known permanent building of the kind. For Campania, under Samnite and Etruscan influence, was particularly devoted to the horrors of the gladiatorial games, and it may have been from this region that the Romans derived them. Pompeii also had a barracks for gladiators, containing nearly a hundred cells, on two levels, grouped round a large rectangular space. On these premises were found sixty-three skeletons of people who lost

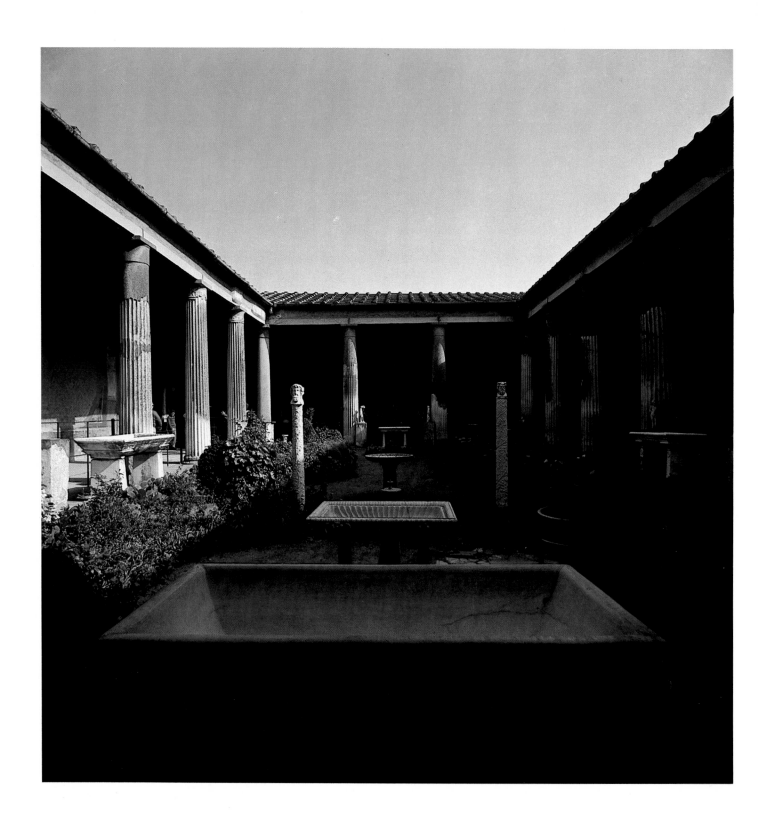

House of the Vettii. *The peristyle and garden as restored by the excavators. With its water tanks, fountains and ornamental statuary, this is one of the best surviving examples of a garden of the early imperial period (62–79* A.D.*).*

their lives in the eruption, one of them a bejewelled woman visitor. In many parts of Pompeii, graffiti celebrating popular and favourite gladiators abound.

Fortunately the Pompeians enjoyed not only the gladiatorial arena, but the drama as well. There were two fine stone theatres; and how many towns of 20,000 inhabitants can say the same today? The Large Theatre of Pompeii, like its amphitheatre, is older than any counterpart at Rome; the tufa seats in its half-circular open air auditorium were constructed nearly three hundred years before the Colosseum. Pompeii also boasted an elegant Small Theatre or Odeon, with room for between 1000 and 1500 spectators, who, unlike the audiences in the Large Theatre, sat under some sort of a roof. Although there could not be the same extensive public for plays as for gladiatorial shows, keen enthusiasm was shown, as numerous graffiti praising actors testify; and of one of them a brilliant bronze portrait, also, has survived.

Pompeii was the possessor of two sports grounds (*palaestrae*), and no less than four luxurious public baths—again a feature which greatly exceeds anything to be found in modern towns of the same size. Their *calidaria, tepidaria, frigidaria* and, sometimes, *laconica* (sweating rooms), although small in comparison with the vast later establishments at the capital, give us better and fuller information about Roman baths, their sophisticated central heating arrangements and their vigorous, varied social life than we possess from anywhere else in the ancient world.

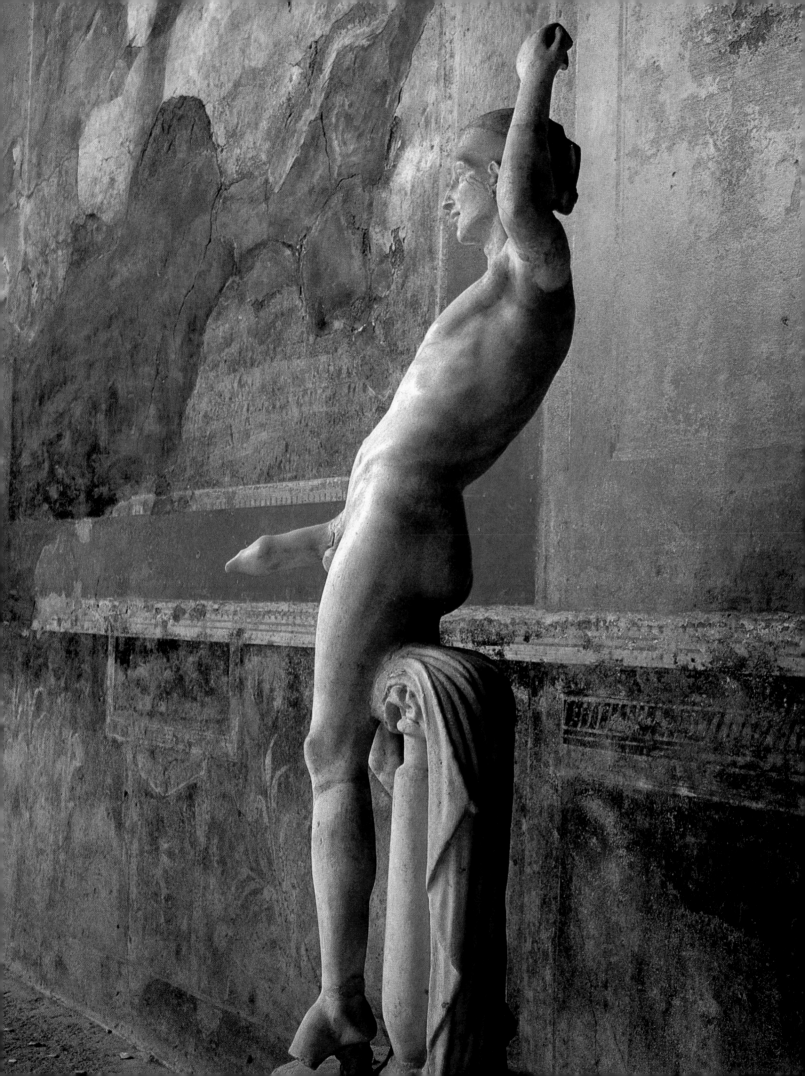

House of the Vettii. *A fountain in the form of an ithyphallic figure, with the phallus serving as a waterspout.*

As in other cities of the Empire, life was intimately bound up with religious cults, whether official, emotional or domestic in character. At Pompeii, ten temples of different deities have come to light—though in most cases the remains are disappointingly meagre. The shrine of the divine patron of the earliest Greek community, Heracles, has almost nothing to show. The temple of his successor as chief deity of the local community, Apollo, is a little easier to visualize from its ruins, since we can see part of its forty-eight-column portico and a superb bronze statue of the god, which is now in the National Archeological Museum at Naples, though a copy has been set up in the temple itself. But during the greater part of its life Pompeii was under the special patronage of the goddess Venus, the Greek Aphrodite. To the Pompeians she was the mistress of Nature itself and the universe and also the ever-present divinity guaranteeing their love-life. But her temple, severely damaged in the earthquake of 62 A.D., had only begun to be reconstructed when the final disaster fell upon the city.

As was appropriate in a Roman and Italian city, the Temple of Jupiter, the king of the gods, stood at one end of the Forum. There were also buildings honouring deified emperors, notably a shrine dedicated to the Genius of Vespasian, who died only a month before the city was finally obliterated. These were somewhat formal cults of a national and civic character. But what engaged the emotions of the Pompeians far more deeply, as with millions of inhabitants of the Empire, were the Mystery religions. For they promised salvation in the after-life to their initiates and were only, much later, prevented by Christianity from completing what might have been a total take-over of the ancient world. One of their places of worship at Pompeii, the temple of the Egyptian goddess Isis, is the best-preserved religious building in the town; its exotic appearance, appropriate to a community with a large Oriental trading population, was finely depicted in the eighteenth century by an engraving of Giambattista Piranesi. When the eruption came, the priests of Isis, interrupted at their lunch, ran out into the streets carrying the temple treasures. But one after another they fell, dispersing their valuables as they collapsed; the last of them took refuge in a house, where they were trapped and died. The other leading Mystery cult at Pompeii celebrated Dionysus (Bacchus) who was not only the god of wine but the liberator of all mankind. His rituals are memorably and enigmatically depicted on the walls of the Villa of the Mysteries outside the town.

But it is the private houses in Pompeii which remain its most wonderful series of monuments—unique, in conjunction with Herculaneum, in their revelations of the ancient world. We are speaking, of course, of the upper and middle classes; for the dwellings of the poor, unless they lived above their shops, were too humble and makeshift to survive. The typical house of these more prosperous Pompeians—at first single-storeyed, though later additional storeys were added—is an inward-looking building blind to the street, like the inward-looking houses of later Arab cities, with a number of rooms surrounding a sky-lit *atrium*. Behind, there is generally a garden, or more than one garden, enclosed in a colonnade or peristyle. The houses seem to us a curious combination of material discomfort and elegant taste. On the one hand, the rooms were mostly small, kitchens and lavatories seem makeshift and cramped, and artificial lighting and heating were inadequate. Windows were few and mostly unglazed: window-panes, made of selenite (a kind of gypsum) were rare in private houses, though they are to be seen in public baths. So it must have been perishingly cold in winter, or, if the shutters were kept closed, very smelly. The smell was sometimes disguised by burning bread.

Page 52:
House of the Vettii. *Two erotic scenes on the walls of a small room at the side of the kitchen.*

Page 53:
House of the Vettii. *Fresco in the entrance showing Priapus busy weighing himself.*

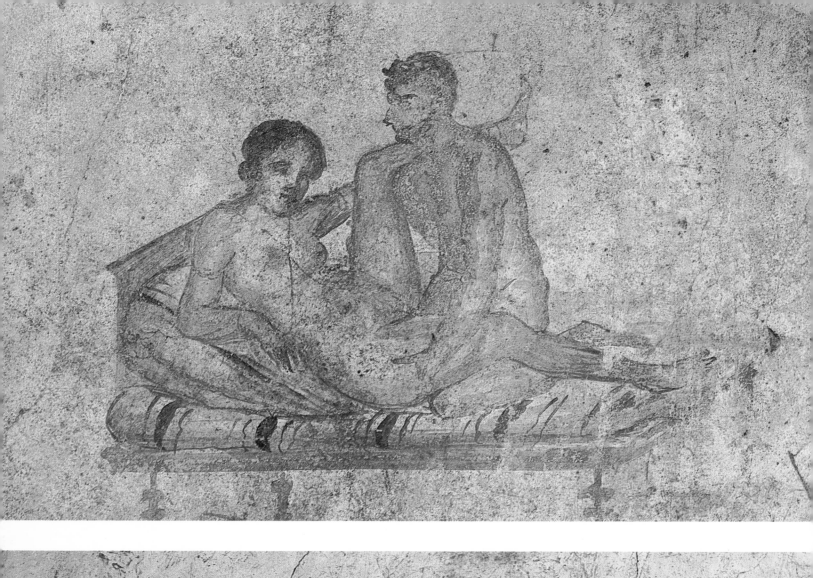

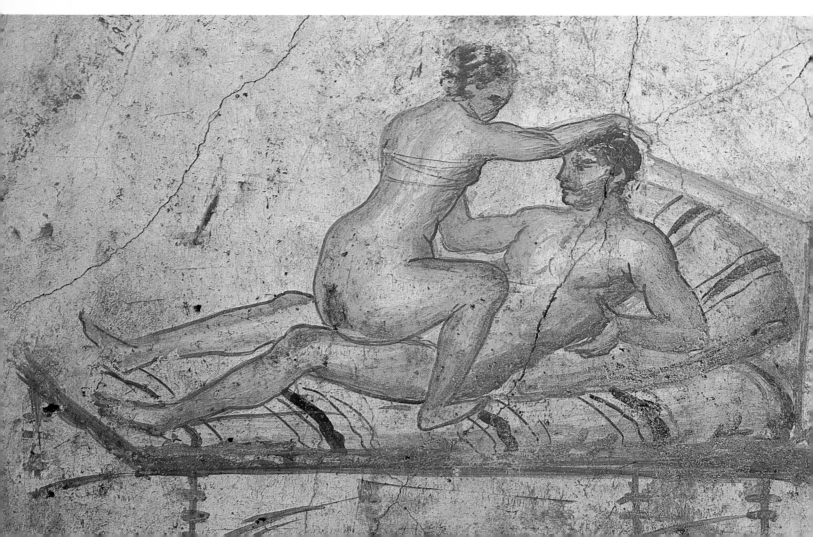

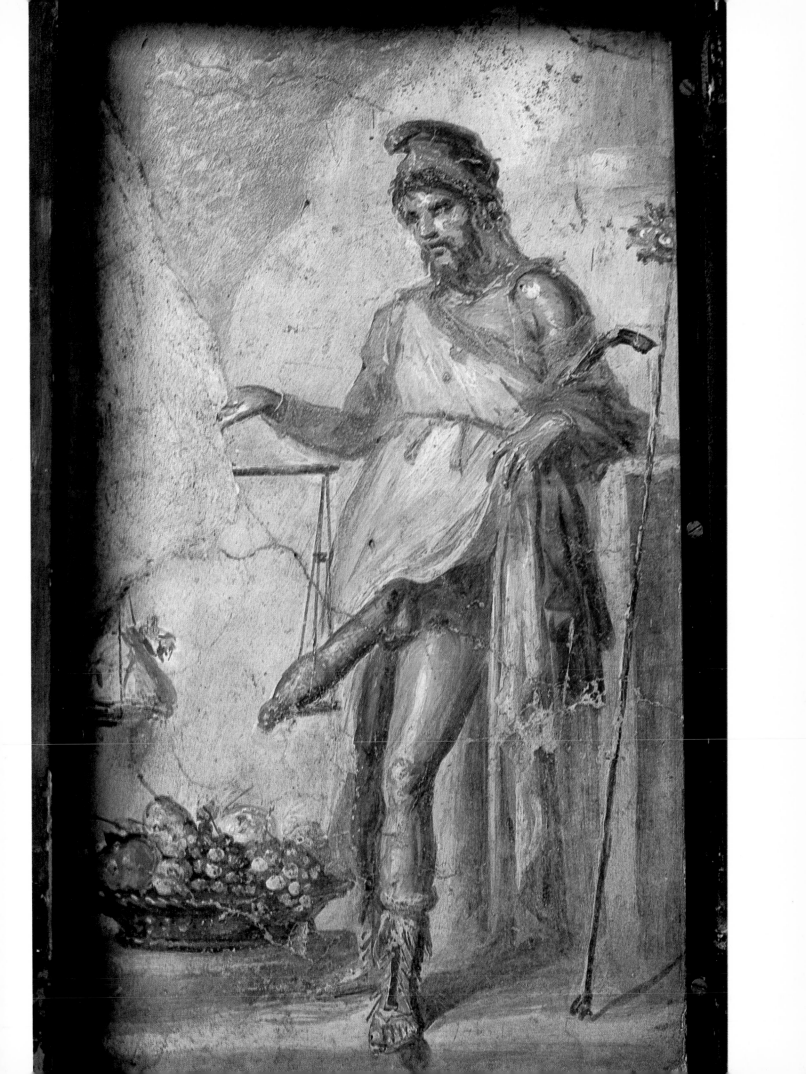

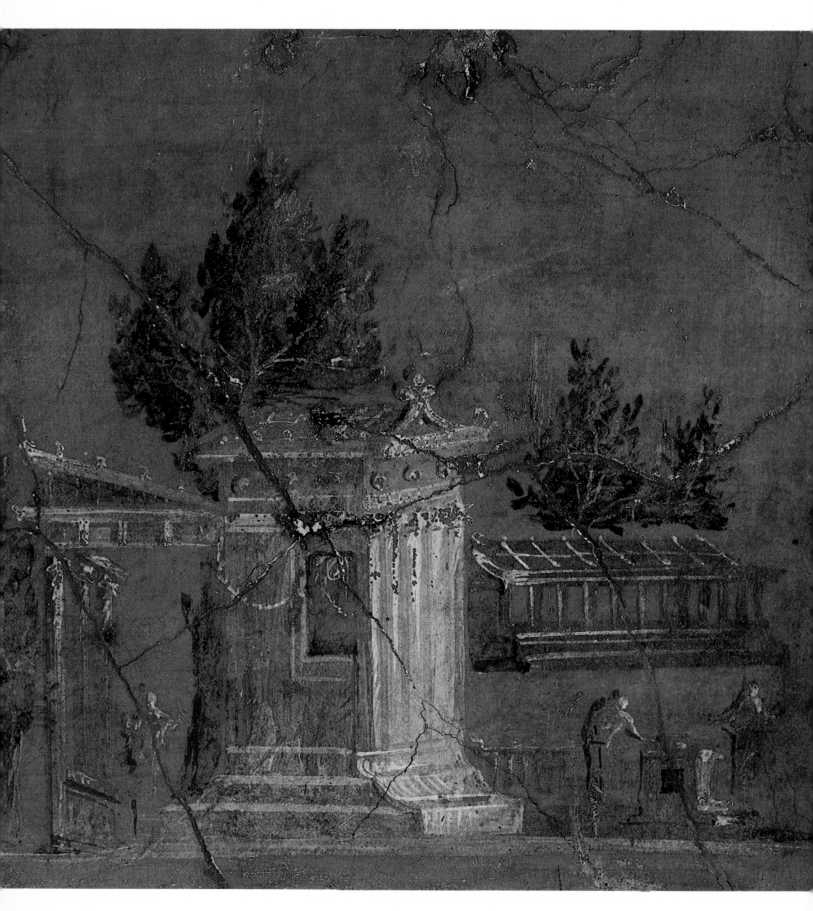

54

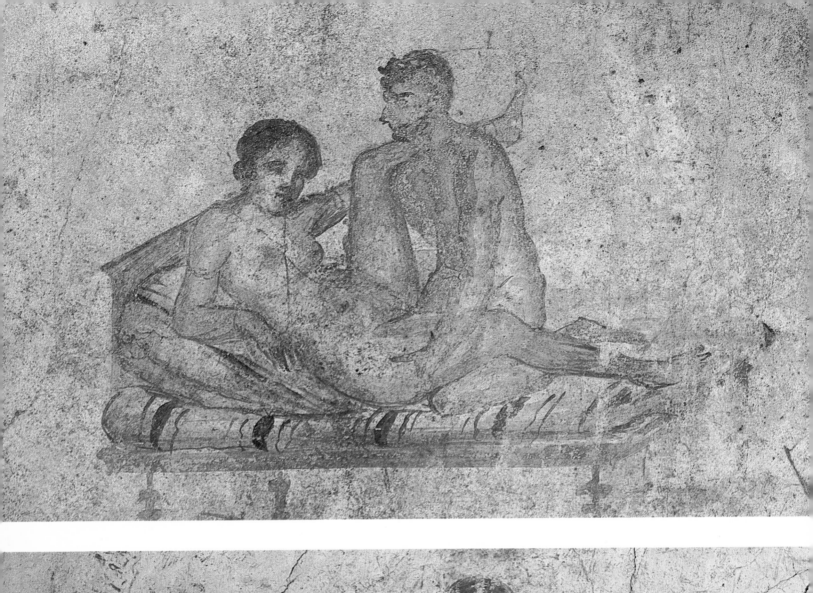

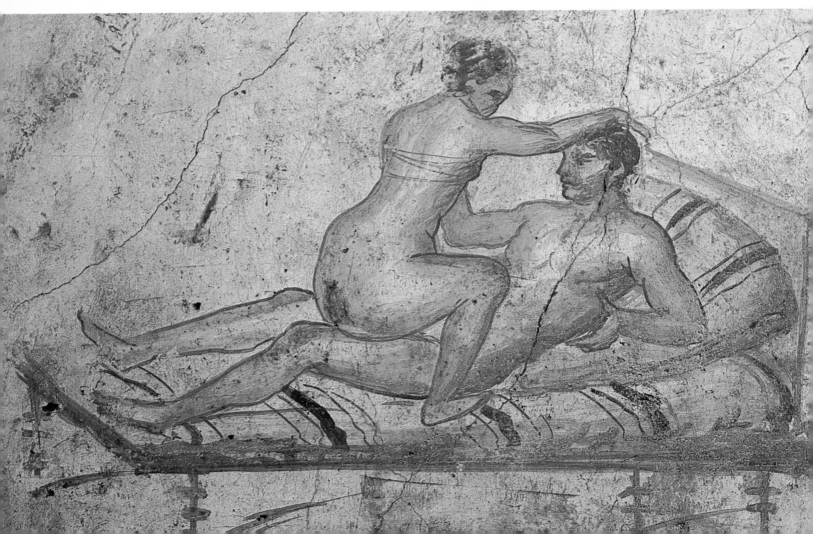

House of the Vettii. *A fountain in the form of an ithyphallic figure, with the phallus serving as a waterspout.*

As in other cities of the Empire, life was intimately bound up with religious cults, whether official, emotional or domestic in character. At Pompeii, ten temples of different deities have come to light—though in most cases the remains are disappointingly meagre. The shrine of the divine patron of the earliest Greek community, Heracles, has almost nothing to show. The temple of his successor as chief deity of the local community, Apollo, is a little easier to visualize from its ruins, since we can see part of its forty-eight-column portico and a superb bronze statue of the god, which is now in the National Archeological Museum at Naples, though a copy has been set up in the temple itself. But during the greater part of its life Pompeii was under the special patronage of the goddess Venus, the Greek Aphrodite. To the Pompeians she was the mistress of Nature itself and the universe and also the ever-present divinity guaranteeing their love-life. But her temple, severely damaged in the earthquake of 62 A.D., had only begun to be reconstructed when the final disaster fell upon the city.

As was appropriate in a Roman and Italian city, the Temple of Jupiter, the king of the gods, stood at one end of the Forum. There were also buildings honouring deified emperors, notably a shrine dedicated to the Genius of Vespasian, who died only a month before the city was finally obliterated. These were somewhat formal cults of a national and civic character. But what engaged the emotions of the Pompeians far more deeply, as with millions of inhabitants of the Empire, were the Mystery religions. For they promised salvation in the after-life to their initiates and were only, much later, prevented by Christianity from completing what might have been a total take-over of the ancient world. One of their places of worship at Pompeii, the temple of the Egyptian goddess Isis, is the best-preserved religious building in the town; its exotic appearance, appropriate to a community with a large Oriental trading population, was finely depicted in the eighteenth century by an engraving of Giambattista Piranesi. When the eruption came, the priests of Isis, interrupted at their lunch, ran out into the streets carrying the temple treasures. But one after another they fell, dispersing their valuables as they collapsed; the last of them took refuge in a house, where they were trapped and died. The other leading Mystery cult at Pompeii celebrated Dionysus (Bacchus) who was not only the god of wine but the liberator of all mankind. His rituals are memorably and enigmatically depicted on the walls of the Villa of the Mysteries outside the town.

But it is the private houses in Pompeii which remain its most wonderful series of monuments—unique, in conjunction with Herculaneum, in their revelations of the ancient world. We are speaking, of course, of the upper and middle classes; for the dwellings of the poor, unless they lived above their shops, were too humble and makeshift to survive. The typical house of these more prosperous Pompeians—at first single-storeyed, though later additional storeys were added—is an inward-looking building blind to the street, like the inward-looking houses of later Arab cities, with a number of rooms surrounding a sky-lit *atrium*. Behind, there is generally a garden, or more than one garden, enclosed in a colonnade or peristyle. The houses seem to us a curious combination of material discomfort and elegant taste. On the one hand, the rooms were mostly small, kitchens and lavatories seem makeshift and cramped, and artificial lighting and heating were inadequate. Windows were few and mostly unglazed: window-panes, made of selenite (a kind of gypsum) were rare in private houses, though they are to be seen in public baths. So it must have been perishingly cold in winter, or, if the shutters were kept closed, very smelly. The smell was sometimes disguised by burning bread.

Page 52:
House of the Vettii. *Two erotic scenes on the walls of a small room at the side of the kitchen.*

Page 53:
House of the Vettii. *Fresco in the entrance showing Priapus busy weighing himself.*

51

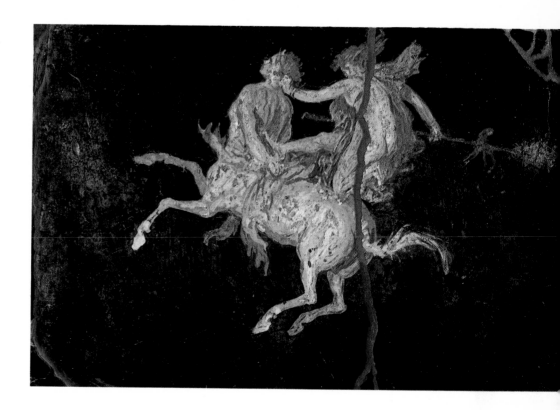

Yet the interiors of these little rooms are covered with wall-paintings, floor mosaics and stucco low-reliefs that comprise, all in all, one of the most exquisite schemes of interior decoration the world has ever seen. It would have seemed to the ancients a disturbance of architectural form to have hung canvases on the walls. Instead their surfaces were painted all over with murals, most of the best of which are now to be seen in the Naples Museum. They cover an extraordinarily wide thematic range: mythological groups, idyllic landscapes anticipatory of Magnasco, architectural fantasies, portraits, still-life paintings like those of the seventeenth-century Dutch Masters, and scenes depicting sex and love. Some are copies of Greek pictures; others are original. They are light, airy, gay and graceful, indicating complete mastery of a difficult technique and a remarkably high standard of visual taste among the householders who demanded such works.

The mosaics in these houses too, rank as outstanding wonders of ancient decorative art. The Italians knew of Eastern carpets but rarely placed them on their floors, which they covered instead with a mosaic ornamentation as integrally essential to the overall décor as the paintings on the walls. The mosaics can be divided, roughly speaking, into two categories: 'rug' or 'mat' patterns consisting of central panels (*emblemata*) with a framework of plain unpatterned mosaic, and 'carpet' designs extending over the whole floor, sometimes reproducing famous paintings, such as the Battle at Issus between Alexander and Darius. Amid all this decoration of the walls and floors, the furniture was, by modern standards, sparse. But the surviving bronze tables, tripods and lamps, and the metal mountings and legs of wooden beds and couches, show that it was a furniture of uniformly taut, elegant design, with none of the modern distinction between pieces that are 'good' and merely mass-produced.

Pompeian houses were inextricably associated with their gardens, which were, and now are, once again, among the major glories of the place—the

charming ancestors of the gardens of Italy which people have come from far and wide to see ever since. They enabled the dark little rooms to have continual access to the fresh air; and their subtle blend of plants, flowers and trees with statues, reliefs, fountains and masks or discs (*oscilla*) waving in the wind, form that brilliant union of Nature and Art which Goethe saw as one of the principal characteristics of Pompeii.

There are some tiny gardens, with their walls painted with scenes of Nature to make them look larger. But in grander mansions the garden surrounded by a colonnade or peristyle, of which a luxurious example is seen reconstructed at the House of the Vettii, is the norm. Grander still are the extensive grounds of the House of Marcus Loreius Tiburtinus, who was not only, as the remains of his studio show, an expert potter, but rejoiced in a large garden with greenhouses for exotic plants and flowers, and orderly rows of plum trees, oaks and various shrubs; these have now been accurately reconstructed and replanted, on the basis of identification from the outlines of their roots found in the ashes. The central feature of the layout is a T-shaped trellised fish-pool, the forerunner of great water-gardens like the Villa d'Este at Tivoli. The House of Julia Felix, the largest Pompeian residence so far to be discovered, also possessed a substantial piece of land, containing a fish-pond crossed by miniature marble bridges, and interspersed with diminutive grottoes and rustic shrines.

Outside the walls of the town, and scattered throughout the neighbouring landscape, were imposing villas, often supported by elaborate farms. Count-

Opposite page:
The atrium *of a house in Pompeii, with the traditional marble table* (cartibulum) *standing behind the* impluvium *(water-tank). Beyond is the large central dining room opening off the* atrium, *and the entrance to a 'wing' or 'side room'* (ala).

Page 59:
House of the Marine Venus *on the Via dell'Abbondanza. Detail of a garden scene from a painting in the Fourth Style.*

House of the Golden Cupids. *Detail of the peristyle with its ornamental statuettes and* oscilla, *decorations in the shape of actor's masks, suspended from the architrave of the portico.*

56

less smaller farms, also, were dotted round the countryside, for agriculture was the most important feature of Pompeian life. Inside the city, some of the most revealing discoveries are of ancient shops, with all their wares left just as they were on the fatal day of the eruption. Many of the shops sold agricultural produce. Twenty wine-shops or taverns have been identified at ancient Pompeii and more than a hundred bars. Prosperous families, notably the Vettii, produced various brands of wine from the numerous farms which they owned.

Ancient wine-drinking differed in some respects from modern practice. The Greeks and Romans usually mixed three parts of water with two of wine, and freely blended their wine with other products as well. The addition of ashes and lime neutralized excessive acid and assisted maturing. Porous wine-jars were lined with pitch for the flavour, just as modern Greeks still mix resin with their wine. Honey, the chief sweetener in the absence of sugar, was also added on occasion, and so were goat's milk, almonds, thyme, myrtle-berries, seawater and the dip of a redhot iron. Italian wines were sweeter and had more body than those of Greece, and Pliny the elder, enlarging on their glories with lyrical patriotism, enumerated some fifty kinds, and listed ninety varieties of grape.

The vintages from the various parts of Campania rank supreme in Pliny's list, and among them the products of Vesuvius occupied a prominent place. In confirmation of this account many jars labelled 'Vesuvium' or 'Vesuvinum' are still to be seen. However, his praise was not unqualified. There was a grape-vine particularly associated with Pompeii which produced wines known as 'Pompeiana'. These had quite a reputation, but Pliny gave them a maximum life of ten years and declared that anyone who indulged in them was apt to get a headache that lasted until noon the next day. They do not sound as good as the excellent Lacrima Christi growing on the lower slopes of Vesuvius today; the poet Gabriello Chiabrera deplored its title, which seemed to him unsuitably mournful.

Many of the inns and bars which served the Pompeian wines also provided cooked foods and snacks to take away, like the *tavola calda* or *rosticceria* of modern Italy. Many bakeries can also be identified. Since bread superseded cereal porridge as the staple Roman food in the second century B.C., it could be bought in very varied forms and qualities. The names of at least ten different kinds of bread are known and many of them can be identified at Pompeii.

Wool was an important industry in the town and its neighbourhood, where it was clipped from the sheep grazing in the Montes Lactarii (Monti Lattari) at the southern end of the Bay. The fullers had their own corporation building beside the Forum.

There was also a provision market (*macellum*), a large porticoed space including a money-changer's booth, auction rooms and a meeting-place for priests of the cult of the Divine Augustus. But above all it contained displays of fruit, vegetables and other foodstuffs. Pompeii, through its preserved remains and paintings, is one of our chief sources of information about the food the Romans liked, and its evidence can be compared with surviving literary records of their inclinations. We read of peahens' eggs stuffed with tiny birds called fig-peckers (*beccafichi*), and roast wild boar stuffed with live thrushes. The cookery book of the celebrated gourmet Apicius writes of pigeons cooked in a blend of melons, dates, oil, vinegar, mustard, honey and wine. Pompeians, and the ancients in general, had no coffee, tea, sugar, potatoes, tomatoes or beans. Moreover, the difference in gastronomic taste between ourselves and the Romans is deceptively greater than apparent resemblances

58

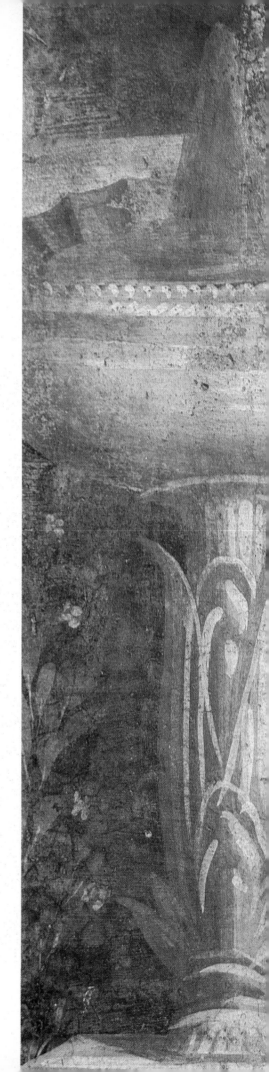

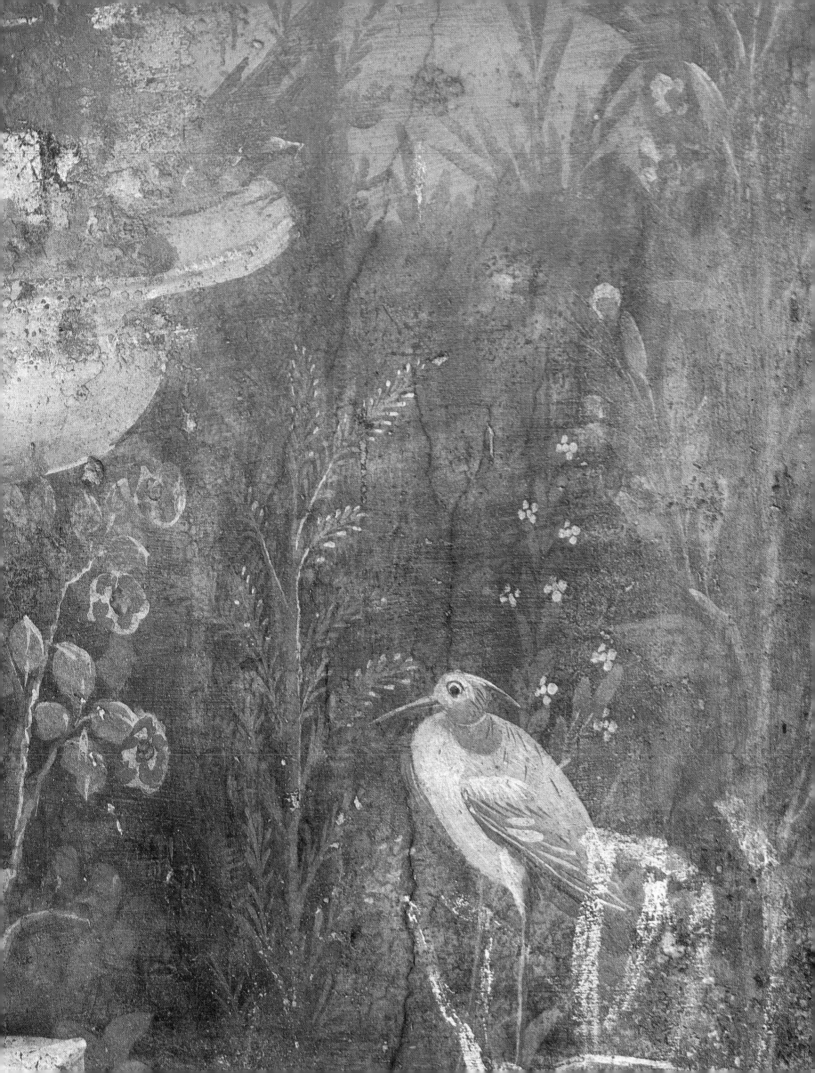

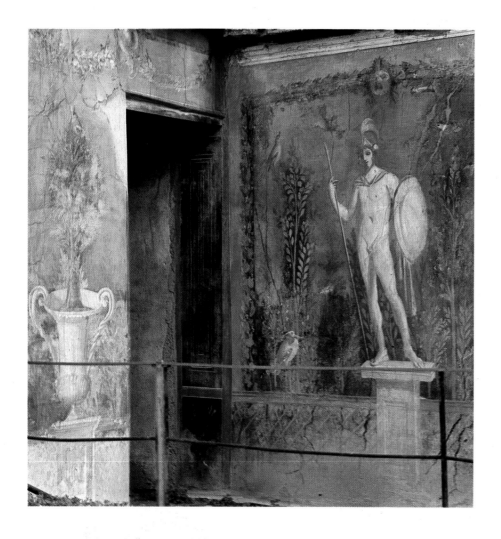

might at first suggest. Like us, the ancients enjoyed mushrooms; but they cooked them in honey. They liked peaches, too; but they liked them pickled, as people do in parts of the United States and elsewhere today.

Romans, and Pompeians, were also extremely fond of fish, though they prepared it with a lavish variety of additions, including plums, and quince and apricot sauces. Served in the ways they favoured, fish was their favourite food—a taste not shared by most Italians today. And so the provision market at Pompeii contained a special fish market, a small, twelve-sided, domed building with a water tank connected with the municipal drains. When the tank was excavated, fish-scales were found. Recently discovered paintings show fishing scenes near the mouth of the Sarnus, and hooks and remains of nets have come to light.

But what these people, like most other ancient Italians, particularly enjoyed was a sharp-flavoured fish sauce, *garum*, of which there was a flourishing local industry at Pompeii, though the finest variety came from Spain. It was made of the entrails of sprats and sardines mixed with finely minced fish, roe and eggs. This mixture was first beaten into a pulp and then left to ferment for six weeks in a basket with a perforated bottom through which the residue filtered slowly down into a receptacle. No wonder that the poet Martial wrote, 'Papilus's breath stinks so fiercely that it is pure *garum*' (*Olfecit postquam Papilus, ecce garum est*). Fortunately another pride of Pompeii was its roses. There were many other guilds, too; and the construction of olive-

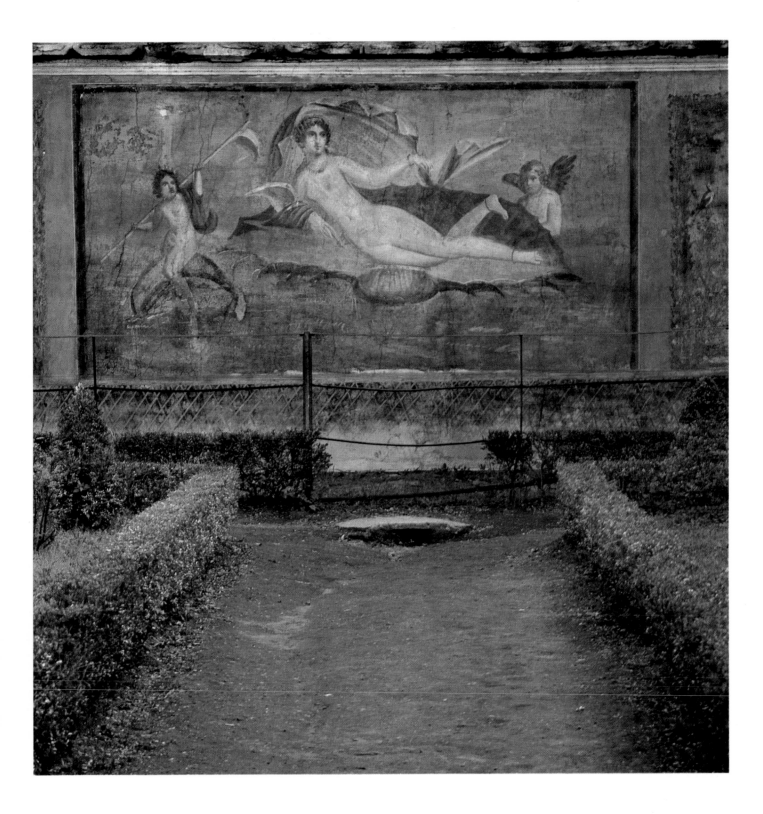

House of the Marine Venus. *Panel in the Fourth Style with a marine Venus and cupids riding on dolphins. This painting decorated the peristyle wall of the house. It has its ancestry in Hellenistic models and typifies middle-class taste in early imperial Pompeii.*

crushers was a speciality. It was a very active little commercial town. The writers of graffiti frankly scrawl a mercantile philosophy on the walls: 'gain is joy' and 'welcome gain' (*salve lucrum*).

The writings on the walls also provide astonishing revelations of local politics. At Rome itself, under the emperors, the annual elections to the antique offices of consul and praetor had become very different from the turbulent elections of bygone Republican times. Now these elections were peaceful affairs, with imperial control ever-present, though discreetly in the background. It is noteworthy, however, that at other towns throughout Italy, such as Pompeii, the annual elections were evidently still conducted and contested with remarkable energy. The top municipal official of early days had long since been superseded by a pair of functionaries, the *duoviri*, based on the model of the Roman consuls; and with these *duoviri* were associated a subordinate pair, the *aediles*. About the annual elections to these offices we are very well informed, because the walls of Pompeii are plastered with election propaganda. In my book *The Cities of Vesuvius*, I described this as follows:

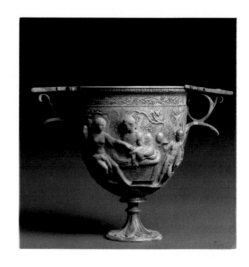

Silver goblet (kantharos) of the Augustan period from the cache of silver in the House of Menander. The relief portrays the loves of Ares and Aphrodite. Naples Museum.
The House of Menander was built in several stages and reached its fullest extent during the reign of Nero. It takes its name from the portrait of the Greek playwright Menander which is on the wall of the rectangular exedra or reception room. In the underground storage chambers of the house a great hoard of treasure was discovered, which contained 118 pieces of magnificent silverware, including a complete dinner service in solid silver, many silver vessels, a couple of mirrors, and a portable table in wood covered in silver foil.

Opposite page: *detail*

But the first problem was how to get elected. About this process we know a very great deal, because the walls of Pompeii are plastered with election propaganda. Nearly three thousand electoral inscriptions have survived. More than half of them relate to the very last year of the town's existence, 79 A.D., because after each successive annual election such appeals had normally been obliterated to leave room for the next batch. The notices were painted, in capitals, in red or black paint on a white plaster ground, or in white upon red. They were executed by professional notice-painters, who were also responsible for official announcements in the Forum. These notices covered matters such as lost property, slave auctions, police regulations, sentences of criminals; there is a mural which shows a placard of this kind stretching across three equestrian statues in a row. One such artist, Aemilius Celer, has painted his name on the wall of his own home; there are also inscriptions cursing men who smudge public announcements.

The voters in the annual elections seem to have included all adult male citizens, voting as individuals or in corporations. While the candidates themselves remained coyly silent (in contrast to modern elections), every one of their dependents or 'clients', the men who used to sit on the benches outside their houses and call on them each morning, had to be active in their patrons' favour. Moreover, all the major trades and industries associated themselves with electoral appeals; and so did the priests of Isis, porters, muleteers, bath-stokers and even the beggars.

Women, too, though they lacked a vote themselves, were well to the fore with electoral slogans. These female canvassers included the girls who worked in Asellina's restaurant; and even prostitutes added their word. Some of the manifestos are very strange. 'Claudius's little girlfriend,' we are told, 'is working for his election as duovir.' And 'Vote for Lucius Popidius Sabinus,' declares another poster, 'his grandmother worked hard for his last election and is pleased with the results.' Were these inscriptions put up by the opposition trying to make fun of Claudius and Popidius? The same suspicion crosses one's mind again when the walls of an inn, next door to the Forum Baths, declare that a certain Vatia is recommended by 'the sneak thieves', the 'whole company of late drinkers', and 'everyone who is fast asleep'. These may, however, have been the authentic, if whimsical, names of smart social clubs, to which people of leisure belonged. Even children were mobilized by their teachers to join in the campaigns: 'Teacher Sema with his boys recommends

62

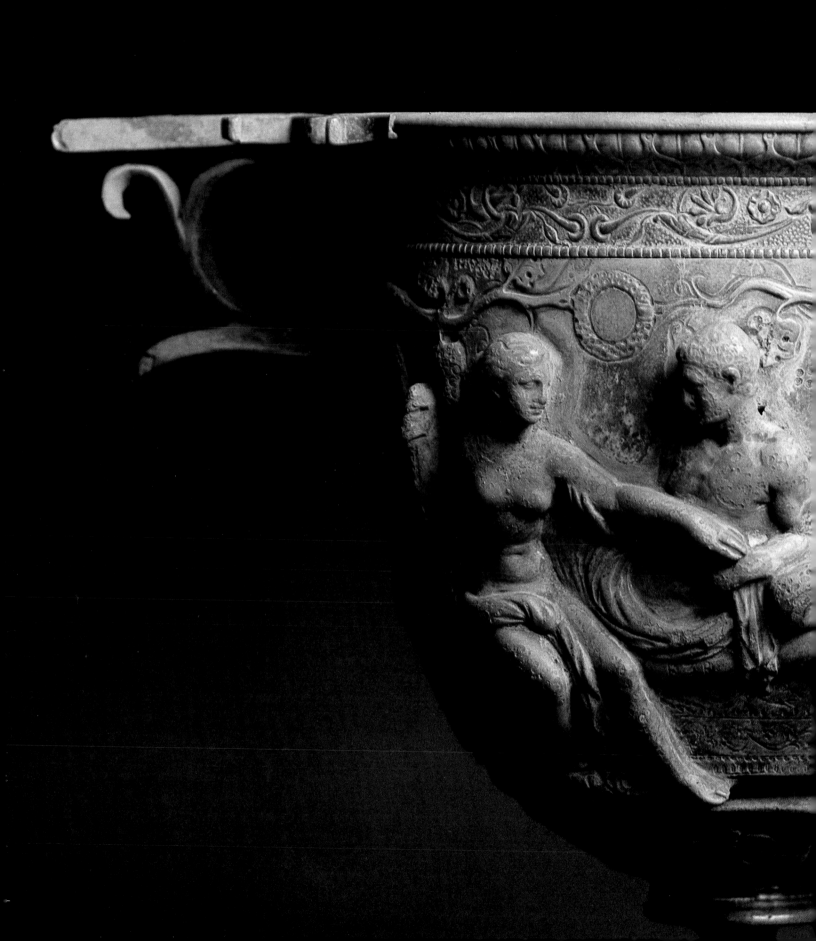

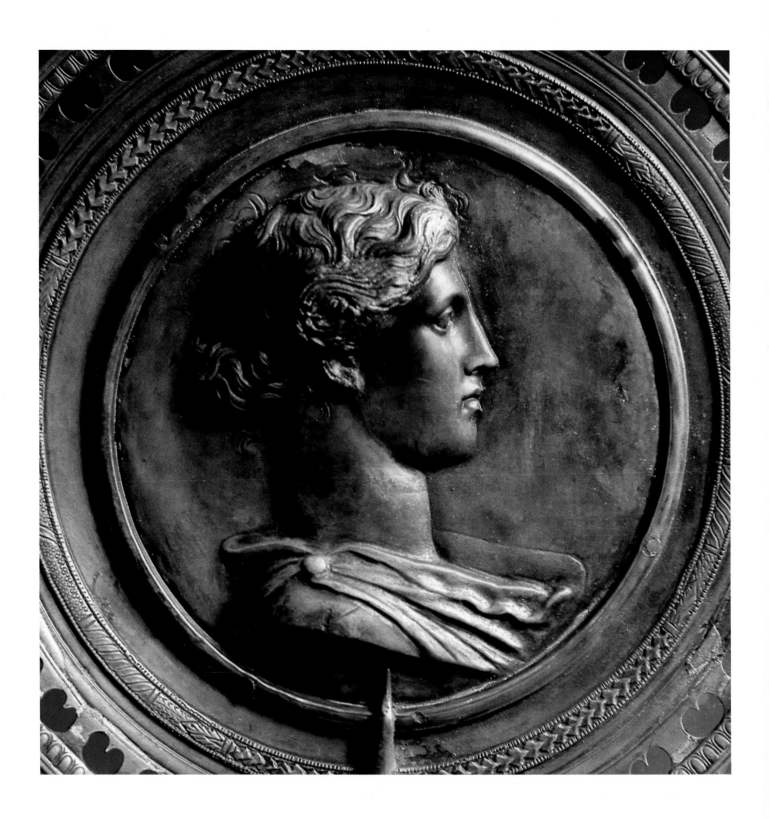

Above:
Reverse of a silver mirror from the treasure in the House of Menander. The fine relief shows the head of a female deity. Naples Museum.

Opposite page, above:
Two views of another silver cup from the Menander treasure, with scenes of centaurs and cupids. Naples Museum.

Opposite page, below:
Silver cup decorated in high relief with olive branches heavy with fruit. From the Menander treasure, Naples Museum.

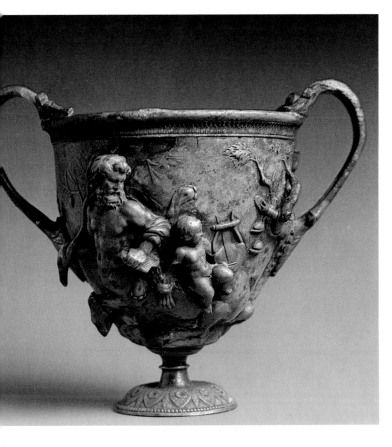

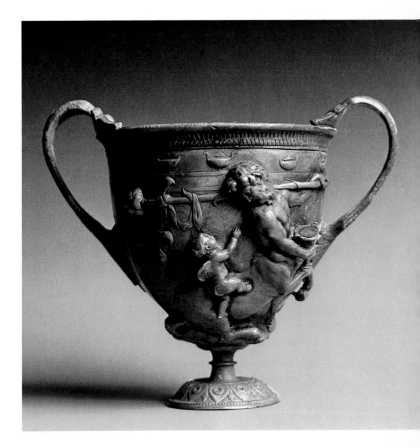

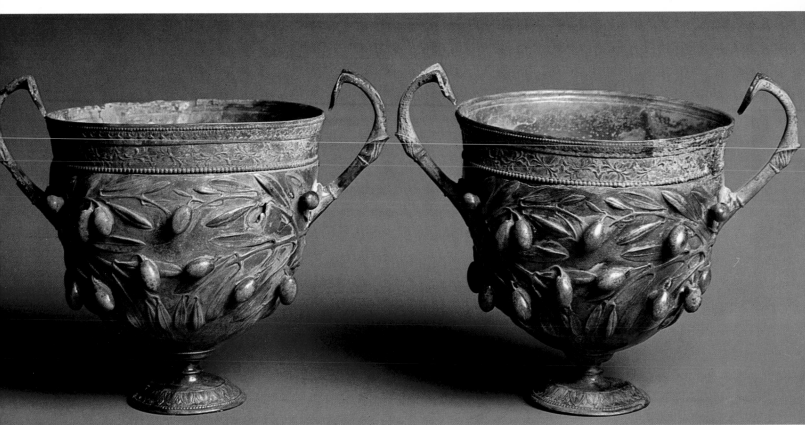

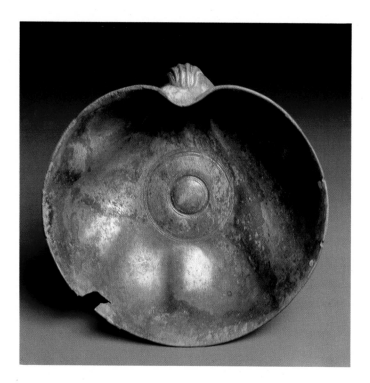

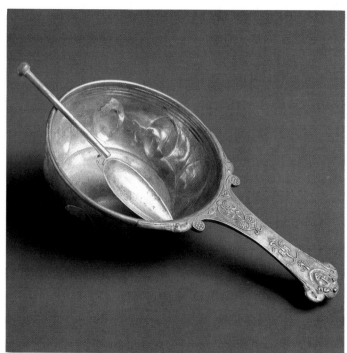

Julius Simplex for the job.' Sometimes we are told that a prominent man is lending his support to a candidate; on other occasions he is urged to do so. 'Proculus, make Sabinus *aedile*, and he will do the same for you.'

This outburst of political canvassing was an annually recurrent phenomenon, giving full scope to what Pio Ciprotti describes as 'the jocular, free-and-easy, pungent spirit of the Pompeians, resembling that of the modern inhabitants of the region'.

But the graffitists of Pompeii, like those of all epochs, also wrote a great deal about sex. Pompeian sex was franker and less inhibited than it is in the modern world, even in permissive 1975. There are various reasons for this. Representations of *phalli* were used as safeguards against the evil eye—even more frequently than the similarly shaped coral horns which are believed to neutralize the evil eye today. Popular aspects of ancient religion, notably the cults of Pompeii's patron deities Venus and Dionysus, ranged all the way from an exalted spirituality to a positive encouragement of sex in which even the after-life tended to be regarded, by the less spiritual adherents of these faiths, as a jolly sensual debauch. And the garden god Priapus was blatantly phallic.

The feelings of the average Pompeian, it becomes clear, were a sort of easy-going Epicureanism. It was much more relaxed than the equation of pleasure with 'freedom from pain' which was the austere ideal of the founder of that philosophy, Epicurus; the general Pompeian belief could be summed up by the doctrine of having a good time while you can. Life was, for most people, much shorter than it is now: how short is suggested by the terrifying surgical implements found in the House of the Surgeon at Pompeii—including probes, catheters, pliers for pulling out teeth and gynaecological forceps. Later the Christians noted the brevity of life, but came to different conclusions. When a skull protrudes from beneath the feet of a magnificently robed cardinal at St Peter's in Rome, its Christian meaning is: remember that you,

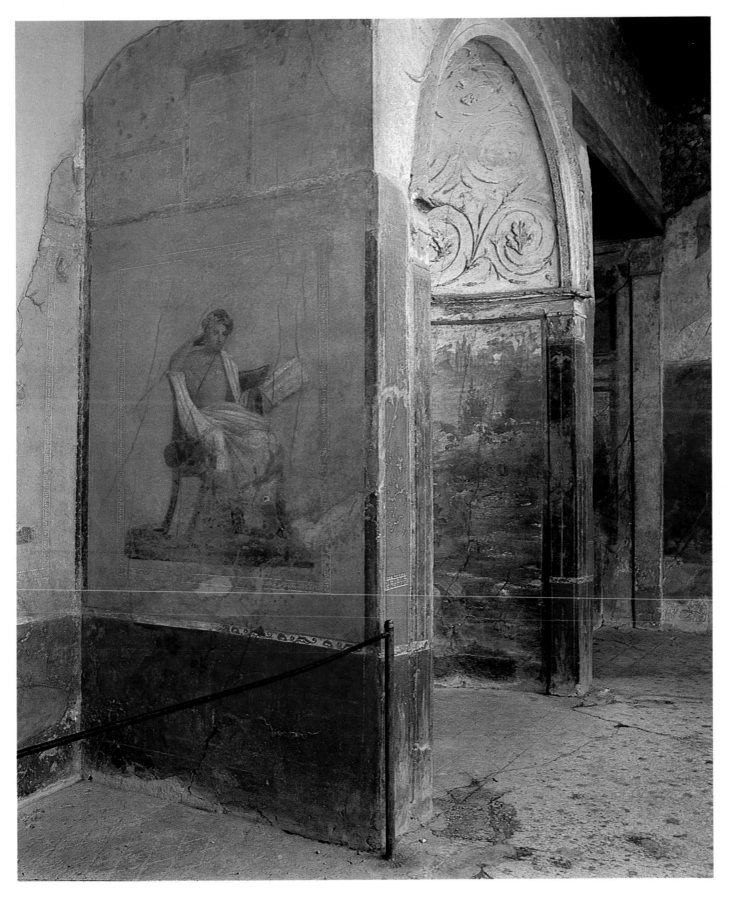

too, are human. But when a skeleton is depicted on one of the magnificent silver cups from the ancient treasure of La Pisanella at Boscoreale just outside Pompeii, its inscription carries quite a different message: enjoy life while you have it—for tomorrow is uncertain. It was, and the imminence of the eruption confers a special dramatic irony on such sayings.

It is in order to ensure enjoyment of the fleeting hour that the graffiti of Pompeii revert repeatedly to the words for luck and happiness, *felicitas* and *felix.* And that, too, no doubt, is why there was a tremendous taste for dice-playing and other gambling in the Roman world. This interest is extremely conspicuous at Pompeii, where paintings and graffiti, at inns, public baths and elsewhere, refer continually to games of chance. 'At Nuceria', reads one such scrawl, 'I won 855 *sestertii* at dice—without cheating.' There was even an association of dice-players. For that was the spirit in which life was lived at Pompeii: make hay, if you can, while the sun shines.

And since sex ranked as an unsurpassed way of enjoying oneself, that is one of the main explanations of the powerful atmosphere of sexuality that is detectable in the city, It was not, of course, limited to Pompeii. An openly sensual trend was traditional in certain genres of literature from all parts of the ancient world; and if we had even a fraction as many paintings, sculptures and graffiti from other towns as have survived from Pompeii and Herculaneum, they would probably tell a not altogether different story.

Nevertheless, there remains the suspicion that the people of this smiling Neapolitan coast were more uninhibited than most others in their sensual

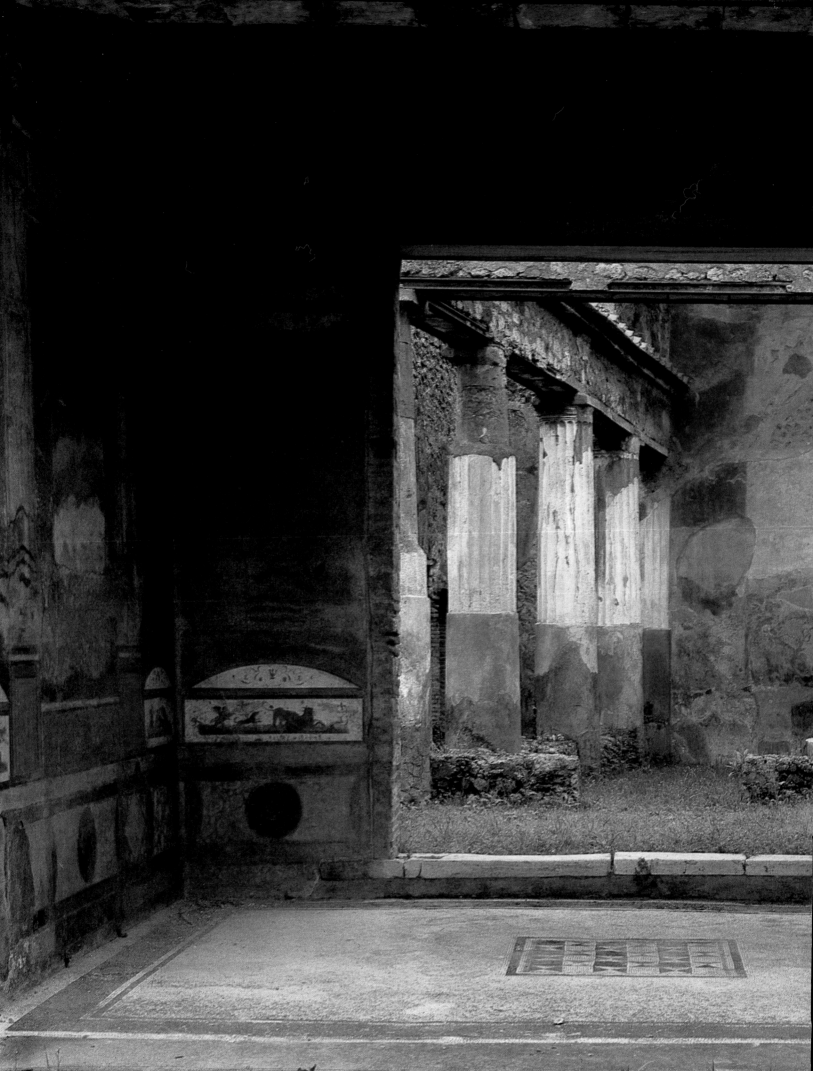

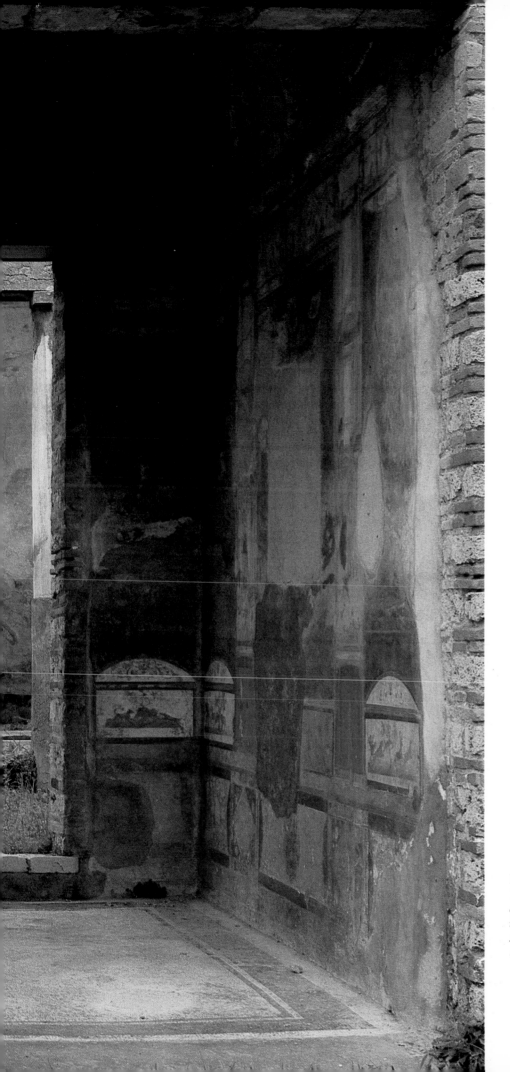

House of the Ancient Hunt.
The tablinium *or dining room with its traces
of rich decoration in the Fourth Style. Beyond
it are the columns of a small peristyle. The
simple mosaic pavement probably dates from
an earlier period.*

71

self-expression. Of course, life was nothing like the continuous orgy depicted by countless novelists and film-makers. A timely corrective, for example, is provided by some of the injunctions to guests painted on the dining-room wall at the House of the Moralist: 'Don't cast lustful glances, or make eyes at other men's wives'; 'Don't be coarse in your conversation'.

On the whole, however, as Paul Valery observed, 'the maxims of morality have offered less resistance to the flames of Vesuvius than the images of vice.' And one reason for this may be because there were more of the latter images than of the former maxims. It does not appear to be fortuitous that the scenes of varied sexual indulgence described by Nero's friend Petronius in his *Satyricon* were staged in one of the cities situated on this very same Campanian shore.

It was a civilization in which women, even if they were allowed to indulge in political canvassing, were not very independent. With the exception of a prominent businesswoman or two, they lacked the drive and culture of some of the formidable ladies of Rome. They sat about wearing their jewellery (or bathing in their special sections of the baths) and left the men to do the shopping and arrange about the food. And there is ample evidence that prostitution, if no more prominent than in ancient Rome, existed on a considerably larger scale than would be found today in a modern town of a similar size.

Many all-night bars and inns (*pervigiles popinae*) offered facilities of such a kind, and there was also an ample provision of brothels, of which a large-scale example is to be seen today at a crossroads beside the Inn of Sittius. It is decorated with lascivious paintings, and with graffiti expressing a wide human range of sexual hopes and boasts, and frustrations as well. But the cells are far from lavish in size. Malcolm Lowry, in *The Present Estate of Pompeii* (1949), felt that it had been 'made to accommodate the consummations of some race of voluptuous dwarfs'. The building was also described by Jack Lindsay (*The Writing on the Wall*, 1960):

Here's a large brothel, with three entries. The first two lead into the main hall on the ground floor with a huge candelabrum and five cells opening out with their wall-beds—skylights over the doors... The privy is under the stairs. Madame is in the screened recess, watching you don't slip off without paying. The third entry is that way. It's got a door-bell. Don't mind how late you are, ring and someone will answer. The stairs lead to the balcony that's used as a corridor to the cells above. The paintings on the walls suggest various things that you might do if you're energetic or rash or drunk enough. Prices are ticketed on the doors.

Yet an essential Pompeian theme is still the proximity of life to death; and the note is struck once again in a graffito elsewhere in the town: 'the cup from which the whore poured her libation is now covered by stones and ashes.' This was one of a number of scrawls which are owed to people who visited the site to recover what they could immediately after the disaster, before the first covering of earth had solidified the desolate scene. Another such inscription, probably written up by a member of the Jewish community, just reads 'Sodom and Gomorrah'.

At that tragic moment after the eruption, the emperor Titus, who had come to the throne only a month previously, increased his reputation for beneficence by taking active measures to resettle the many homeless in neighbouring Campanian cities. He also gave instructions that rebuilding on the

The main *atrium* of the Villa of the Mysteries. *In the centre of the pavement is the* impluvium *or water-tank. The walls bear traces of decoration in the Second Style. The wall at the far end opens on to the peristyle corridor. It proved possible to reconstruct the door on the left by taking a plaster-cast of the impression it left in the ashes. (c. 70* B.C.*).*

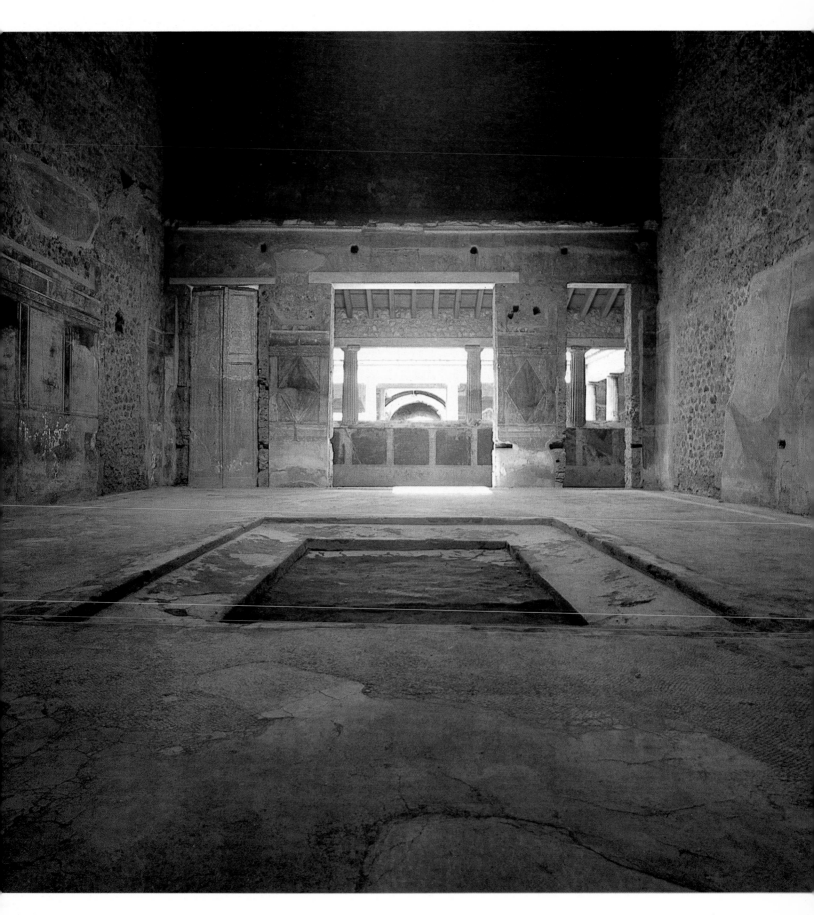

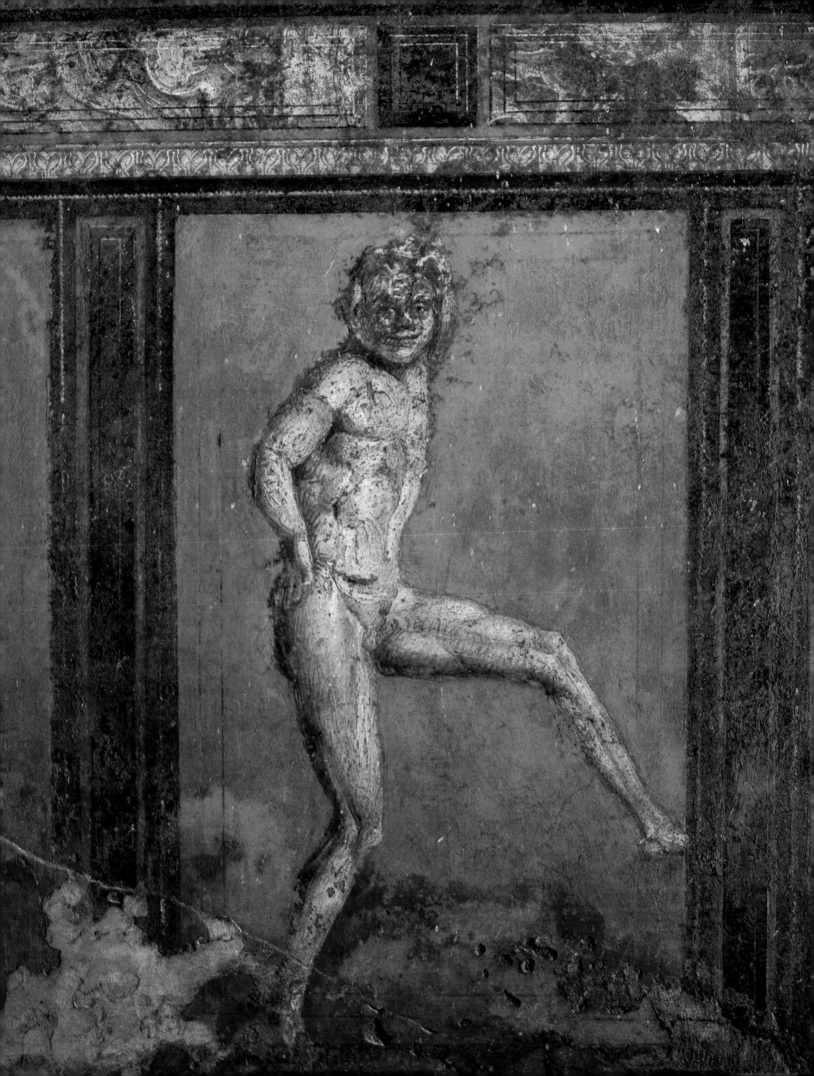

Left:
Villa of the Mysteries. *Detail from the small room outside the 'Room of the Mysteries' showing a young satyr dancing.*

Right:
Villa of the Mysteries. *Room with a grandiose decorative scheme based on architectural forms. Early work of the Second Style (80–70 B.C.).*

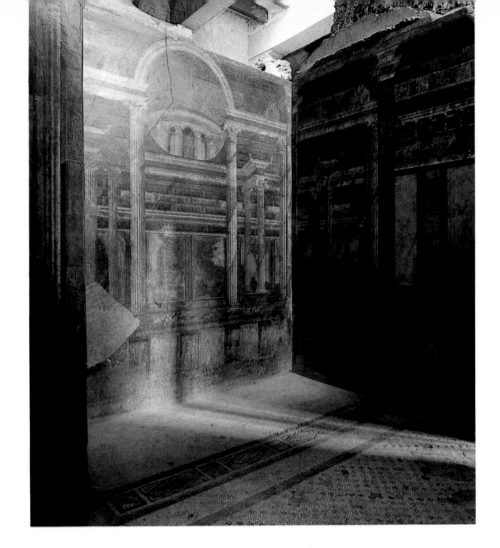

Right:
Villa of the Mysteries. *The so-called 'Room of the Mysteries', perhaps the dining room of the house. This rich pictorial complex is one of the most outstanding examples of Hellenistic painting in Italy (80–70 B.C.). The paintings show the initiation of a young girl into the Dionysiac mysteries, and in the centre of the far end wall are the figures of Dionysus himself and Ariadne.*

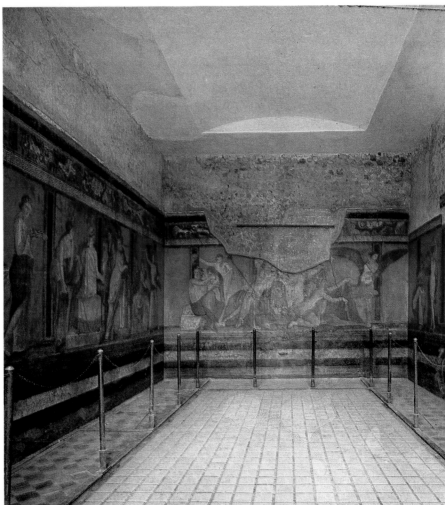

obliterated sites should be set in motion. But this was never attempted. In the following century a few poor huts were put up on the site of Pompeii. But after 800 A.D. they, too, were abandoned. A medieval settlement nearby later became the modern Pompeii, with its famous shrine of the Virgin Mary, the Madonna of the Rosary.

Jupiter, said the Neapolitan poet Statius, had torn out the entrails of Vesuvius, and lifted them up to the stars, and cast them down again on top of his victims. And so things remained until 1594, when Domenico Fontana, an architect who had helped to complete the dome of St Peter's, was directing the construction of a tunnel to take Sarno water to the town of Torre Annunziata. His workers came upon inscriptions and remains of buildings, in a locality called La Civita. This was in the middle of ancient Pompeii, but it was not recognized as such. The development of the area did not follow until 1748, when Cavaliere Rocco Gioacchino de Alcubierre discovered traces of a vast site and it was not long before clandestine excavators, who still cast such a blight upon the modern archaeological scene, were greatly in evidence. Then, in 1763, an inscription was found specifically and unmistakably identifying the location by a reference to the community of Pompeii, the *respublica Pompeianorum*. Herculaneum had been discovered earlier, and the new sensational finds from both places were gradually published by the Accademia Ercolanese, initiated by Valetta in 1757, with the aid of a generous subsidy from Charles of Bourbon, King of Naples and Sicily. The German archaeologist Johann Winckelmann also did a great deal to impress the importance of these excavations and their discoveries upon Europe, where they acted as a catalyst upon the whole trend of decorative art, in a society which was tired of heavy, dying baroque and was ready for Pompeian rococo. The notorious Casanova's artist brother Giovanni Battista succeeded in deceiving Winckelmann with fake paintings illustrated in his *Monumenti antichi inediti*. But one would have liked to see the German savant sitting at a newly discovered antique Roman table drinking Lacrima Christi with Camillo Paderni, director of the museum at Portici. This collection, the predecessor of the Naples Museum, was built originally as a royal palace for Charles of Bourbon, who, on being warned of the excessive proximity of Vesuvius, had remarked, 'God, the Immaculate Virgin, and Saint Gennaro will look after us.' The same monarch, when he left to become King Charles III of Spain, set a fine example for the future by punctiliously leaving behind in Naples, as state property, a ring presented to him on the site.

Since those days, progress in the uncovering of Pompeii has not been continuous, but has continued in periodical leaps and bounds. On 18 March 1813, Queen Caroline Murat and the sculptor Antonio Canova were both present at the discovery of a tomb. In 1833 the archaeologist Antonio Bonucci came upon the young Edward Bulwer (later Lord Lytton) sitting disconsolately on a stone bench, and their subsequent discussion helped to

Villa of the Mysteries. *Detail of the fresco showing the initiation ceremony. To the left, the initiate, cowed by the whipping received from a female winged spirit (see the previous illustration), takes refuge in the lap of a priestess. On the right, a participant in the mysteries dances naked to the sound of castanets. Behind her a bacchante with a* thyrsus, *or wand, assists in the ritual. (80–70 B.C.).*

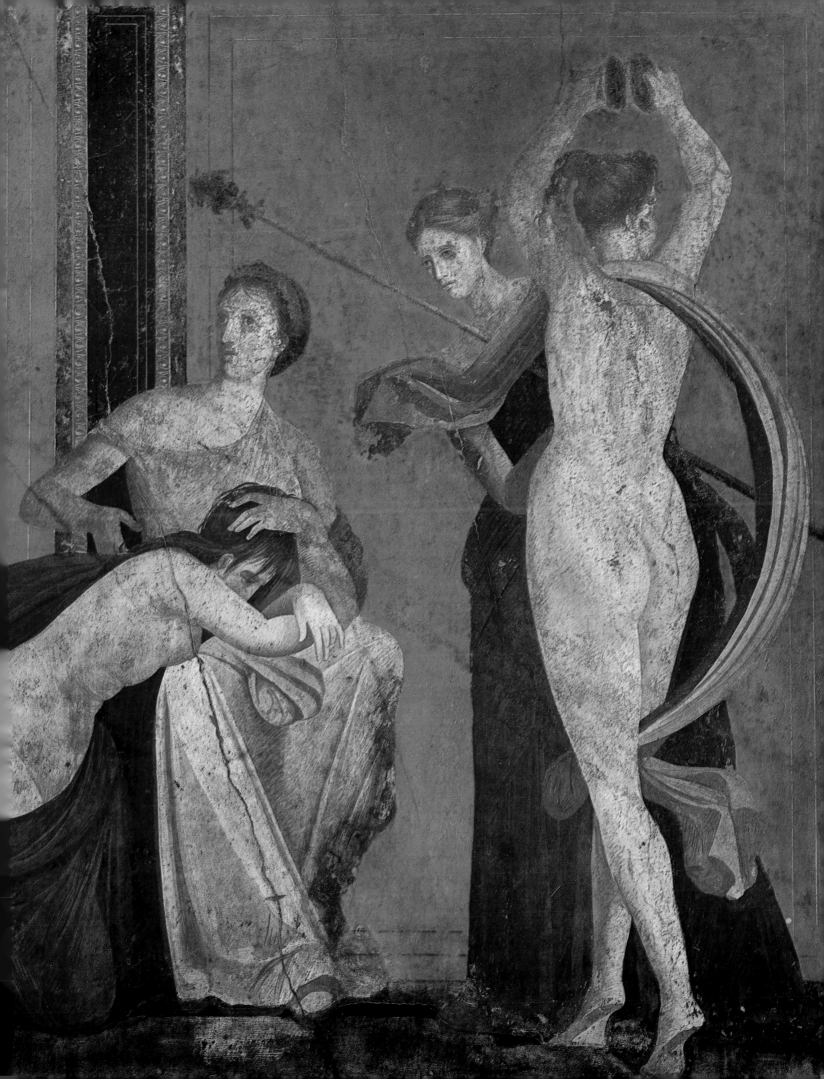

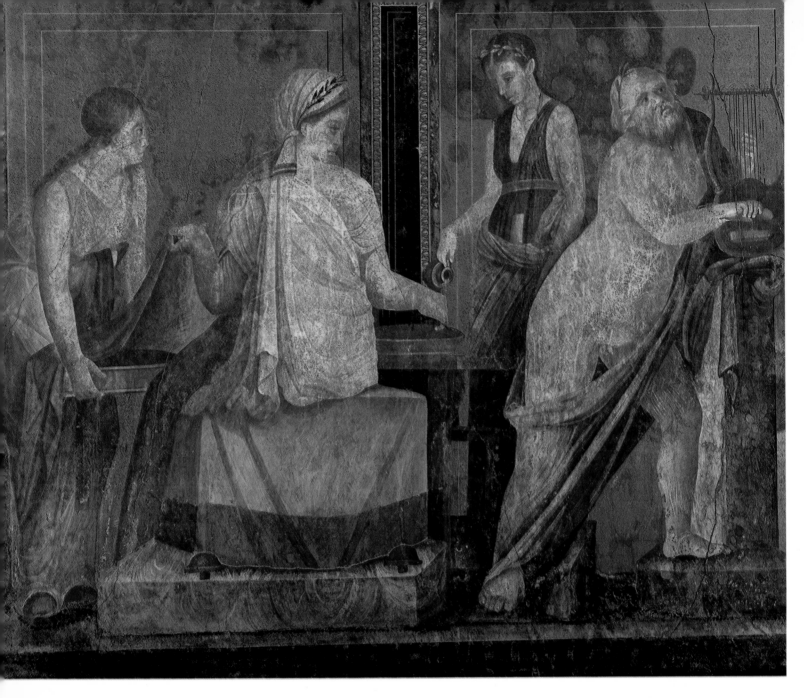

inspire the Englishman's famous novel *The Last Days of Pompeii* (1834). The Italian archaeologist Fiorelli, of whose technique for reconstructing the outlines of ancient corpses something has already been said, got into political trouble in 1848 for training his twenty diggers as revolutionary artillerymen, but managed to survive. Later, between 1910 and 1923, Vittorio Spinazzola excavated the street of shops, the Via dell'Abbondanza, employing new methods for the preservation and reconstruction of the traces of upper storeys of houses, with windows, balconies and loggias.

During the Second World War, in 1944, Pompeii was lamentably damaged by bombs, but in 1951 excavations were resumed. Throughout all this period, indeed from 1924 until his death in 1963, the Superintendent of Antiquities was Amedeo Maiuri, who once again registered significant progress, including technical innovations such as the use of electrical boring machines and mechanical shovels. And, above all, he was not content to remove his discoveries to the Naples Museum as hitherto (with the exception of such priceless objects as the silver treasure found in the House of Menander). Instead, he persevered in retaining as much as he could on the spot, so

Villa of the Mysteries. *Another detail of the initiation rites. To the right stands a silenus. On the left a priestess, aided by two helpers, robes herself in ritual fashion.*

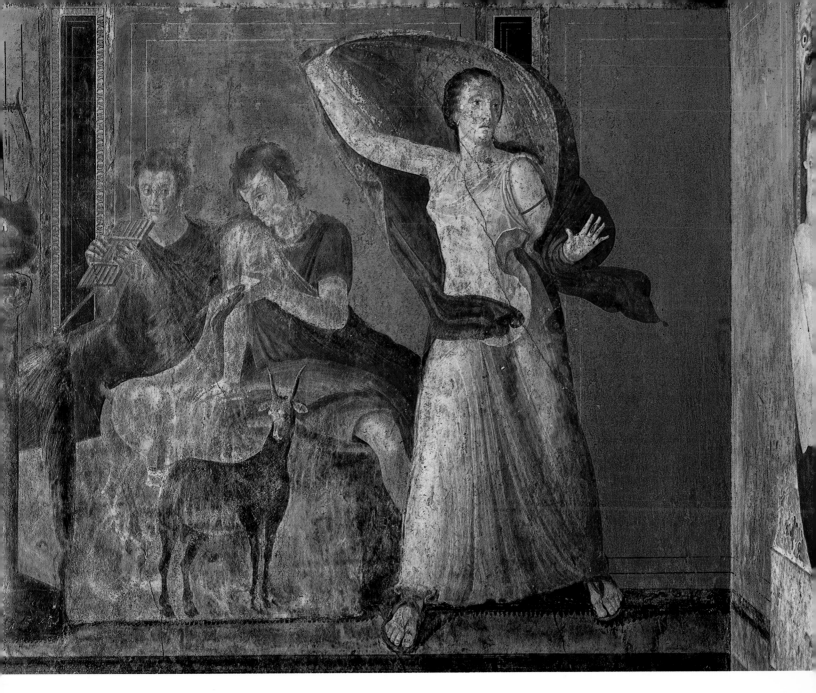

Villa of the Mysteries. *Further along the tableau, a female satyr suckles a young goat while a young girl recoils before the appearance of Dionysus and Ariadne and the symbols of the mysteries.*

as to show clearly what the houses and buildings actually looked like. His successor is Professor Alfonso de Franciscis, under whom further important advances have once again been made. He himself has described the extremely attractive wall-paintings discovered in the House of Gaius Julius Polybius; and another of the small towns overwhelmed by the eruption of 79 A.D., Oplontiae, has been identified at Torre Annunziata, where a huge and spectacular villa has been found.

Meanwhile, Pompeii has continued to kindle the imagination of writers. Malaparte in *La Pelle*, Montale in his *Sarcofaghi*, have not forgotten its lure. But how much of the city even now remains undiscovered? Still one-quarter, or two-fifths—in addition to many villas and farms that remain hidden outside the walls. So Fiorelli, when he calculated in 1873 that after another seventy-four years—at the current rate of progress—the work of excavation would be complete, was excessively optimistic. But we must pray that the work will never cease until it *is* complete. For Pompeii remains one of the principal jewels of Italy; and one of the most remarkable and exciting of all the archaeological sites in the world.

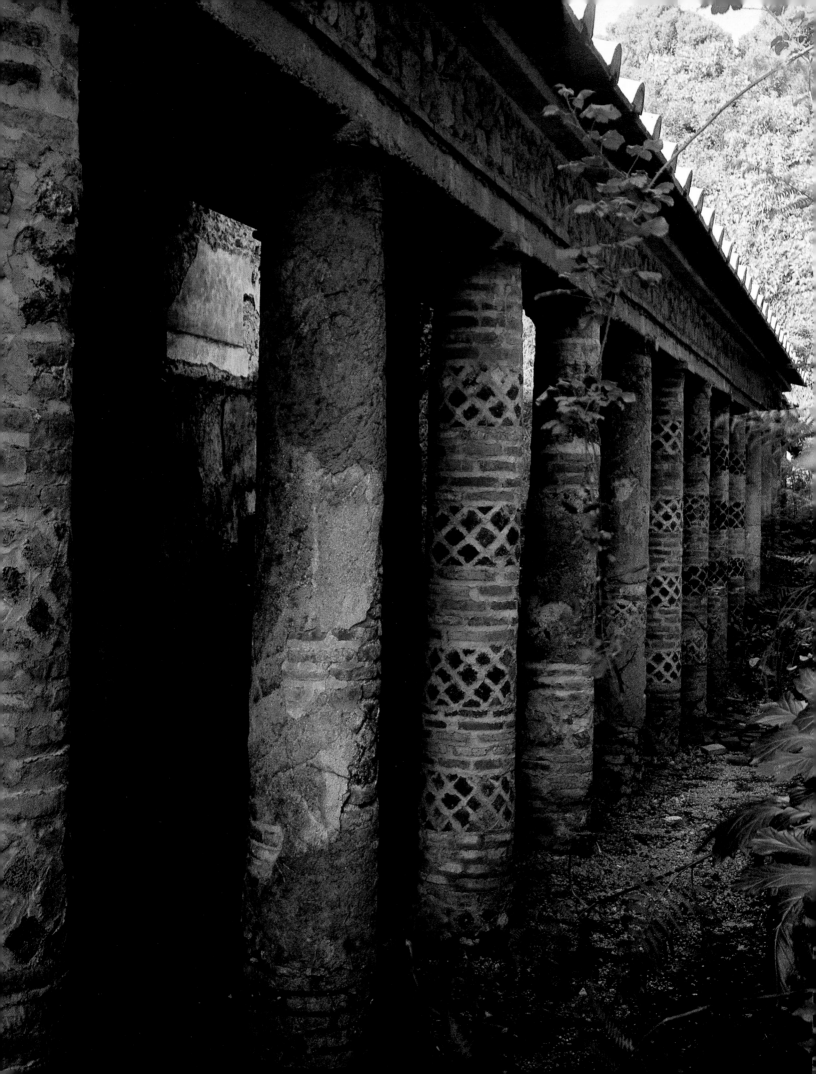

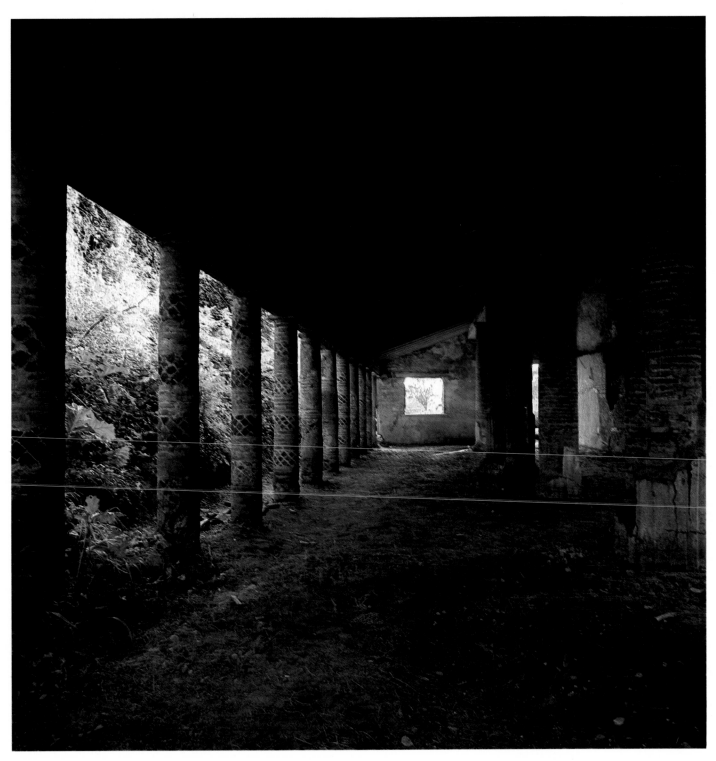

Above:
Villa of the Mysteries. *Covered balcony along one side of the building. In contrast to city dwellings which are enclosed on the outside, the villa opens on to the surrounding countryside.*
Opposite:
Detail of the balcony columns.

Pages 82–3:
Villa of the Mysteries. *The peristyle, with its original free-standing columns enclosed by a wall erected during the final building period under the early empire. What was once a luxury villa was converted into a practical country farmhouse devoted to the production of wine and olive oil.*

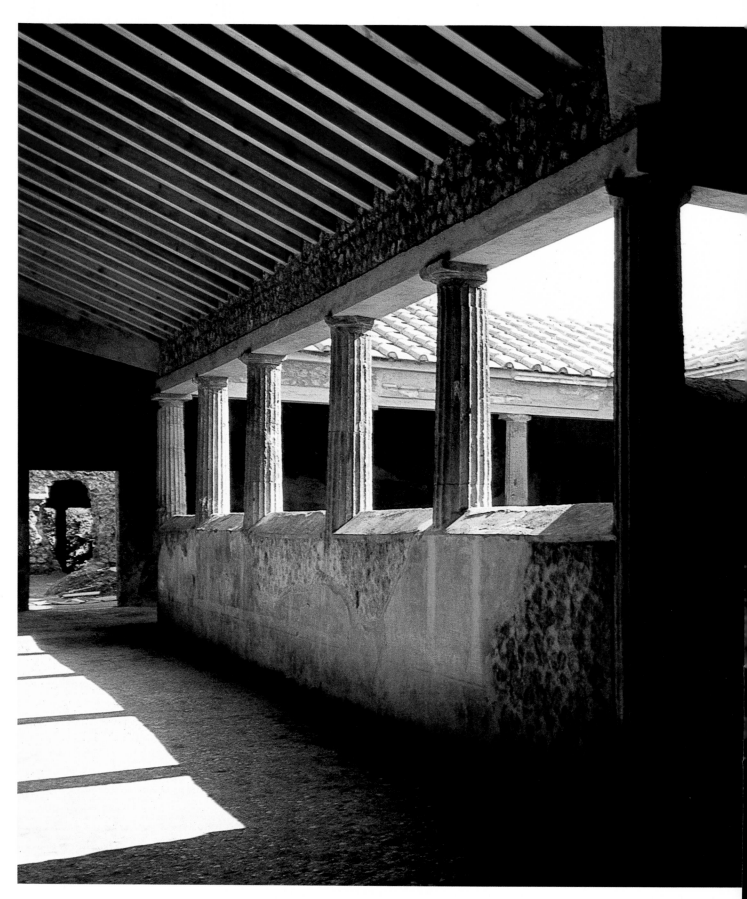

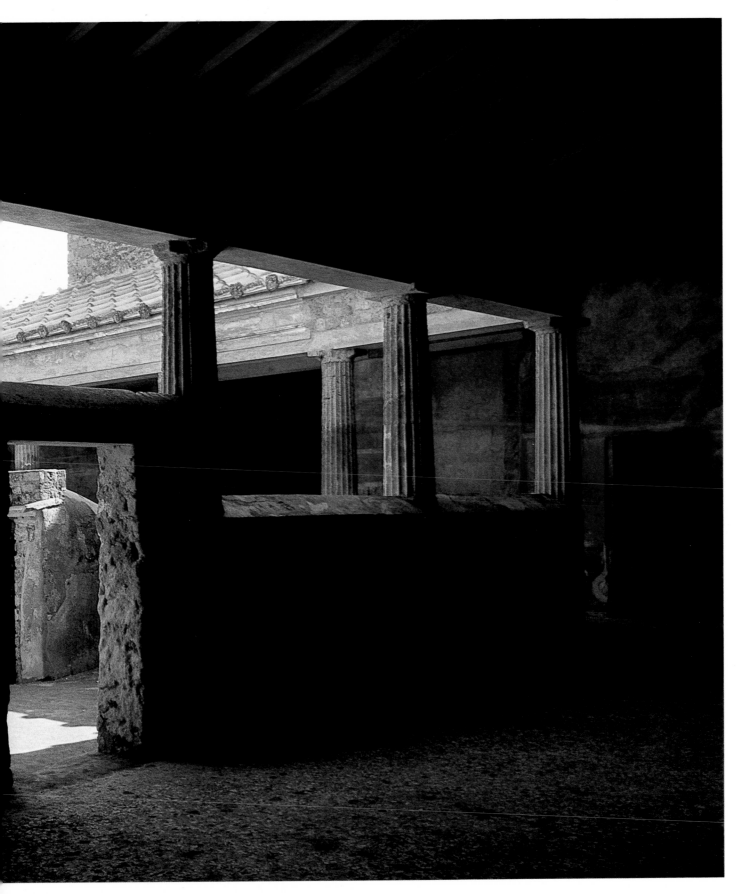

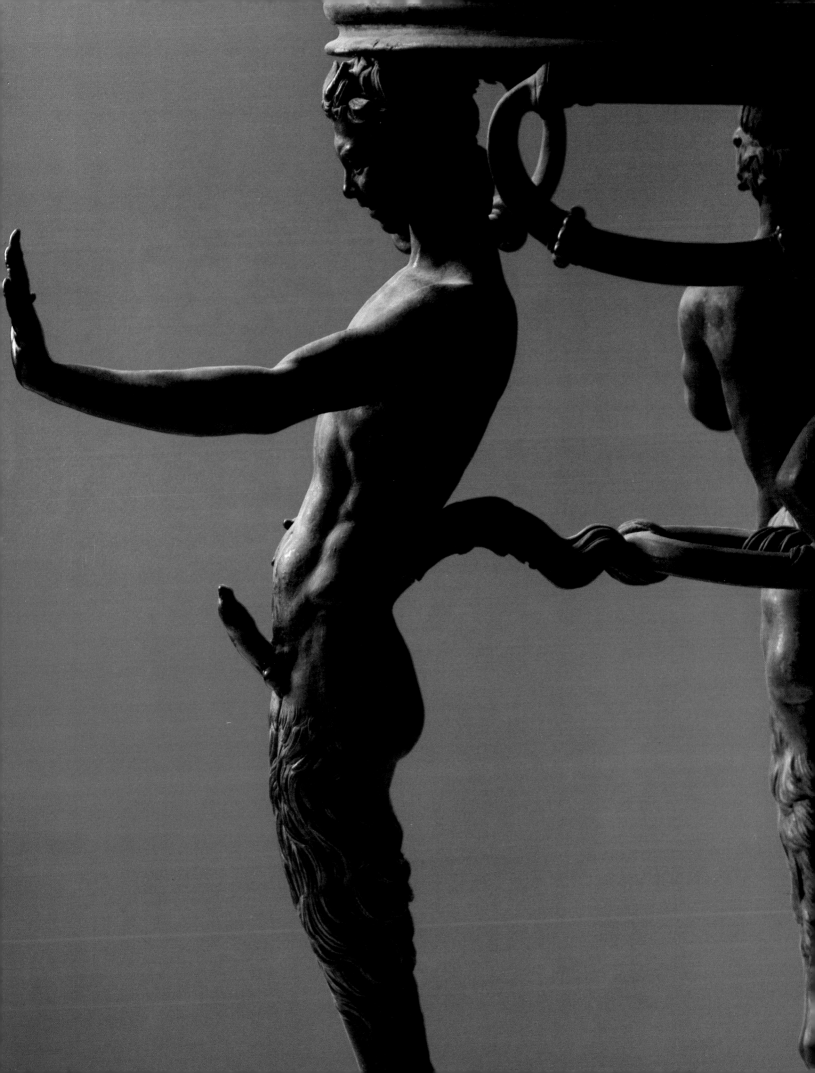

The Secret Collection

Antonio De Simone
Maria Teresa Merella

TRIPOD WITH
ITHYPHALLIC YOUNG PANS
Detail from the illustration on page 9
This tripod is a splendid example of the
accomplished elegance which is so character-
istic a feature of Hellenistic art. It consists
of a lebes or basin, in the form of a basket
held up by three ithyphallic Pans. The
beautiful young Pans seem to emphasize their
proud virility with a parallel gesture of the
left hand. Their smooth, taut bodies taper
downwards in a graceful arc which ends in
the cloven feet of the goat. The overtly phallic
content of the tripod, which was clearly in
use as a household article, was the reason for
it not being on view to the public. It is now
displayed in one of the galleries of the museum
as a domestic object, alongside other furnish-
ings from Pompeii.

EROTIC SCENE—GRAFFITO ON STUCCO *p.6*

The walls of the ancient city of Pompeii teem with inscriptions, mottoes and caricatures. They display the mordant and aggressive wit of Southern Italy, which Horace called '*acetum Italicum*'—'Italian vinegar'. Salacious and grotesque expressions vie with subtle phrases, and with comments where the tone is satirical rather than merely cynical. The graffito in the House of the Lovers, which is undoubtedly one of the most beautiful that have survived, is a telling example: 'Lovers, like bees, sip a life as sweet as honey.' Beneath is a witty addendum that brings us back to reality—'*Vellem*' ('If only it were true!'). At Pompeii the habit of scribbling on walls was particularly widespread, and it is not surprising that it takes on that competitive element so characteristic of graffiti writing. The Pompeians were well aware of the volume of their activity: a humorous couplet frequently found on the walls of the Basilica, the Theatre and the Amphitheatre goes: 'I wonder, wall, you do not smash, Beneath the weight of all this trash.'

The little sketch on page 6, which is similar to many found in the brothel, could well be the work of a client whiling away the time as he waited, imagining the coming encounter.

SATYR AND NYMPH
Marble sculpture; 57 × 105 cm
From Pollena Trocchia
(12 April 1963)
Early Imperial period
RP, Inv. no. 152873

SATYR AND NYMPH—MARBLE SCULPTURE

In the early Imperial period Pompeii was already a flourishing town whose economy was based on commerce and shipping. Splendid houses replaced the more austere dwellings and the display of luxury soon became the characteristic feature of Pompeii's wealthy and pretentious bourgeoisie. Rich merchants merged with land-owning aristocrats, and the city reached its peak of architectural development with more buildings spreading into the surrounding countryside. The buildings were residential rather than commercial, and in a short time the slopes of Vesuvius were dotted with elegant country villas, the second homes of rich city-dwellers. The piece of sculpture illustrated here was found near the ruins of a small semicircular temple in the fields near Pollena Trocchia, at the foot of Monte Somma. It probably belonged to one of the numerous art collections that adorned the luxurious country homes of the great landowners of Pompeii and Herculaneum. Though excavations have never been undertaken in the area, objects regularly come to light in the fields. This strip of country was not directly hit by the eruption of 79 A.D., though violent earthquakes may well have affected the subsequent viability of the land for farming. The richness of the archaeological finds certainly suggests considerable prosperity under the Romans. The marble group shown is bold in composition and its form is strongly rhythmical.

EROTIC SCENE—SMALL BRONZE *pp. 88–9*

The small size of this work suggests it is decorative rather than functional. The position of the couple, usually termed *more ferarum*, the position in which animals have intercourse, is mentioned by Lucretius in his *De Rerum Natura*, Book IV, when dealing with the causes of fertility and sterility. The bronze is magnified ten times.

Pages 88–9:
EROTIC SCENE
Small bronze; 4 × 3.5 cm
From the Museo Borgia
RP, Inv. no. 27715

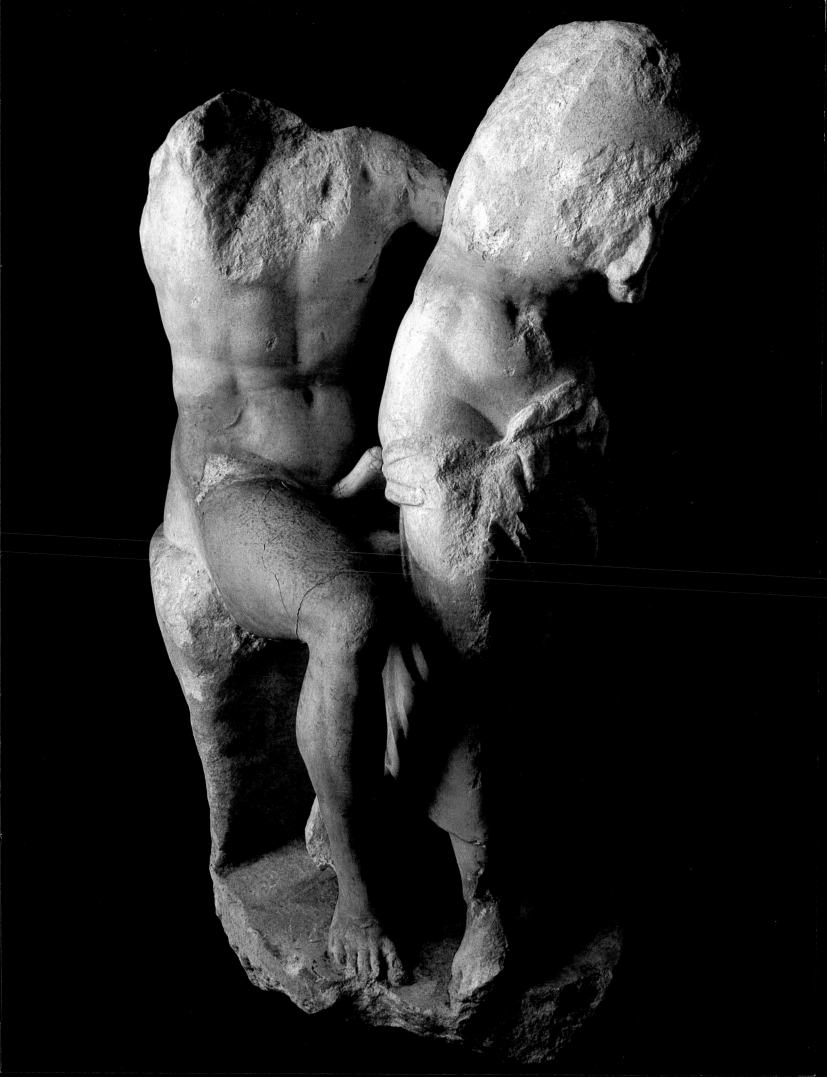

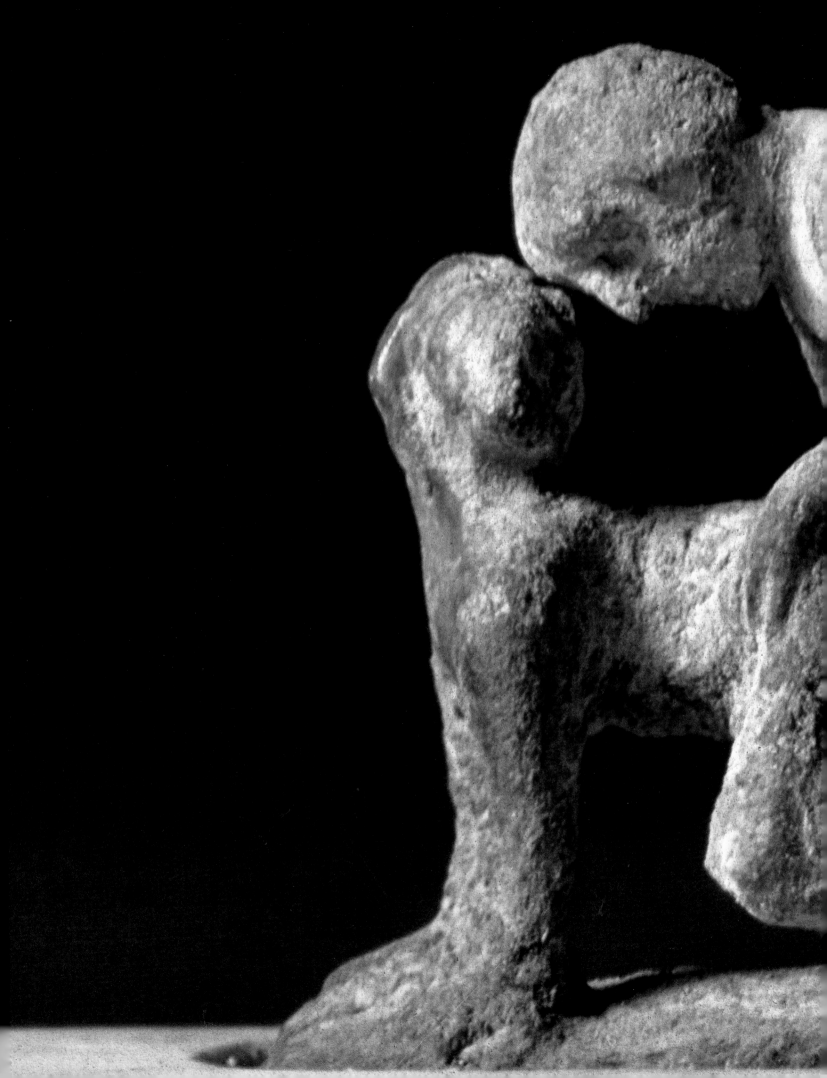

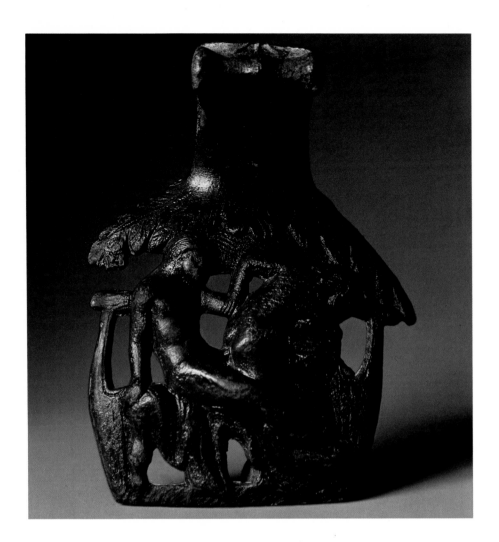

VASE HANDLE
WITH EROTIC SCENE
Bronze; height 13 cm
From Pompeii
(4 April 1902)
Beginning of 1st century B.C.
RP, Inv. no. 129477

VASE HANDLE WITH EROTIC SCENE

Illustrated here is the finial of a handle from a bronze vase. Vases made of metal (either bronze or silver) often had handles with a decorative part that joined on to the main body of the vessel as an appliqué ornament. These decorations are often little masterpieces of the engraver's art. The small scale of the object demands all the skills of a miniaturist, and the rounded shape of the vase lends itself to creative treatment of form. Function and ornament are skilfully combined in this piece; the lines of the handle open out into scrolls of foliage to form a tree which shelters a couple in the act of love. Their identification poses some problems. The woman has the flowing hair which usually characterizes a maenad, or follower of Bacchus. But the male figure has none of the attributes of a satyr, who is normally found in the company of maenads. One thing is clear, however, as this scene shows. The theme of love was frequently depicted, and quite accepted as a normal part of life, since it was used to decorate objects in everyday use. Despite the small dimensions of the work, the artist has succeeded perfectly in rendering the smooth sensuality of a moment of abandonment.

The art of the Pompeian bronze-workers, and, still more, that of the artists of Tarentum (Taranto), was famous throughout the ancient world. Local production probably developed under the impetus of Greek prototypes. The elaborately carved *triclinia* or couches which were to be found in Pompeian houses are derived from the famous bronzework of Sparta.

BACCHANALIAN SCENE
Detail of marble sarcophagus on
pages 92–3: Satyr and Herm

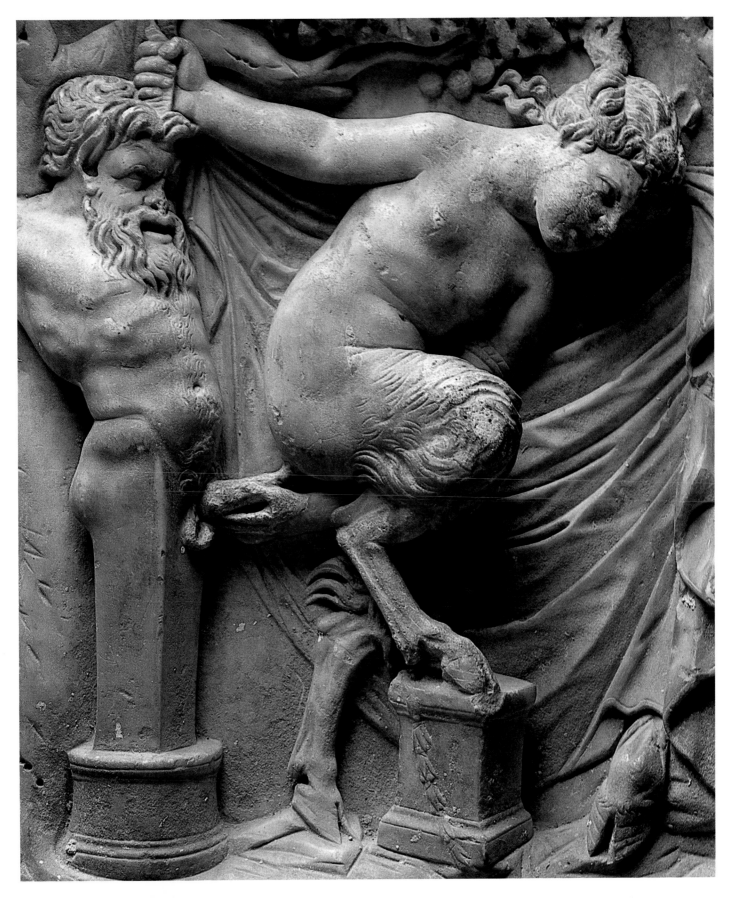

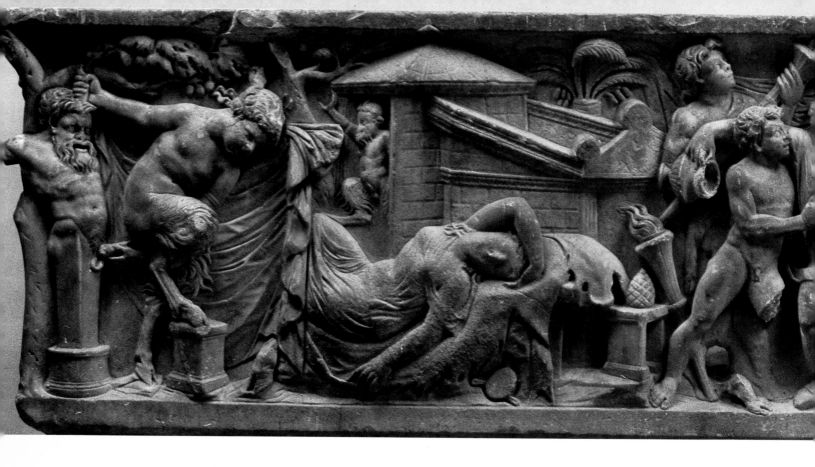

BACCHANALIAN SCENE—MARBLE SARCOPHAGUS

The cult of Dionysus was of Greek origin, and to begin with the rites were celebrated only by women. The degeneration of the sacred character of the cult came about when men too were admitted. Following the inquiry held by the consul Publius Albinus into the orgiastic rites that were held in the woods of Rome and Italy as a whole, the Bacchanalia were abolished by decree of the Senate in 186 B.C., but the law was applied only briefly and in desultory fashion.

The abundant libations drunk in honour of the god and the frenzy of the rituals freed the participants from moral restraint, and the ceremonies took on a licentious character. During the Imperial period, these feasts took place with increasing frequency and with more and more uncontrolled orgies.

But the cult had a more sombre side, since Dionysus had strong links with death. He was a fertility god, the god of vegetation renewed each spring; he was thus linked with man's life cycle and with the mysterious powerful forces which watch over his death and rebirth. Hence, Dionysus figures as a symbol of immortality on many sarcophagi and was even acceptable in a Christian context, since sarcophagi employing scenes of Dionysiac rites were produced until the third century A.D. The sarcophagus illustrated here is certainly one of the most beautiful and complete examples of the genre. In the centre of the relief is an elderly and rather corpulent Dionysus, with hair and beard styled in Oriental fashion, surrounded by his followers who are in a frenzied state. One maenad is sleeping it off, some are dancing, and a female follower of Pan is offering herself to the herm of her master.

The drunken and swaying Dionysus is held up by two satyrs. The deeply modelled, expressive faces and the animated composition make this one of the most powerful works of Roman sculpture of the Antonine period (mid-second century A.D.).

BACCHANALIAN SCENE
Marble sarcophagus
From the Museo Farnese
Second half of 2nd century A.D.
RP, Inv. no. 27710
Right: detail

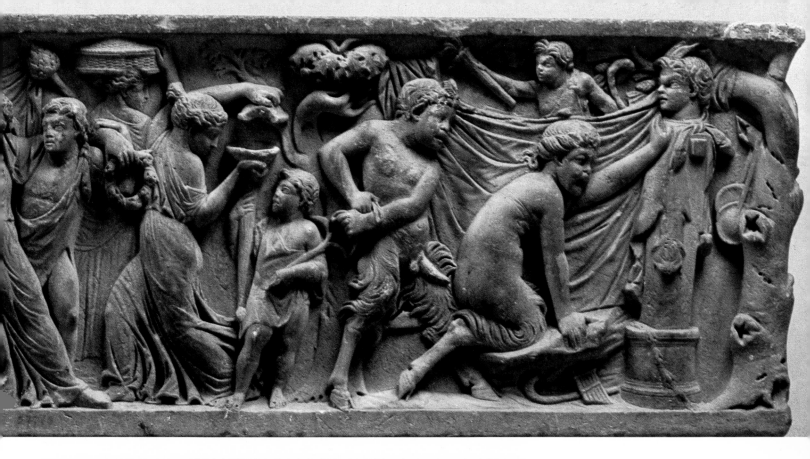

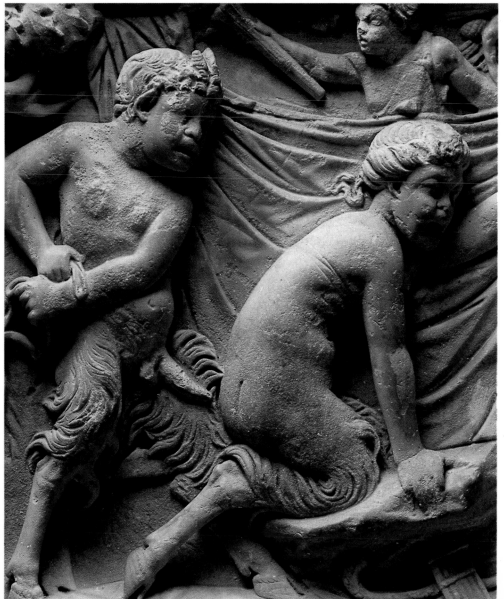

Pages 94–5:
PAN AND THE GOAT
Detail and whole work
Marble groups; 47 × 49 cm
From Herculaneum
1st century B.C.
RP, Inv. no. 27709

93

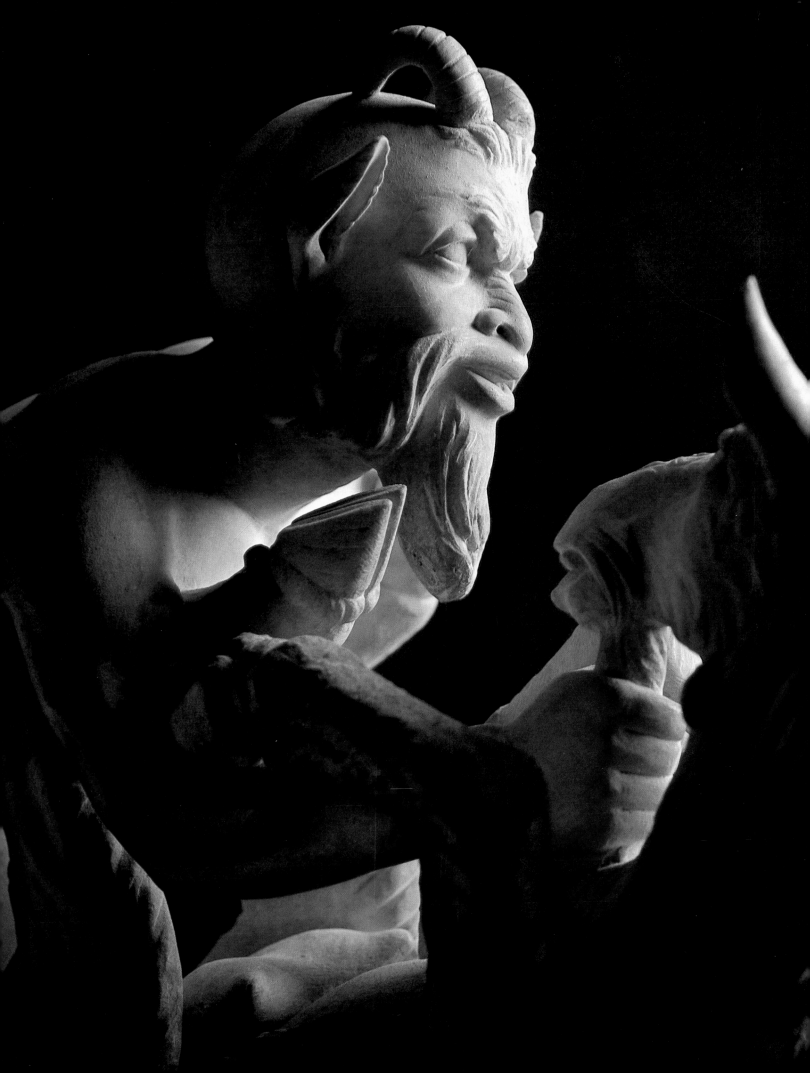

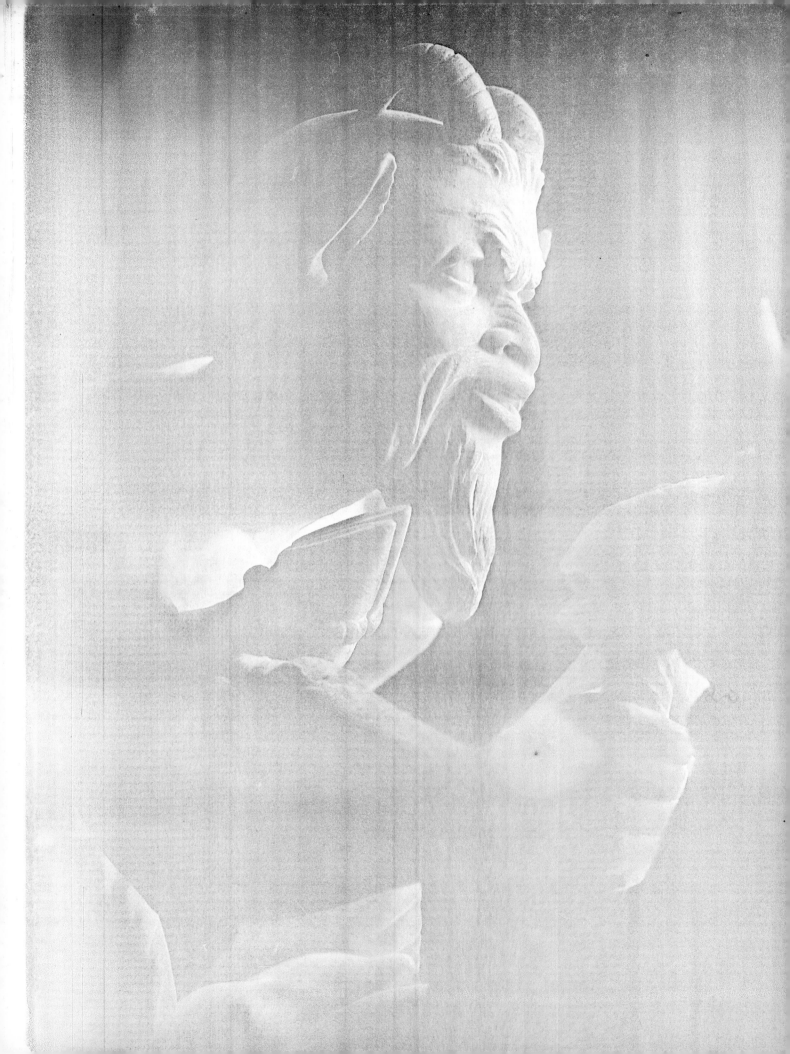

human gesture. The group, adapted from a block of Greek marble, is a striking anticipation of two characteristic features of late Hellenistic art. There is a terseness and formality to the work, which is conceived on a rectangular plan, combined with a strong element of realism which strips the god of his anonymous divinity to present him in a more human and accessible form.

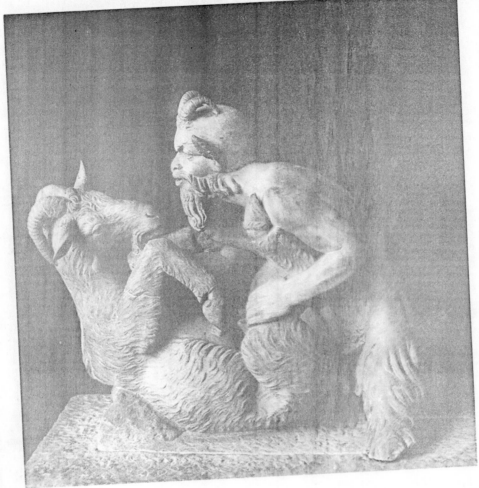

95

from Herculaneum, Pan is copulating with a goat, suggesting his dual nature as man and beast. With uncommon mastery the sculptor succeeds in bringing out both aspects by inverting the usual sexual patterns. Pan is participating in animal fashion whilst the goat submits to him in the normal human position. The group, sculpted from a block of Greek marble, is a striking anticipation of two characteristic features of late Hellenistic art. There is a tautness and formality to the work, which is conceived on a rectangular plan, combined with a strong element of realism which strips the god of his anonymous divinity to present him in a more human and accessible form.

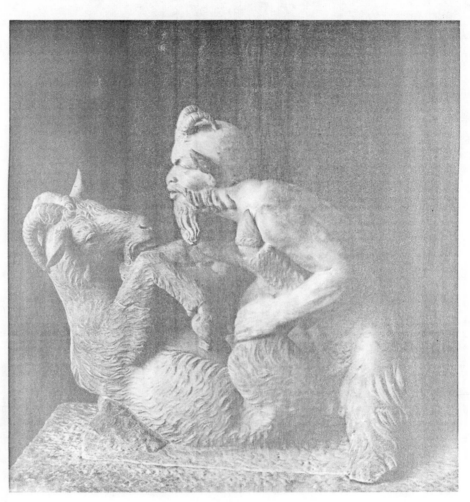

95

PAN AND THE GOAT

The pedigree of the Greek god Pan is rather confused and uncertain: some traditions say that he was the son of Zeus and the nymph Callisto, whilst others maintain he was the son of Hermes and of Dryope, or Enid or yet again of the nymph Penelope. Half-man, half-goat, his face had animal features; horns, a snub nose, goat-like ears and a dense beard. He was a figure of great character and ambiguity, and he became one of the favourite motifs in Hellenistic art. In time Pan was portrayed with less emphasis on his divinity and more was made of his special nature as a woodland spirit. Pan taught music to the graceful Daphnis and to the nymphs, drew a thorn from the foot of Silenus, and even menaced Aphrodite, who, as in the group in the National Museum in Athens, drove him off with her sandal with the help of a little winged cupid. In this sculpture from Herculaneum, Pan is copulating with a goat, suggesting his dual nature as man and beast. With uncommon mastery the sculptor succeeds in bringing out both aspects by inverting the usual sexual patterns. Pan is participating in animal fashion whilst the goat submits to him in the normal human position. The group, sculpted from a block of Greek marble, is a striking anticipation of two characteristic features of late Hellenistic art. There is a tautness and formality to the work, which is conceived on a rectangular plan, combined with a strong element of realism which strips the god of his anonymous divinity to present him in a more human and accessible form.

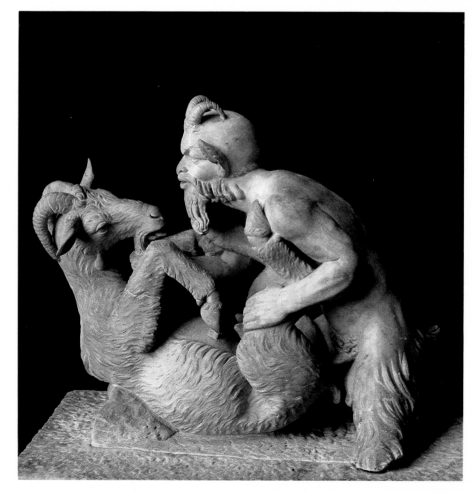

MIRROR WITH EROTIC SCENE
Bronze; diameter 16 cm
From the Museo Borgia
First half of 4th century B.C.
RP, Inv. no. 27672

MIRROR WITH EROTIC SCENE

Relatively rare in Greece in the Minoan and Mycenaean periods, mirrors made of metal were probably reserved for religious rites or were associated with magic practices. In the fifth century B.C. mirrors on the lids of caskets came into use, with their outer surfaces decorated in relief. They were produced mainly in the Chalcidice, at Corinth and in Magna Graecia, and eventually became ordinary household objects. From the fourth to the second century B.C., mirrors were produced on a large scale in Etruria, particularly at Vulci and Perugia. The craftsmen produced them according to fixed designs, the variations in which are of great help today in dating and classifying them. The mirror in the illustration shows an erotic scene framed in a garland of myrtle and, unlike most mirrors of the same period, it has few artistic pretensions, being a simple object for everyday use.

BAS-RELIEF WITH EROTIC SCENE

It was not unusual for Pompeian sculpture to combine the use of the brush and the chisel to achieve a subtle finish. The bas-relief in the illustration is trapezoidal in form and, judging by surviving traces of colour, was partly painted. The colour helped to accentuate the chiaroscuro effect and made the relief stand out from its background, thus heightening the sense of form.

BAS-RELIEF
WITH EROTIC SCENE
Marble; 37 × 37 cm
From Pompeii
Mid-1st century A.D.
RP, Inv. no. 27714
Opposite page: detail

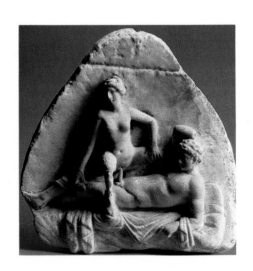

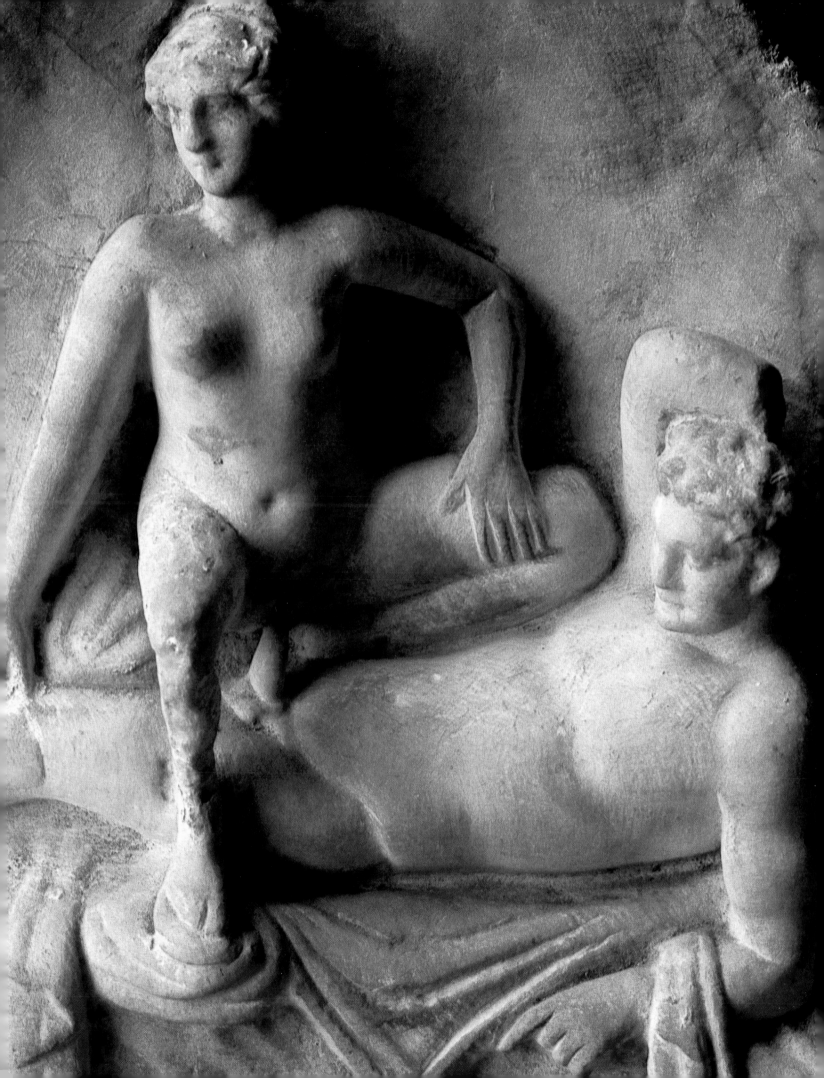

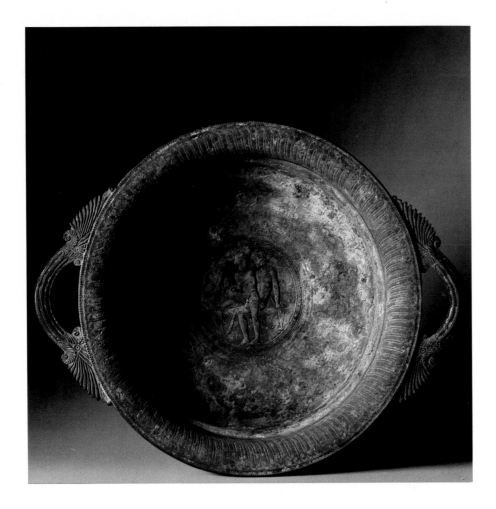

LEBES WITH
SATYR AND NYMPH
Bronze; height 12 cm, diameter 39 cm
From Pompeii
1st century B.C.
RP, Inv. no. 27671
Opposite page: detail

The line of the woman's neck and shoulders is echoed by the line of her
thighs, adding to the elegance of the composition.

> If you have youthful legs and a flawless breast,
> the man will lie supine and you perpendicular to him.
> Fear not to move your free-flowing hair,
> twisting your head like a bacchante.
> (Ovid, *Ars Amatoria*, III, 781–784)

LEBES WITH SATYR AND NYMPH

The large metal basin called a *lebes* (a word probably derived from the
Greek verb 'to pour', 'to make a libation') had a wide range of functions
in antiquity. They were liturgical objects, used for ritual ablutions and
small ones, often of precious metal, were used during sacrifices to catch
the blood of the victim. Very large ones were used for boiling. They were
also given as trophies to the winners of athletic contests and to victorious
commanders.

The *lebes* illustrated here is a very beautiful example. The rim is decorated
with a tongued ornament and with palmettes (ornaments derived from
palm leaves) joining the handles to the vessel. The same tongued motif
encloses the roundel, which contains a delicately composed scene showing
a satyr and a nymph making love against the drapery of a raised garment.

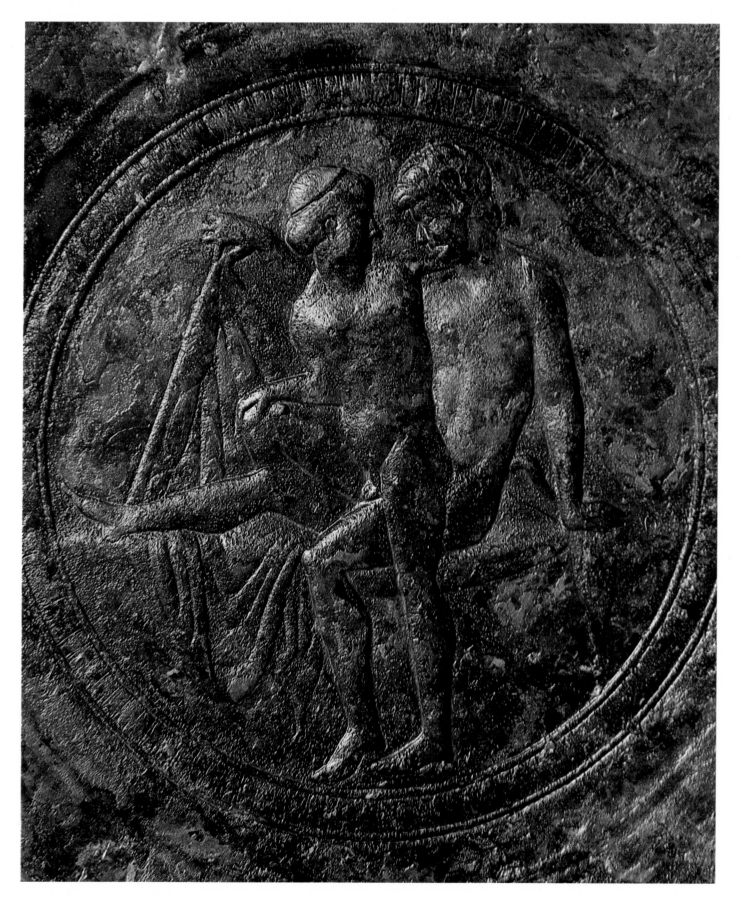

Satyrs and nymphs are usually associated with Dionysus, and it was at Pompeii that the Dionysiac cult, despite the bans on it, was particularly strong.

SKYPHOS WITH SCENE OF SATYR AND MAENAD

The introduction of pottery manufacture into Southern Italy coincided with the period of Greece's greatest expansion. With the intensification of trade, the artistic, economic and technical prowess of Greece was reflected in her western colonies, Sicily and Magna Graecia, where homes were soon enriched with the beautiful ceramics of Attica. Even as early as the eighth and seventh centuries B.C., kraters (vessels used for mixing wine) in the geometric style and small protocorinthian vases (delicately ornamented vases produced in Corinth) for aromatic oils and essences, were in use as tomb furnishings. The workshops of Cyrene, Naucratis (Egypt) and the Chalcidice supplied the market with vases whose decorations grew increasingly more beautiful and refined. In the sixth century B.C., for reasons which are not clear (changes in taste or in technology may be involved), there was a complete revolution in decorative style: the natural background of red clay was now painted completely black, and the vases were decorated with red figures. This made the design much sharper and allowed much more freedom to the individual artists, who testified to their new role by signing their works from now on. This radical development provoked full-scale competition between the workshops of Etruria, Sicily and Magna Graecia for the services of the best potters who could help to corner more of the market.

The artist who made the *skyphos* (two-handled drinking cup) in the illustration was one of the most sought-after potters of the time; his name was Epiktetos, and some thirty signed works of his are known.

The subject treated in the decoration of the cup is clearly derived from the corpus of Dionysiac themes. On one side of the cup a Bacchante tries to escape from a tailed silenus; on the other side a maenad invites an

SKYPHOS WITH SCENE OF
SATYR AND MAENAD
Red-figured Attic vase; 9.5 × 17 cm
From Anzi di Basilicata
Last quarter of 6th century B.C.
RP, Inv. no. 27669
Opposite page: the other side
of the same cup

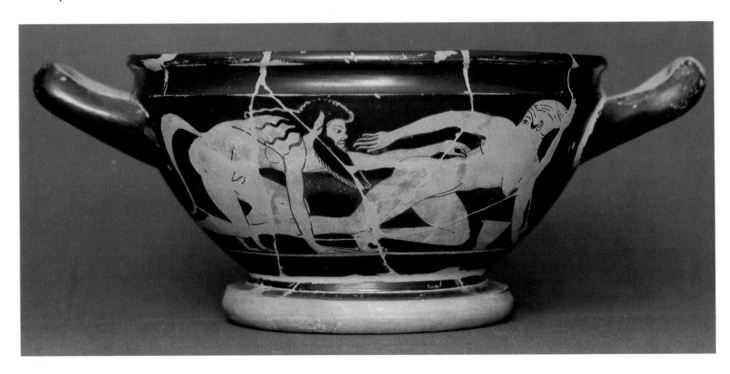

100

ithyphallic mule to drink from her cup. These mules were the steeds of Dionysus and the sileni.

As in all Epiktetos's works, or those attributed to him on stylistic grounds, there is an uncluttered purity of design with strong, simple shapes, and a harmonious integration of the figures. This cup is one of the finest examples of Attic ceramic art.

DISH WITH EROTIC SCENE *p. 102*

It is sometimes very difficult, if not actually impossible, to determine whether certain vases are imports from Greece or of local Italian manufacture. From the sixth century B.C. onwards, Greek pottery began to be rivalled by indigenous Italian products. Pots based on Attic models were produced at centres such as Canosa, Peastum, Saticula, Ruvo, Armento and Cumae.

The illustration shows an erotic scene painted on the inside of a shallow drinking cup *(kylix)*, whose provenance is uncertain. The two figures are delineated with extraordinary efficacy, and are elegantly framed in a meander border interspersed with checkerboard motifs.

AMPHORA WITH EROTIC SCENE *p. 103*

The Etruscans reached the height of their artistic skills in their production of *bucchero*, a type of pottery made from powdered clay mixed with charcoal. Although the technique was not a new one, Etruscan *bucchero* ware was the finest produced in antiquity, rivalling bronze and silverware in its magnificence.

The Etruscans did not show equal skill in their imitation of imported Greek pottery, as the amphora illustrated here demonstrates. Its upper part is decorated with birds and ivy leaves and the same scene is repeated on both sides with only slight variations. The debt owed to Attic models is evident, but the coarse brushwork and the roughly drawn figures make this amphora a rather second-rate piece of work.

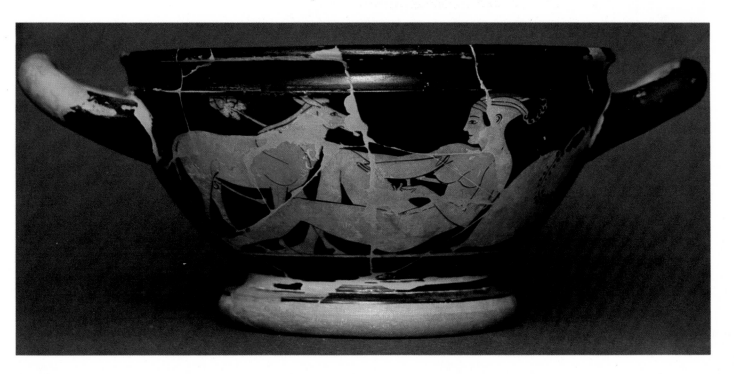

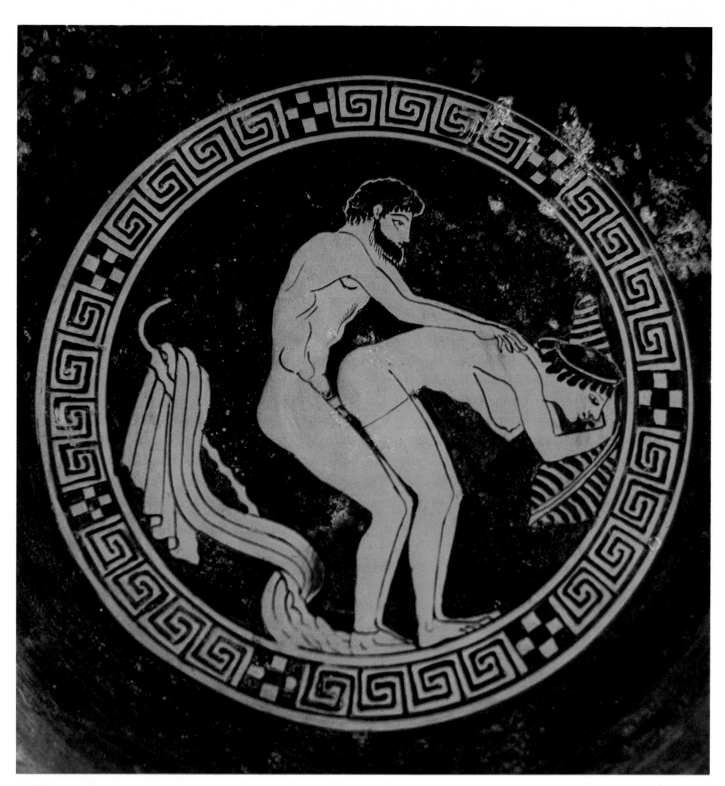

DISH WITH EROTIC SCENE
Detail
Attic red-figure vase; height 9.5 cm,
diameter 23.5 cm
Origin unknown
Date c. 480–460 B.C.
RP, s.n.

AMPHORA WITH EROTIC SCENE
Etruscan black-figured pottery; height
24 cm, diameter at mouth 11.5 cm
From the Palatine Collection
Last quarter of 6th century B.C.
RP. Inv. no. 27670

LAMPS WITH EROTIC SCENES *pp. 105 and 106–7*

The lamp came into use relatively late in Southern Italy. In contrast, hieroglyphics attest its use many centuries earlier in ancient Egypt, and both the royal tombs at Mycenae and the palace of Knossos have yielded numerous examples in stone. The Romans learned the use of lamps from the Greeks, and Greek lamps were in fact imported into Central Italy from at least the sixth century B.C. onwards. They were usually made of clay or bronze, and could be open or closed in shape. Terracotta lamps, in particular, lent themselves to decoration of the concave surface.

The lamp illustrated on the opposite page, in brown-painted terracotta, achieves a harmonious balance between form and decoration; the robust winged phallus is contained in a shape which boldly echoes it.

In contrast, the lamp shown on page 106 has a delicately drawn relief showing the act of love in an elegant, timelessly classical way. Here too the composition of the figures echoes the curving shape of the lamp.

Framed by concentric circles and modelled in high relief, the decorations on the other lamps all develop variations of the same theme. As a rule, one does not find an absolute correlation between the function of an object and a decorative motif. But in these tiny lamps function and decoration are strongly linked: night is the time for love, with only the discreet flicker of the lamp as witness:

> Conspiring with you in the joys of love,
> I'll keep secret all you may wish to do.
> (Martial, *Epigrams*, XIV, 39)

The small lamps illustrated here may well have been for use in the most secluded rooms of the Pompeian home, but the Pompeians also loved a well-illuminated house. They favoured the use of elaborate light-fittings, rather like chandeliers. One of the more ingenious examples that survives consists of a large metal centrepiece with smaller arms branching off, on which individual lamps were hung.

The lamps shown here have certain standard features. In the bowl of the lamp is a hole for the oil. Each has a nozzle where the lamp is lit, and these do not vary much in shape except for the example opposite, p. 105, which has two fins on either side.

All the lamps, except the last one on p. 107 (which is of rough workmanship), have scroll-like ornaments filling in the space where the nozzle joins on to the bowl. This last example bears the name of the craftsman who made the mould for it—he signs himself 'Heraclius'.

BAS-RELIEF OF SMALL TEMPLE WITH SCULPTED PHALLUS

p. 108

The Romans lived out their lives in a world full of ritual, which had to be scrupulously observed. The religious calendar not only set aside days for religious festivals, but decreed whether any individual day was auspicious *(fas)* or inauspicious *(nefas)*, which might affect the outcome of battles or business. The goodwill of the gods, and the happy outcome of events, could only be procured by doing the right thing at the right time, following the rules of rigid formalism. Anything which fell outside the bounds of tradition might be rejected; any person who violated the established canons was a bearer of misfortune, *fascinum*. An evil sight could be neutralized

LAMP WITH WINGED PHALLUS
Brown-painted terracotta; height 4 cm,
length 15 cm
From the Museo Borgia
Augustan period
RP, Inv. no. 27867

Page 106:
Page 106:
LAMP WITH SPIRAL SPOUT
AND NO HANDLE,
WITH EROTIC SCENE
Red-painted terracotta; height 2.5 cm,
length 10.5 cm, diameter 6 cm
From Herculaneum
Beginning of 1st century A.D.
RP, Inv. no. 27862

*Page 107 from left to right
and top to bottom:*
LAMP WITH EROTIC SCENE
Brown-painted terracotta; height 2.5
cm, length 11.5 cm, diameter 5.6 cm
Found at Herculaneum c. 1873
First half of 1st century A.D.
RP, Inv. no. 110112

LAMP WITH EROTIC SCENE
Brown-painted terracotta; height 2.6
cm, length 12 cm, diameter 6.4 cm
Found at Pompeii c. 1872
First half of 1st century A.D.
RP, Inv. no. 109412

LAMP WITH EROTIC SCENE
Red-painted terracotta; height 2.8 cm,
length 12 cm, diameter 6 cm
Found at Pompeii
First half of 1st century A.D.
RP, Inv. no. 27865

LAMP WITH EROTIC SCENE
Brown-painted terracotta; height 2.8
cm, length 11.5 cm, diameter 7.3 cm
From the Museum of Noja
First half of 1st century A.D.
RP, Inv. no. 27864

LAMP WITH EROTIC SCENE
Brown-painted terracotta; height 2.7
cm, length 12 cm, diameter 4.6 cm
Found at Pompeii
First half of 1st century A.D.
RP, Inv. no. 109413

LAMP WITH ROUND SPOUT
AND EROTIC SCENE
Red-painted terracotta; height 2.5 cm,
length 11.4 cm, diameter 4.9 cm
From the Museo Borgia
Middle of 1st century A.D.
RP, Inv. no. 27861

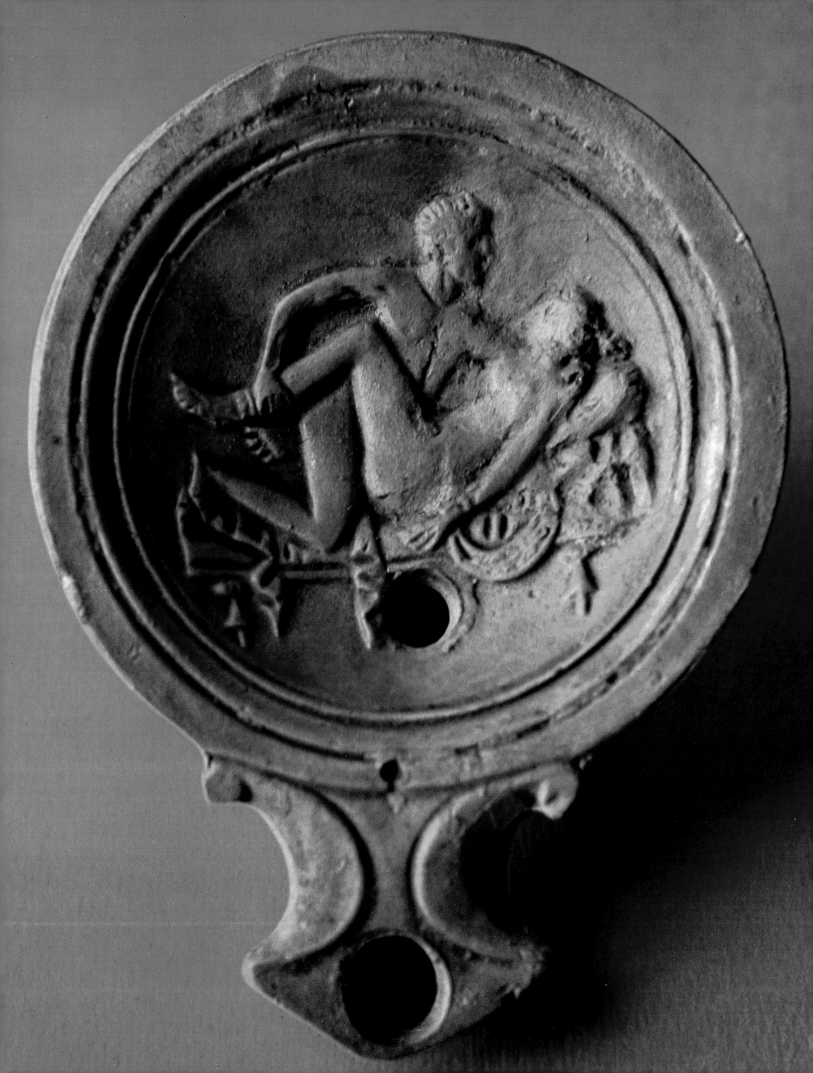

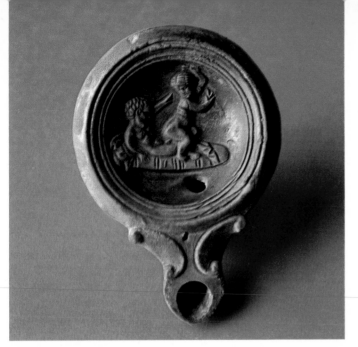
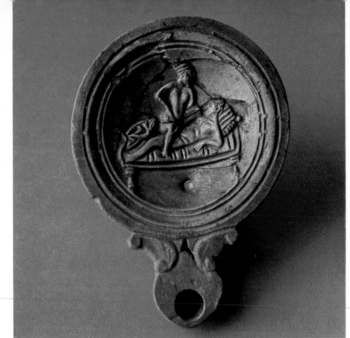
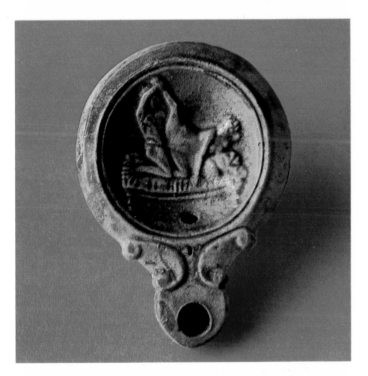
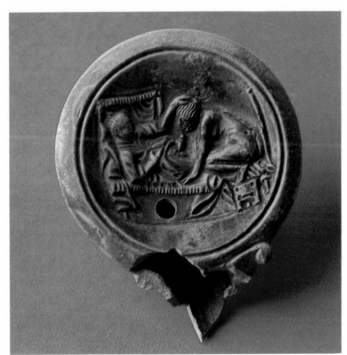
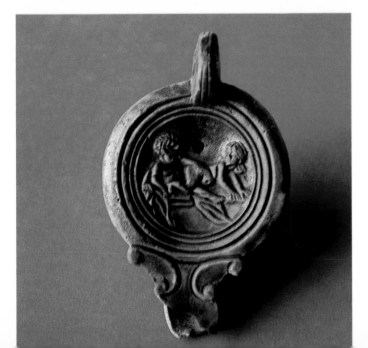
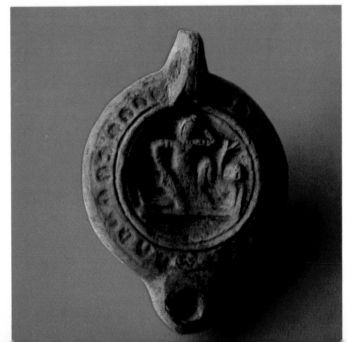

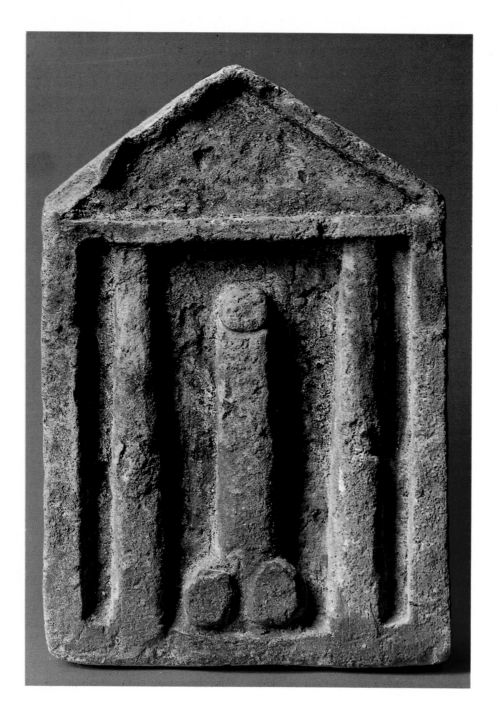

BAS-RELIEF OF SMALL TEMPLE WITH SCULPTED PHALLUS
Bas-relief in travertine; 31 × 45 cm
From Pompeii (?)
RP, s.n.

by making an appropriate gesture with the fingers crossed (symbolizing the act of intercourse). Such sexual symbolism was protective, as with the object illustrated above. This is a plaque, probably from Pompeii. It shows the facade of a small temple housing a phallus that has been given the status of a tutelary deity to protect the house from the evil eye.

The custom of placing the sign of the phallus on houses to avert evil spirits continued into medieval times, and examples have been found on the walls of churches.

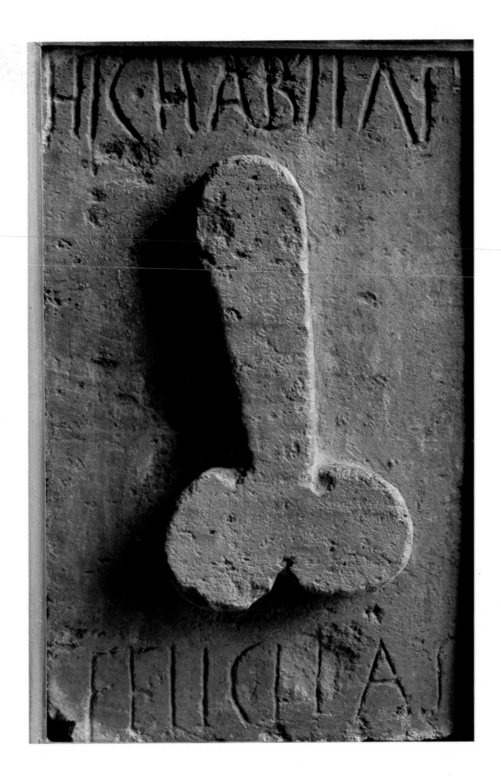

HIC HABITAT FELICITAS

The phallus symbolized the procreative power of Nature, and it was venerated as the personification of the god Fascinus who had the power to ward off the 'evil eye'. Carved in relief on a small slab of red-painted travertine, this phallus is bordered by the following inscription: 'HIC HABITAT FELICITAS' ('Here dwells happiness'). Evidently of popular origin, the motto clearly demonstrates the value of the phallic symbol as a good-luck charm.

GIANT PHALLUS IN PAINTED TUFA

The cult of the phallus was widespread in the ancient world, and there is evidence of its worship in India, Asia Minor, Egypt and Greece. The Romans identified the phallus with the god Fascinus, and attributed him with the power to make new shoots spring from withered plants, to make sterile women fertile, and to ward off the 'evil eye'. Thus the worship of the phallus, or the use of phallic symbolism, served a very real function in Roman society.

The phallic ritual was originally free from vulgarity, and was followed in order to solicit the good offices of a divinity who was capable of keeping away the 'evil eye'. Likewise the frank and uninhibited language which was used to counter the power of an evil-doer did not originally have the connotation of overt vulgarity.

On a wall near where this sculpture was found, was the inscription: 'HAC EGO CACAVI' ('I had a shit here'). To deface a house or monument with obscene writings was obviously intended as an insult to the owners, who would no doubt curse those who perpetrated the nuisance. But to make the same gestures towards one who bore the 'evil eye' did not carry the same stigma; it was an acceptable way of protecting oneself against evil forces.

This large sculpture, made from Nocera tufa, a stone widely used in Pompeian buildings, exercised a protective function over the house in front of which it had been set up.

ITHYPHALLIC DWARF *p. 112*

This roughly fashioned image is of a dwarf contemplating an enormous phallus. Sculpted figures of this kind were held in great esteem by the Romans, who attributed to them special magic power. The dwarf in the illustration is made of limestone which was widely used by the Romans in their building work. Similar figures were also produced in metal and in leather.

PHALLUS *p. 112*

Sculpted in various sizes and in a variety of materials, the phallic symbol as a harbinger of good fortune is found not only in private houses, but also in public buildings. At the *taberna lusoria*, the local casino of Pompeii, where illegal gambling took place both with money and with precious objects, the sign of the house was a bas-relief of a vase set between two phalli.

The phallus could also be used for functional purposes. (Compare the illustration on page 50 where the phallus serves as a waterspout.) The phallus illustrated here may have been set over the lintel of a door, and almost certainly served a propitiatory purpose.

ITHYPHALLIC DWARF—SCULPTURE IN LIMESTONE *p. 113*

This roughly worked statuette would have had the same symbolic function as the three preceding figures. It certainly served as a household ornament, but its poor state of preservation makes any dating or stylistic analysis difficult.

GIANT PHALLUS IN PAINTED
TUFA
Sculpture in Nocera tufa; height 64 cm
From Pompeii
regio IX, *insula* V (30 August 1880)
RP, Inv. no. 113415

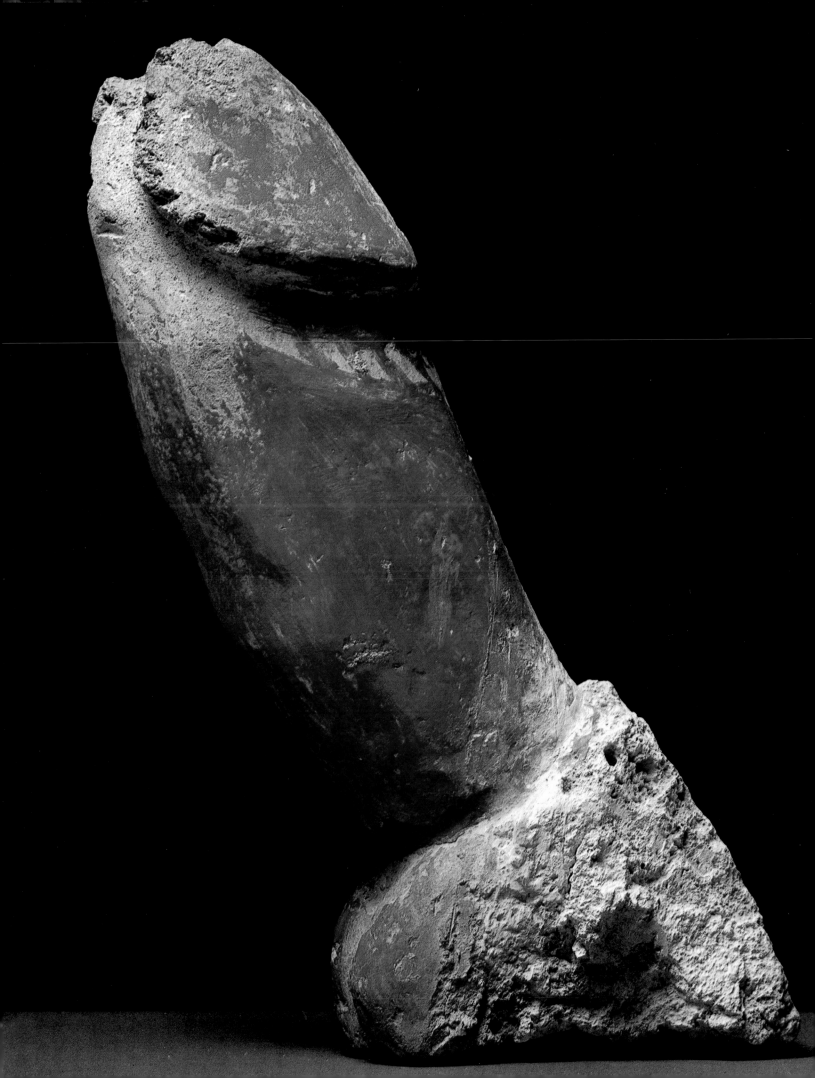

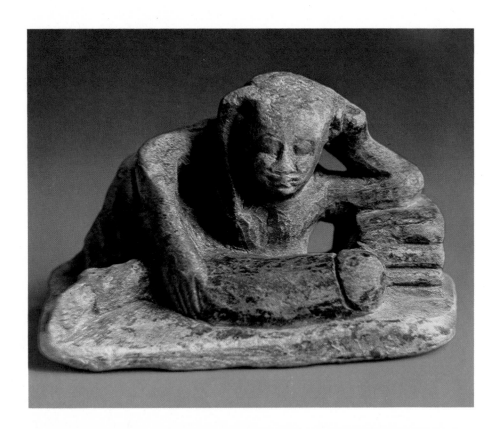

ITHYPHALLIC DWARF
Painted limestone; 11×7 cm
From the Museo Borgia
RP, Inv. no. 27678

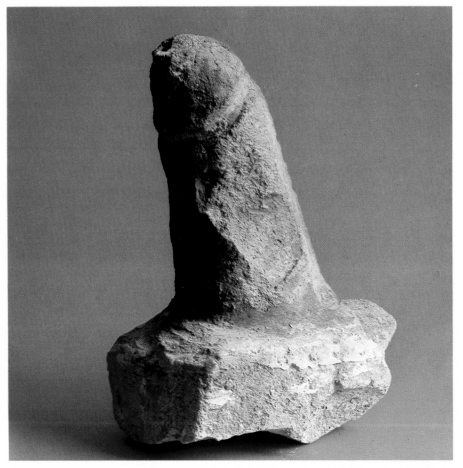

PHALLUS
Sculpture in tufa; height 39 cm
From Pompeii (?)
RP, s.n.

ITHYPHALLIC DWARF
Sculpture in limestone; 7.5×6 cm
From the Museo Borgia
RP, Inv. no. 27673

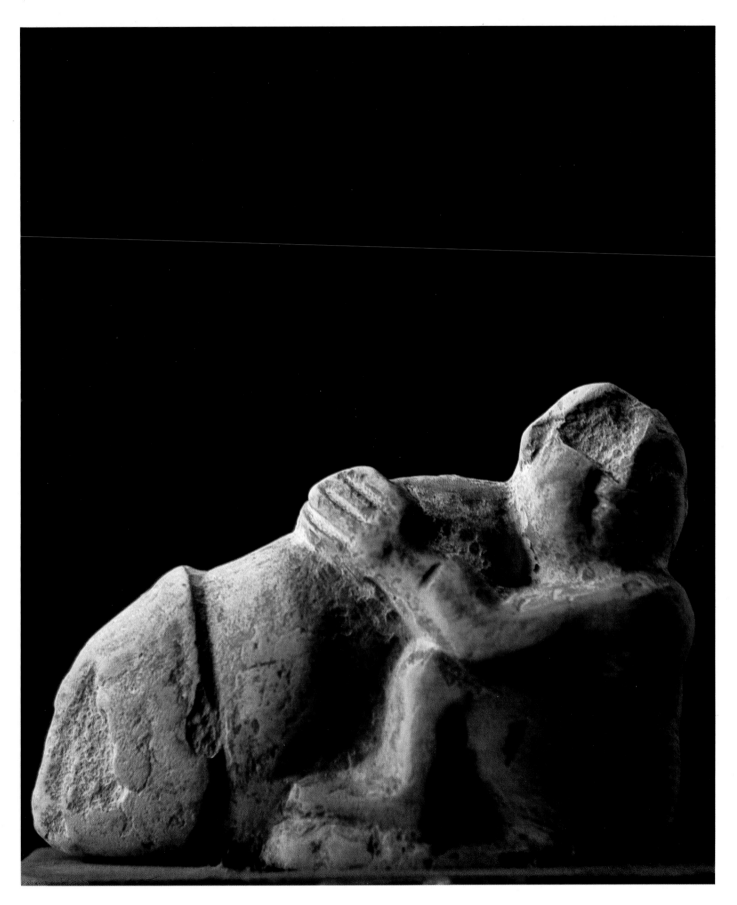

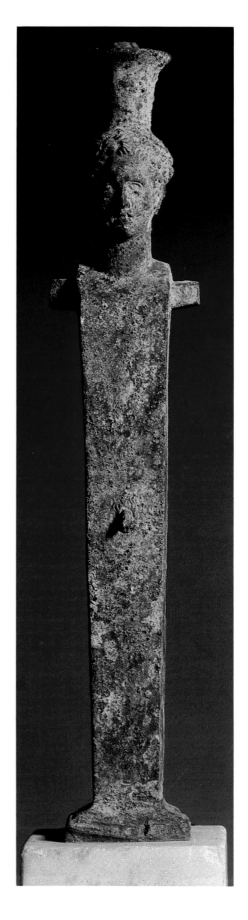

CANEPHORA-HERM

Canephorae, such as the one sculpted on the little herm shown here, were originally the girls who took part in processions in Ancient Greece carrying baskets on their heads full of offerings to the gods. Statues of *canephorae* were made by Polyclitus and Scopas, and portrayals of processions with *canephorae* appear in the decoration on Attic vases. The Ionian builders had followed the practice of using figures of *canephorae* to support architectural features, and even in the third millennium B.C. small votive figures similar to *canephorae* appear in Mesopotamia. The phallic emblem visible in the illustration shows that this is, exceptionally, a male type deriving from the original female type. Like the sculpture opposite, this herm is clearly of Hellenistic workmanship, as is shown by the clarity of the representation and the delicate rendering of the features.

HERM WITH HEAD OF BOY

Alcibiades, the great military leader of classical Athens, fell from grace in 414 B.C., when he and his companions profaned the Eleusinian mysteries and mutilated the herms of Athens. The moral ostracism which he then suffered is an indication of the importance the Greeks attached to these monuments.

Roman religion was based on a fairly tolerant polytheism. Its ability to absorb cults and divinities from other countries, particularly from Greece, favoured the spread of many cults, including that of Hermes. Amongst the many attributes which popular belief credited to the god was that of fertility; he was also the guardian of the fields and protected people from danger on the roads, particularly from evil spirits at crossroads.

Hermes was commonly represented by rectangular pillars which had male attributes and were surmounted by a human head. They were placed as boundary-stones between estates and served as landmarks for travellers. These herms eventually came to be venerated as divine objects, and began to appear at the entrances of houses, in gymnasiums, in libraries and on tombs; they were considered sacred and inviolable, and the faithful made offerings to them of incense and garlands. After the time of Alexander the Great the cult of herms declined and as their sacred character disappeared they assumed a purely ornamental function. The original bearded male head of the divinity was replaced by the more pleasant features of women and boys, and the herm became a decorative element in the Roman home and garden; a miniature herm might be placed in the domestic shrine of the household gods.

The herm in the illustration, equipped with its traditional phallic appendage and two more appendages for arms, follows the classic rules of the Hellenistic prototype.

CLOTHED HERM *p. 116*

The herm eventually lost its religious significance and became a merely decorative object in the Hellenistic period, embellished and beautified in a hundred different ways. It was ideally suited to garden settings. The herm shown here comes from what was probably once a Pompeian orchard. It is in pavonazzetto marble (a more precious variety of Breccia marble), delicately veined with green and violet.

CANEPHORA-HERM
Bronze sculpture; 3×21 cm
From Pompeii (?)
1st century A.D.
RP, s.n.

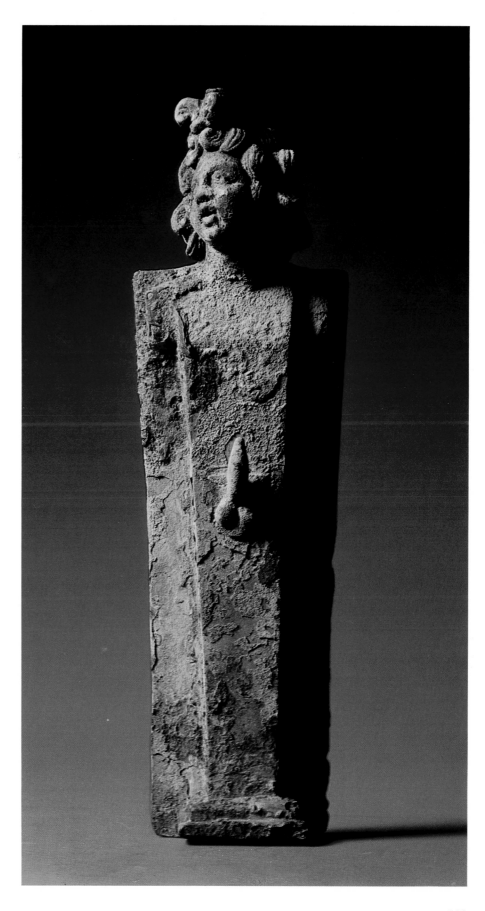

HERM WITH HEAD OF BOY
Sculpture in bronze; 4.5×17 cm
From Pompeii (15 November 1904)
1st century A.D.
RP, Inv. no. 129434

115

CLOTHED HERM
Sculpture in pavonazzetto marble;
height 142 cm
From Pompeii (?)
1st century A.D.
RP, s.n.

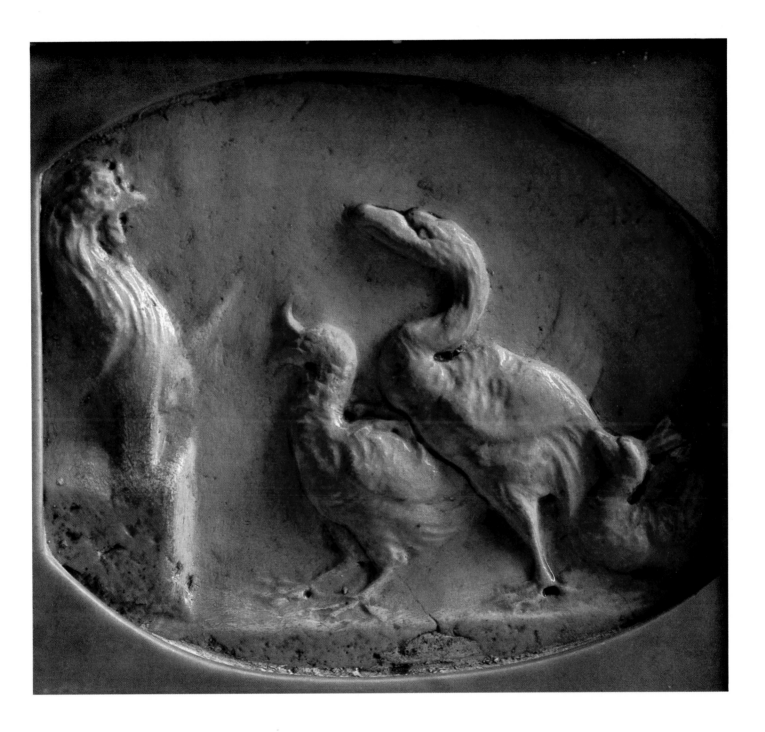

ANIMALS ADORING A PHALLUS
Stucco bas-relief; 17 × 14 cm
From the Museo Borgia
1st century A.D.
RP, Inv. no. 27713

ANIMALS ADORING A PHALLUS

This plaster panel, with its smooth modelling and gentle highlights, has a peahen, a goose and a Numidian hen adoring an ithyphallic herm in the shape of a proud cockerel. It is part of a much larger work, presumably one of several panels that made up a large wall decoration. The scene may be an allegory suggesting the universal generative power of the phallus, but more probably it is a caricature, a witty exercise elaborated according to the canons of Hellenistic and Roman art, which on occasion used bizarre and even grotesque subject matter.

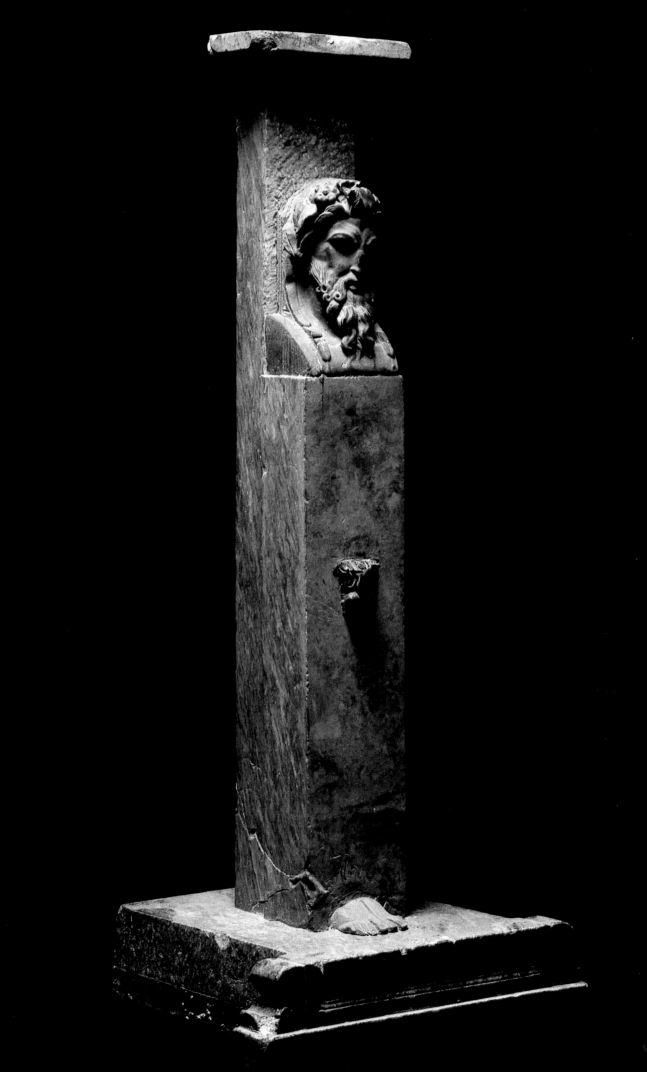

TRAPEZOPHORON IN THE
FORM OF A MALE HERM
Sculpture; height 102 cm
From Pompeii
1st century A.D.
RP, Inv. no. 27730

TRAPEZOPHORON IN THE FORM OF A MALE HERM

The majority of herms are truncated at the top and taper towards the base. This one had the secondary function of supporting a table top; hence the flat support above the head and the solid marble base. The phallus is made of bronze and the head is deeply modelled in dark marble. The thick crown of hair, the flowing beard and majestic aspect of the head suggest that this is Faunus, the divinity of fields and flocks, usually represented with the features of Jupiter. Popular belief credited him as the source of foreknowledge, sometimes revealed in dreams. The iconography of Latium, however, contradicts this hypothesis. The Faunus venerated by the Romans had a radiate crown on his head, not the ivy crown with ribbons falling to the shoulders of the herm in the illustration on the opposite page.

RECLINING ITHYPHALLIC SATYR

This bronze formed the handle on the lid of a cist, a large receptacle used for ritual purposes or as a container for clothing, commonly found in antiquity.

The drunken ithyphallic satyr is pouring wine into a cup from a *rhyton*, the wine-horn used in Greece, which frequently appears in mythological scenes. A very similar satyr appears on a fifth century B.C. coin from Naxos, Sicily.

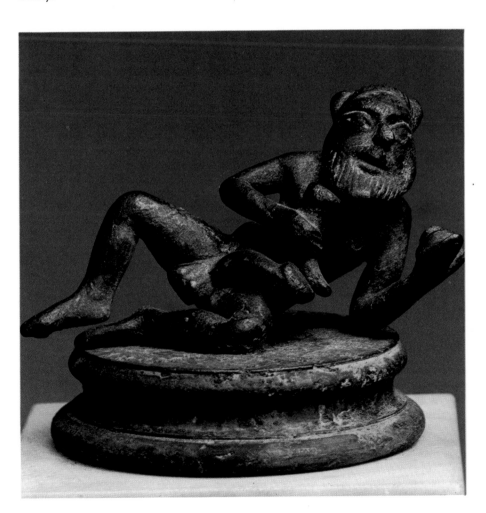

RECLINING ITHYPHALLIC
SATYR
Bronze sculpture; 6.5 × 4 cm
From the Museum of Capodimonte
Late 5th—early 4th century B.C.
RP, Inv. no. 27682

PLACENTARIUS
Two sculptures in gilded bronze;
height 25 cm
From Pompeii
regio I, *insula* VII, nos. 10–12,
House of the Ephebe
Last years of Pompeii
RP, Inv. no. 143760 (same inventory
number for both statuettes)

PLACENTARIUS

By the first century A.D. the influences of Hellenistic art had been completely assimilated in Pompeii. Wall-paintings, mosaics and sculpture all reached a highpoint of artistic development in some of the most sumptuous and luxurious dwellings of antiquity.

In the House of the Ephebe, Hellenistic taste and influence are particularly evident and, as with the majority of Pompeian houses, refined and expensive works are accompanied by examples of more popular art which are of considerable interest. The two little bronze figures illustrated here were found in the corner of a room close to the central hall or *atrium*, protected inside a wooden box alongside other similar figures. The little trays fixed to the hands had been detached to take up less space in the box; this suggests that the objects had just arrived from their place of manufacture and were still awaiting permanent arrangement when the volcano erupted.

The statuettes are of elegant workmanship, and were very probably used as sauce dishes, the sauce dish proper being placed in the hollow in the little silver tray. The thin naked man is symbolically ithyphallic, as in practically all humorous representations. He is a *placentarius*, a street seller of *placentae*, carrying his flat muffin-like cakes of pastry and honey on a shallow tray. The statuettes are thus highly caricatured representations of real-life personalities.

STUPIDUS *p. 122*

Hellenistic artists turned to everyday life as a source of inspiration. The down-and-out, the pedlar, the unemployed actor, the drunken old woman were used as models, their down-to-earth qualities captured in an intimate and human way. These genre portraits allow penetrating and witty observations about the bizarre and the odd—and even the deviant features of contemporary life. But such art can slip into rhetoric and rather excessive virtuosity if particular characteristics are overemphasized.

One of the greatest centres during the expansion of Hellenic culture was Alexandria, and within this great city an enormous variety of artistic traditions flourished side by side. But one thing common to all the craftsmen of the city was their great commercial success. Alexandrian sculptures, which were mainly genre portraits and grotesques, were in great demand, not least for export abroad.

The figure in this illustration, tellingly sculptured in physical details, is Stupidus, a character with a rather unpleasant appearance who played a central role in mimes. In spectacles of this kind the actors performed without masks in market places or in private houses. They acted out farces and traditional stories in which the spoken text was very brief, using a mime language of standard gestures, poses and facial expressions. The names of the individual characters and their appearance suggested a specific type and role; Stupidus was the fool of the company and behaved as such on stage.

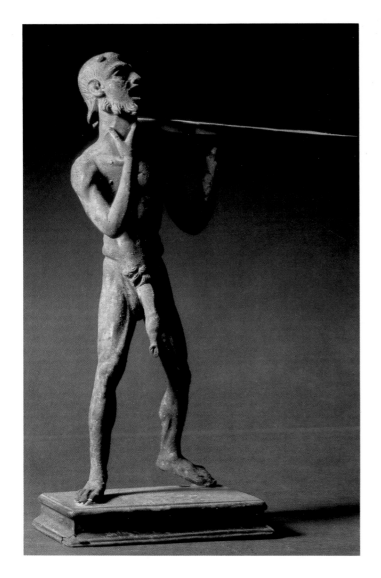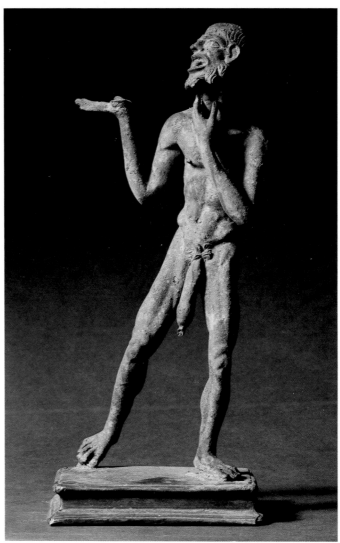

DANCER

p. 123

In the process of assimilation of Greek culture by the Romans, the development of the dance played a crucial role. The dances of the Salii (the priests of Mars) were warlike and also magical, their aim being to propitiate the god and ward off evil. They were replaced by ritual dances of Etruscan origin, and then finally by Greek dance, which caught on because of its spectacular and mimic nature. When choreographic realism reached the height of its development, dance became popular at all levels of society and *Sanniones* or buffoons performed in the squares with their improvised dances, clowning and exchanging banter with the onlookers. The bronze illustrated here probably represents a *Sannio* in a typical pose and the exuberance of the physical detail brings out the grotesque nature of the characterization. The expressive modelling and skilful workmanship of this delightful statuette betray its Hellenistic ancestry.

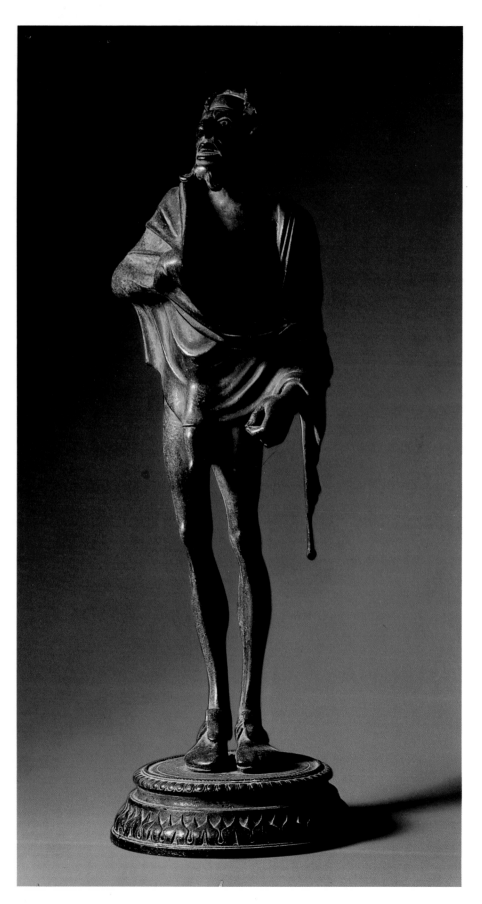

STUPIDUS
Bronze sculpture; height 35.5 cm
From Pompeii
1st century A.D.
RP, Inv. no. 27729

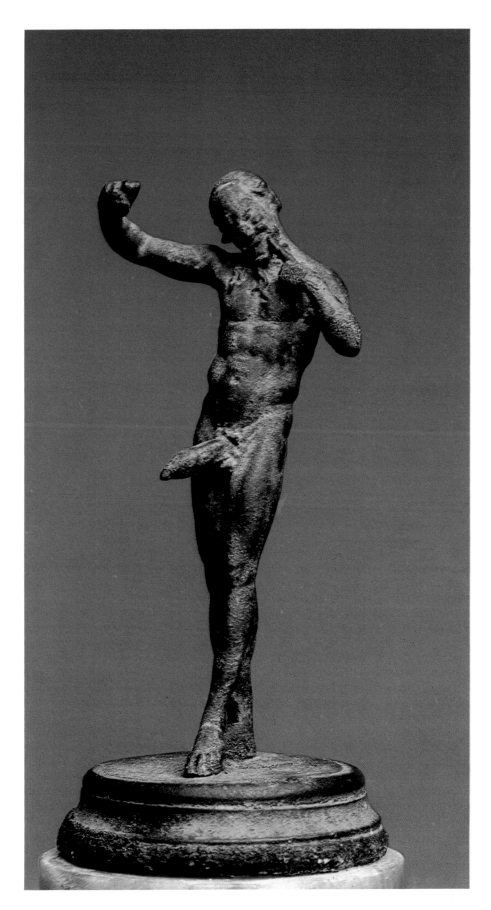

DANCER
Bronze; height 8.5 cm
From Civita (13 June 1755)
End of 1st century B.C.
RP, Inv. no. 27733

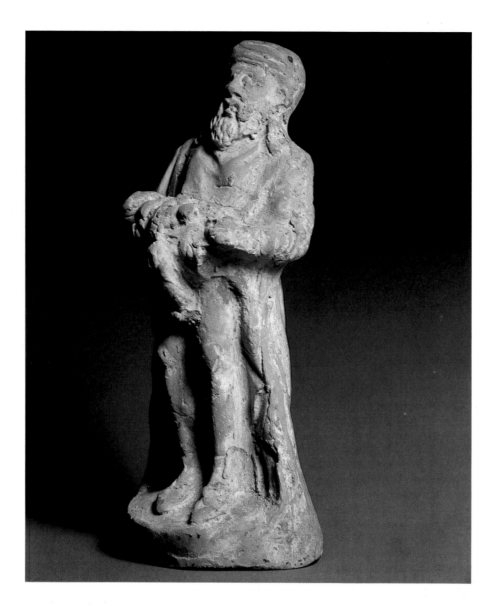

PRIAPUS
Sculpture in terracotta; 5.5 × 14 cm
From Pompeii
1st century B.C.
RP, Inv. no. 27717

PRIAPI

According to a widespread tradition, Priapus was the son of Dionysus and Aphrodite; his place of origin was Lampsacus in Mysia, and the cult of Priapus spread from there to the Aegean islands, to mainland Greece and the whole of the Romanized world. During this process of expansion the cult of Priapus absorbed elements from similar cults. Thus over the centuries Priapus came to be connected with Pan, with Silvanus and with the phallic rites of the Dionysiac orgies. The variety of permutations is evident in the iconography, which sometimes portrays Priapus with the Oriental features of Dionysus-Sardanapalus and sometimes with the animal features of Pan. But the most powerful characterization of Priapus is certainly the Alexandrian one, in which he appears, as in the two sculptures illustrated here, with a bearded face and his tunic raised chest-high to carry fruit. Priapus was the object of particular veneration at Alexandria, and in every procession or liturgical representation he appeared beside the major divinities. His sacred animal was the ass, which symbolized sexual incontinence, and during the Imperial period his popularity grew enormously thanks to certain uninhibited and religious rites performed in

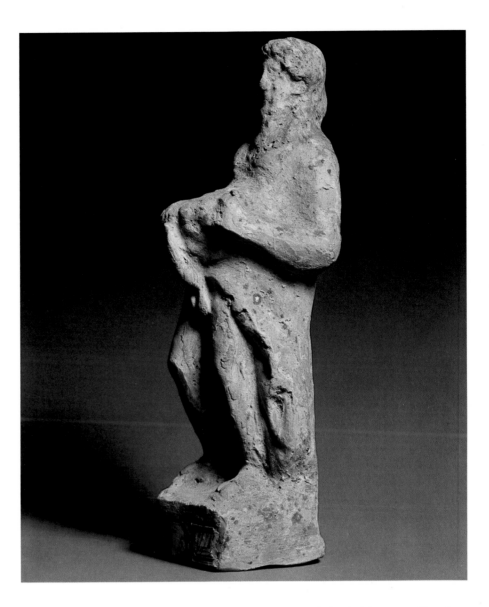

PRIAPUS
Sculpture in terracotta; 4.5 × 16 cm
From Pompeii
1st century B.C.
RP, Inv. no. 27719

his honour. Deep in the country, the first fruits of the field were offered to his rustic image; often he was given no more than a simple piece of stone or wood:

> In spring with roses, in autumn fruit
> and in summer with ears of corn I'm covered;
> but winter's a fearful season;
> I fear the cold and I fear the wooden
> simulacrum may make firewood for the lazy farmer.
> (*Carmina Priapea*, LXXXIII)

PRIAPI POURING *pp. 126–7*

In his *Natural History* (XXVI, 10) Pliny describes certain aphrodisiac herbs that may be used to rejuvenate the old and it has been suggested that these two bronzes depict somewhat elderly gentlemen anointing themselves with a stimulant. But in fact they are more likely to be representations of the fertility god, Priapus, in the process of pouring a libation in honour of his phallus to secure a rich harvest. The bronzes differ somewhat

125

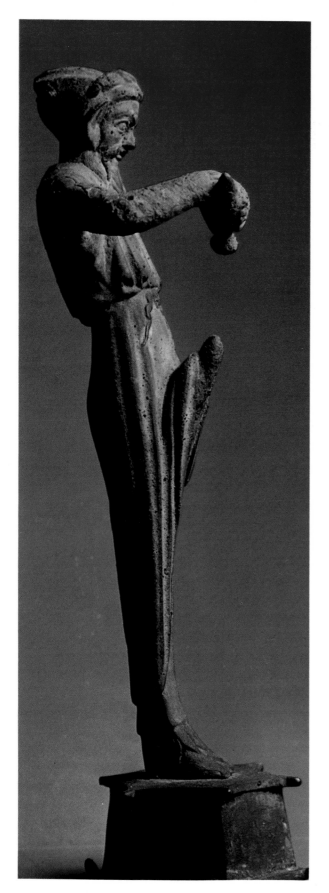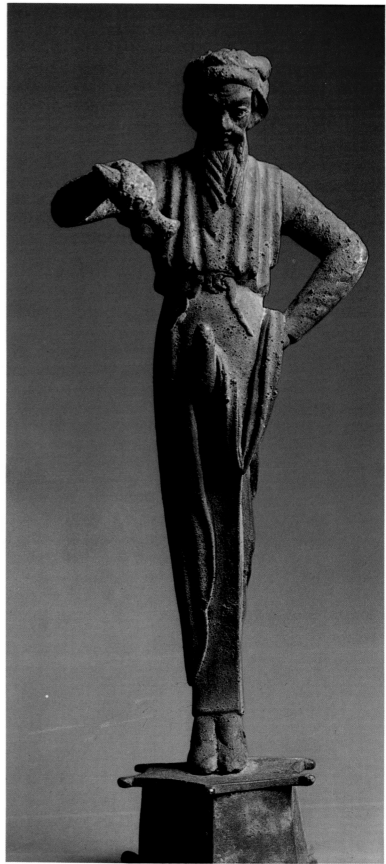

PRIAPUS POURING
Bronze sculpture; height 22 cm
From Portici (1 February 1746)
1st century A.D.
RP, Inv. no. 27731
Centre: same statue seen from front

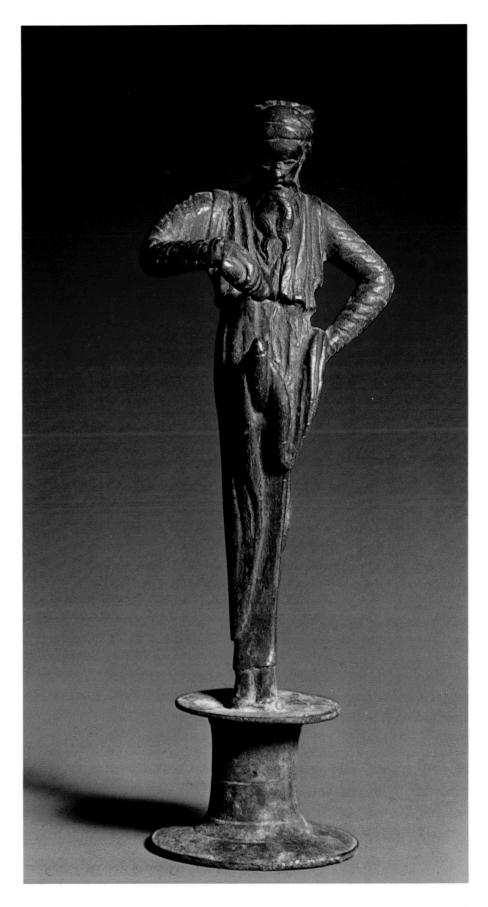

PRIAPUS POURING
Bronze sculpture; height 22 cm
From the Museum of Capodimonte
1st century A.D.
RP, Inv. no. 27732

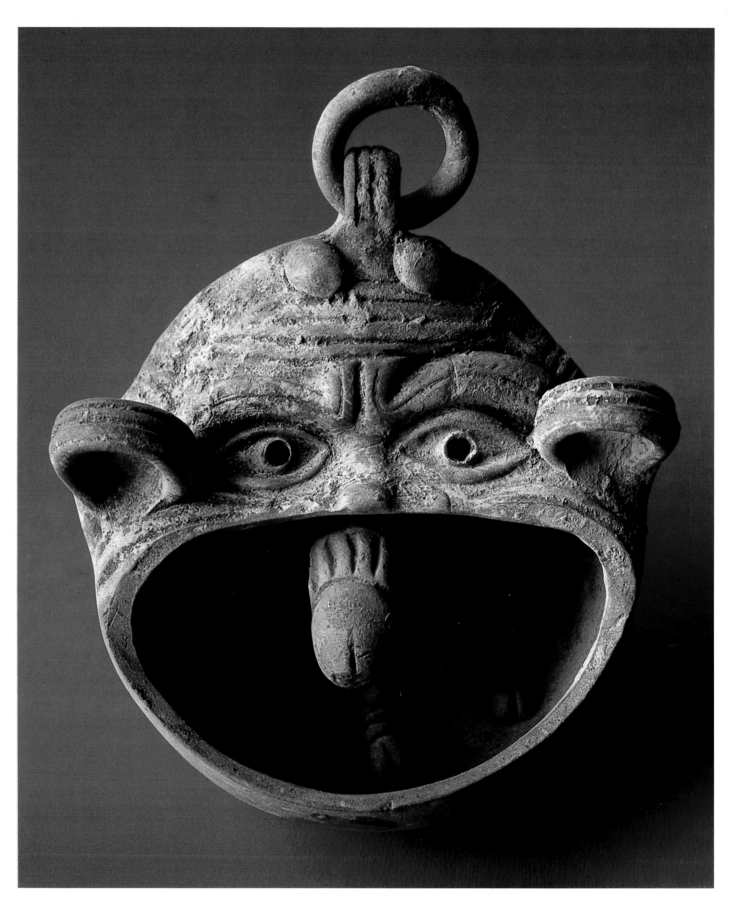

DRINKING-BOWL MASK
Terracotta; 9.5 × 9 cm
From Pompeii (22 May 1843)
1st century A.D.
RP, Inv. no. 27859

from the usual iconography, and have the appearance of mass-produced work. They are probably of Alexandrian origin.

DRINKING-BOWL MASKS

Throughout every part of the ancient world that came under the influence of Rome, one of the most widespread of decorative motifs was the mask. Enormous grotesque faces, usually in stone or terracotta, were used to adorn the voussoirs of arches, the pediments of buildings and the mouths of fountains and waterpipes. The three examples shown here follow the same pattern as these other forms of mask but are usually identified as drinking-bowls for birds or birdbaths. A number of things tend to confirm this. They are fairly small and can hold a certain amount of liquid. They have a base which is wider than the upper part of the mask so that they are very stable, and the ring-shaped handles on the sides might act as perches. In the mouth of each mask is a mobile phallus which could act as a float when the vessel was filled with water. All these technical points add up to a convincing identification, given that the Romans were particularly fond of birds. This is amply documented by Latin writers, and the custom of keeping birds at Pompeii has been demonstrated by the excavation of elaborate dovecotes with arched entrances for the birds, *fictilia columbaria*.

DRINKING-BOWL MASK
Terracotta; 8 × 7.5 cm
From Torre Annunziata (from the excavations carried out at the end of the last century in the Battari district)
1st century A.D.
RP, Inv. no. 125169

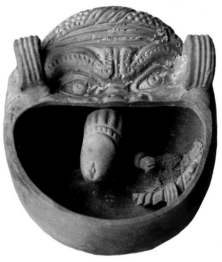

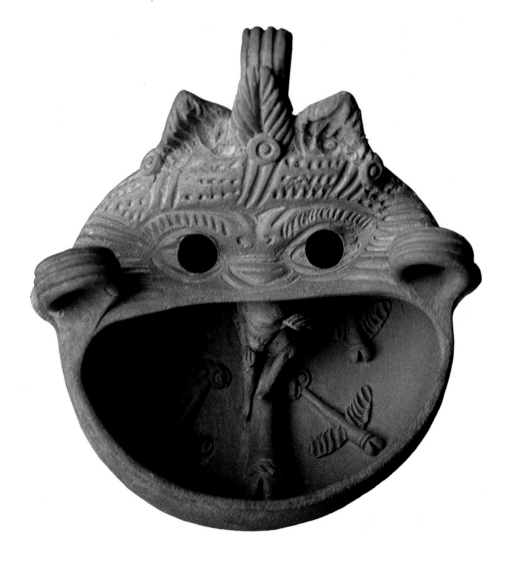

DRINKING-BOWL MASK
Terracotta, 11 × 8 cm
Origin uncertain
1st century A.D.
RP, Inv. Santangelo 908

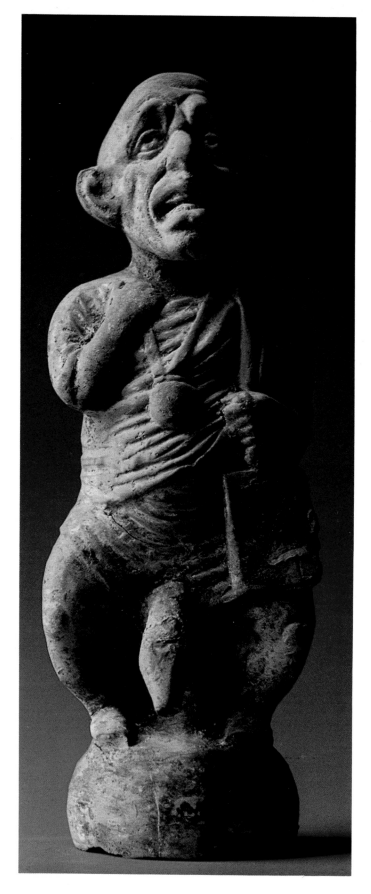
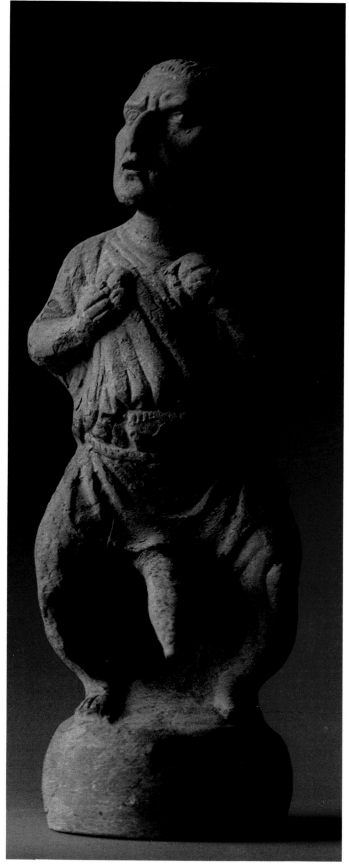

MORIONES

Julius Caesar began his legislative activity with a series of laws which were intended to remedy many political problems of the late Republic. Some provisions, such as those against parricide and treasonable activity, turned out to be most effective. On the contrary, the measures taken to limit the competition of slave labour against free workers failed to change the situation, partly because Caesar himself had swollen the slave market after his conquest of Gaul by selling some 63,000 prisoners of war. The wealthy Romans possessed great numbers of slaves, and amongst these a particularly sought-after category can be distinguished: the *moriones*, young slaves whose job it was to amuse their masters.

Moriones were bought to provide a diversion for the rich, as household jesters, and at Rome there was a special market for them, where they commanded prices higher than for other slaves:

He was said to be a fool, and I bought him for twenty thousand sesterces;
Give me back my money, O Gargilianus: this one thinks.

(Martial, *Epigrams*, VIII, 13)

The *morio* on the left is dressed up as a schoolboy. He is wearing the *bulla puerilis*, a kind of seal which children hung round their necks as an amulet, and carries wax writing-tablets. The contrast between these typical childhood objects and the disproportionate phallus of the *morio* makes his figure grotesque. The statuette is in fact a container for liquids, as the presence of an opening and the handle fixed onto its shoulders indicate. The *drilos* cups, as these containers were called, were used for drinking, and the meaning of the word can be gathered from its etymology: 'to drink from a *drilos*', which was a colloquial term for a phallus.

This vessel of such noteworthy shape does not escape the attention of writers. 'He drinks from a beaker in the shape of Priapus' (Juvenal, *Satires*, II, 95), and Pliny the Elder comments: 'It is the fashion to portray lust on cups and to drink from objects of an obscene form.' (*Natural History*, XXXIII, I)

DWARFS RIDING

pp. 132 and 133, left

Alexandria was responsible for spreading this highly caricatured form of sculpture, a by-product of the genre representations of everyday life. Dwarfs and pygmies riding on a phallus were amongst the Pompeians' most sought-after household objects.

Deformed beings were frequently the subject of paintings and mosaics, mainly because popular superstition credited them with the ability to ward off evil spirits. Tiny bells which (judging by the traces of hooks) were hung from the phalli of the two bronzes illustrated here, also had the same preventive function against the 'evil eye'. The two dwarfs are lamps, as can be seen from the hole for the flame in the tip of the phallus, and from the opening for the oil which is usually located on the shoulders. Dwarfs provoked mirth amongst the Romans and they were frequently the object of ironic and rather cruel comment:

If you look at his head alone, he seems to be Hector;
if you look at the whole of him, he seems to be his son Asthianactes (Astyanax).

(Martial, *Epigrams*, XIV, 212)

Opposite page, left:
MORIO
Drilopos in terracotta; 9 × 30 cm
From Herculaneum (11 May 1755)
End of 1st century B.C.
to beginning of 1st century A.D.
RP, Inv. no. 27857

Opposite page, right:
MORIO
Drilopos in terracotta; 9 × 30 cm
From Herculaneum (11 May 1755)
End of 1st century B.C.
to beginning of 1st century A.D.
RP, Inv. no. 27858

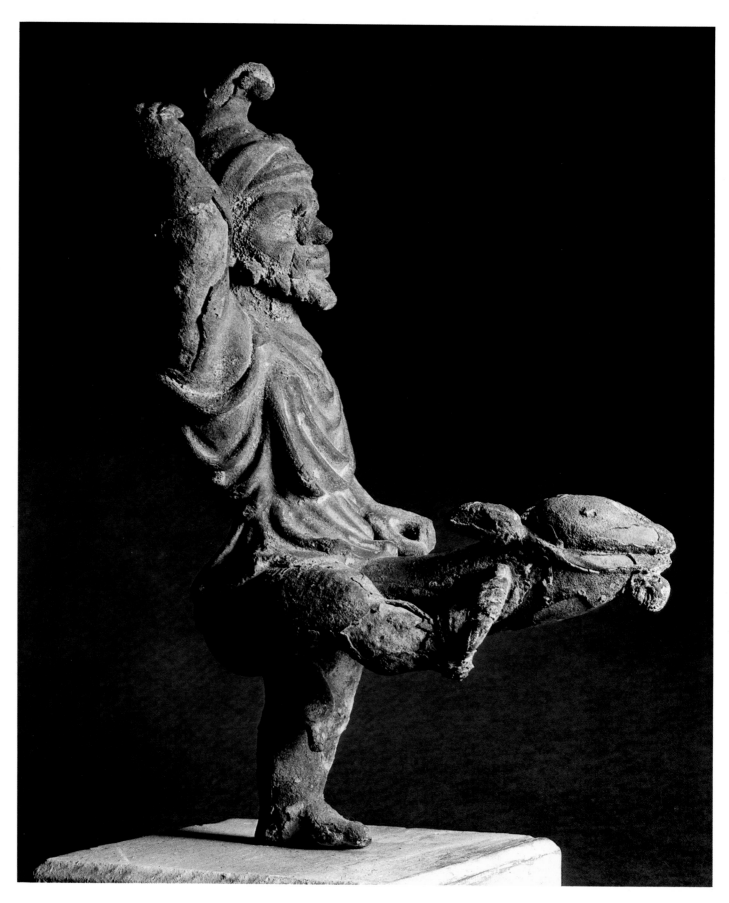

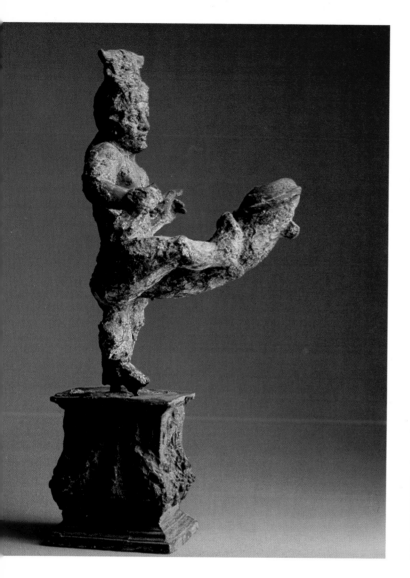 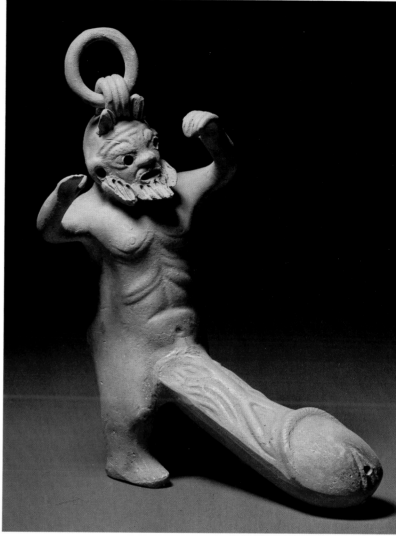

DWARF RIDING
Bronze lamp; height 22 cm
From Pompeii
1st century A.D.
RP, Inv. no. 27872

**TERRACOTTA LAMP
IN THE SHAPE OF A FAUN**
Terracotta lamp; height 20 cm
From Pompeii
1st century A.D.
RP, Inv. no. 27869

DWARF RIDING
Bronze lamp; height 22 cm
From Pompeii
1st century A.D.
RP, Inv. no. 27871

TERRACOTTA LAMP IN THE SHAPE OF A FAUN
This statuette was also a lamp, with the additional feature of a large ring at the top which suggests it was a hanging lamp.

The faun which this lamp portrays is one of the most frequently used motifs in decorative household wares of the period. This predilection is understandable if we bear in mind how much respect the Romans had for traditional beliefs, for the faun is of some historical significance. One Roman tradition maintained that the first Roman settlement had been founded on the Palatine by the Greek prince Evander, with the help of the native Italian god Faunus, whose cult Evander developed by instituting the ritual feasts called the Lupercalia. Later, Faunus, having lost his divine prerogatives, was identified as the first king of Latium, and was supposed to have been succeeded by his son Latinus.

In this statuette, the gesture of the arms is somewhat reminiscent of the celebrated sculpture of 'Faunus Dancing', a magnificent Pompeian work found in the house which is therefore called the House of the Faun.

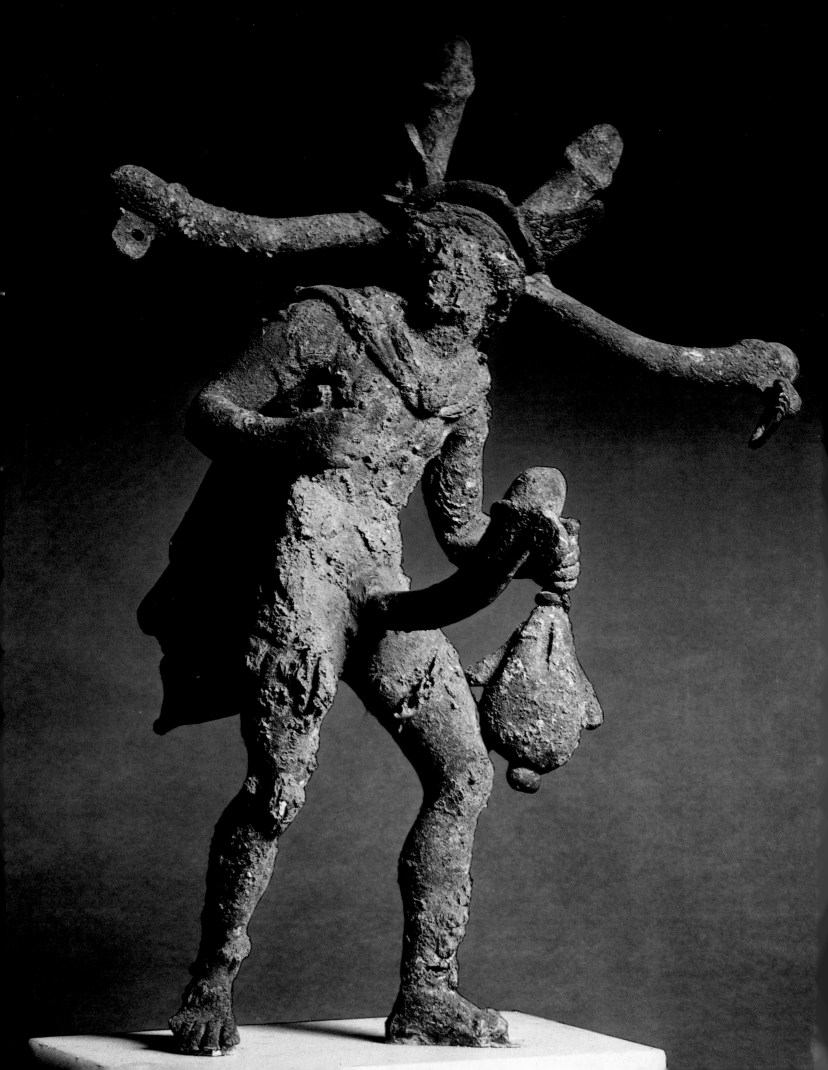

POLYPHALLIC MERCURY

This bronze is of Mercury, patron of all commercial activities, and one of the best-loved and most venerated gods of antiquity. The perforated piece of metal at the tip of each phallus shows that the figure was originally hung with bells. It is a *tintinnabulum* (an onomatopoeic word for the ringing of bells), probably set up to protect a shop against the 'evil eye'. Missing from the sculpture is Mercury's sceptre or *caduceus*, a winged rod with two serpents twisted around it. The sack he is holding in his left hand symbolizes trade.

CARICATURE

The Roman artist did not always fall back on the more traditional characterizations, such as mountebanks, *moriones* or comic actors, for his subject matter. Quite often he chose to portray ordinary individuals whose physical appearance already had rather strong features. The artist merely accentuated particular characteristics, sometimes adding details which bring out the element of the caricature. Here a wart on the forehead is transformed into an erect phallus, emphasizing the rather strange, faun-like features of the subject.

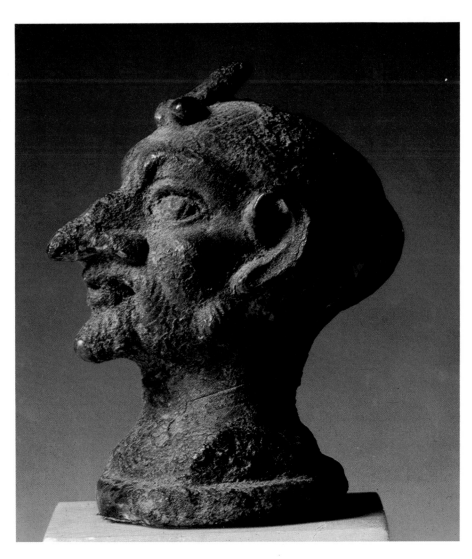

DANCING DWARF
Bronze; height 16 cm
From Herculaneum
1st century B.C.—1st century A.D.
RP, Inv. no. 27735

DANCING DWARF
Bronze; height 13 cm
From Portici (6 April 1747)
1st century B.C.—1st century A.D.
RP, Inv. no. 27734

Page 139:
THE RIDER
Tintinnabulum. Bronze; length 10.5 cm
From Pompeii
1st century B.C.—1st century A.D.
RP, Inv. no. 27844

By the end of the Hellenistic period a vast market had grown up for the countless varieties of decorative objects produced by craftsmen. 'Dancing dwarfs' are just one among many specific types of portrait which were in vogue at the time. Some of the best specimens of these statuettes (now on show at the Bardo Museum in Tunis) were recovered from the seabed near Mahdia, an ancient Tunisian city, from the hold of a ship which sank in the first century B.C. The ship was on its way from Athens with a highly precious cargo of works of art destined to adorn the luxurious villas of Rome. The presence of these little grotesques alongside the more important works witnesses their popularity and the diversity of the luxury trade of the Mediterranean. The predilection of the Romans for this kind of ornament may reflect their taste for the ridiculous, or even the monstrous, but these rather touching little figures have an animated quality which makes them quite attractive objects. In ancient Rome dwarfs performed in the games at the circus, duelling with amazons amid the hearty laughter of the audience. They were present at the Imperial court: Suetonius mentions a dwarf who reminded Tiberius of a political enemy he had forgotten to execute (*Life of Tiberius*, 61). All the great houses kept them, and the habit of buying dwarfs to amuse themselves and their guests became common amongst rich Pompeians.

TINTINNABULA

The sacred objects which were used in the rituals of the Oriental cults could be found everywhere in the ancient world in one form or another. Amongst these were the *tintinnabula*, bells which were credited with magic powers capable of warding off the 'evil eye'. Like the phallus, they were a symbol of abundance and prosperity. The Romans joined the two objects into a composite form, with the phallus as the main part and the bells as appendages. The exact design varied according to the inventiveness of the craftsman, but it frequently took the form of an animal, adorned with one or more bells attached to special hooks. The composite object kept the name of *tintinnabulum*, and was often hung from the ceiling of shops, as a charm to bring good fortune in trade. (Compare the Mercury *tintinnabulum* on page 134.) The *tintinnabulum* opposite is an interesting example produced with considerable skill and with a certain elegance in its arrangement of form. The phallus on which the dwarf is riding is in fact an ithyphallic horse. The frequency with which animals were represented (see also the *tintinnabula* on pages 140–3) may relate to the zoomorphism of the cult of Mithras, the Iranian religion which spread to Rome and throughout the whole of the Empire.

The *tintinnabula* included here all combine both decorative and apotropaic features; the *tintinnabulum* on page 141, right has another function, since it was converted into a hanging lamp by the addition of a lamp bowl with double burners.

The *tintinnabulum* on page 143 is a remarkable design that would gladden the heart of any Freudian. A gladiator armed with his short sword *(gladius)* is about to decapitate a snarling dog. But the dog is also his phallus, and its furious attack is thus a visual simile for the uncontrollable sexual impulse. The details so carefully portrayed by the craftsman make this little bronze a very successful work, of historical and artistic interest. Indeed *tintinnabula*

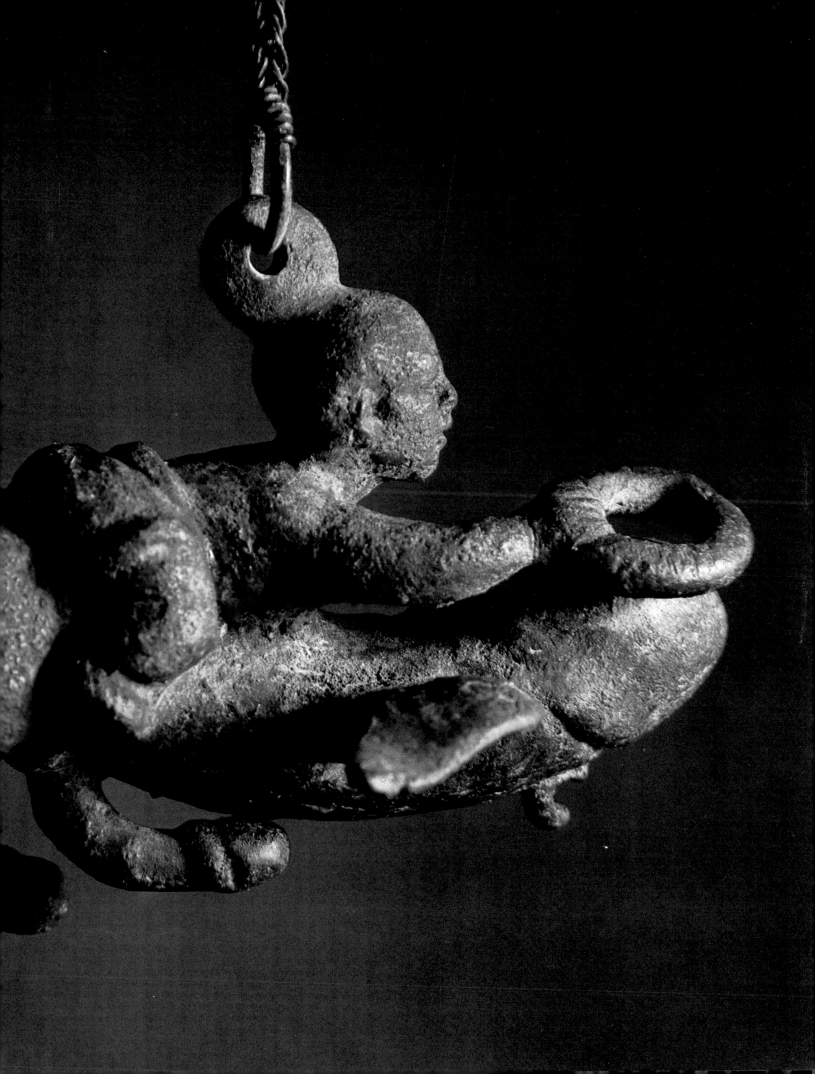

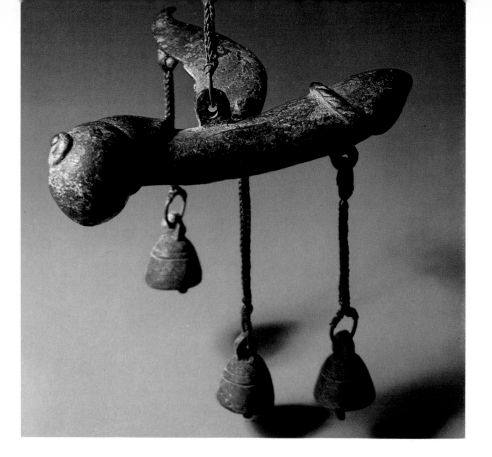

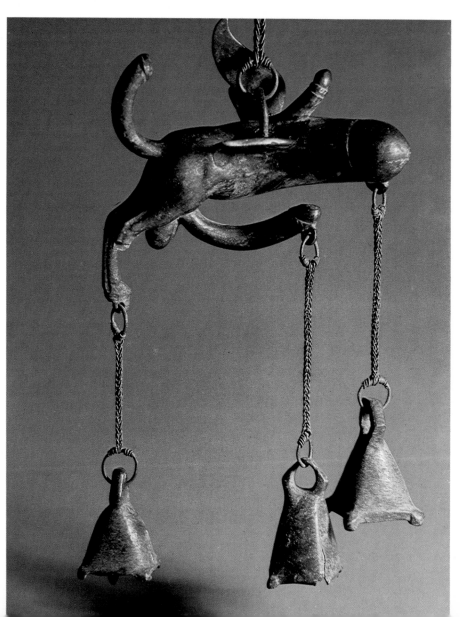

MERCURY AND THE RAM
Tintinnabulum. Bronze covered
with silver foil; 15 × 18 cm
From Pompeii
1st century B.C.—1st century A.D.
RP, Inv. no. 27855

THE LAMP
Tintinnabulum. Bronze; height 26 cm
lamp: length 18.5 cm, height 5 cm
From Pompeii
1st century B.C.
RP, Inv. no. 27873

themselves have an interesting history because of their particular connection with the Oriental cults which spread across the Roman world.

Rome's increasing contact with Syria, Egypt and the countries of Asia Minor, during the late Republic, paved the way for greater diffusion of religious influences from the East. The Romans began to turn to less formalized forms of worship, and even the great leaders of the civil war period—not least of all Sulla—became active supporters of mystery cults, whose secret rites were divulged only to the initiated.

But the political framework of Roman religion (there was in a sense an 'official' religion of the Roman State), did not allow the introduction of new divinities or cults which were judged incompatible with Roman tradition. The law of 186 B.C. against the Bacchanalia, followed in 139 B.C. by the expulsion from Italy of Oriental astrologers—the famous Chaldaean magi—showed beyond all doubt that the ban on the adoption of foreign rites was absolute.

Augustus gave full acknowledgement to the interdependence between state and religion. He attempted to reinforce the moral foundations of the Empire by outlawing unacceptable beliefs, restoring and building new temples and re-establishing ancient cults that had fallen into disuse. He seems to have been convinced that only a return to the original authentic religious spirit of Rome could ward off the danger of new doctrines which

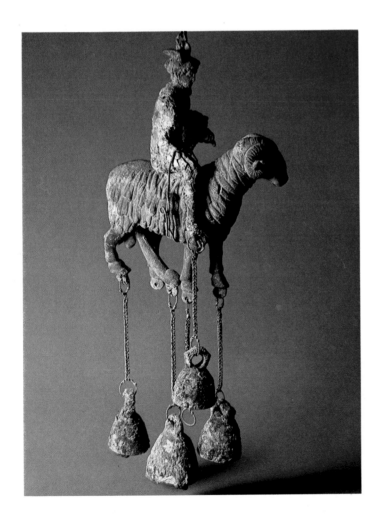

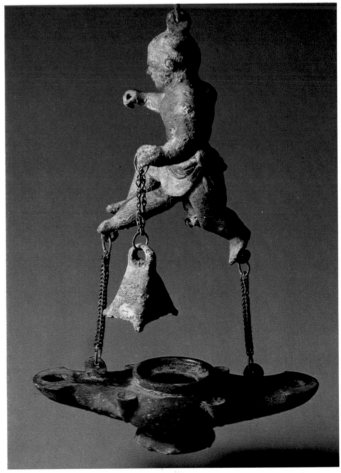

might undermine individual and collective ethics. The Sibylline Books, which had been introduced into Italy along with the Greek cults, had been burned in 83 B.C., then subsequently reconstructed on the basis of oracles from Asia Minor. During the reign of Augustus the same books were carefully edited to erase all passages which prophesied the diffusion of Hellenism and Eastern religions.

Augustus's larger political programme, however, implied the extension of Roman civilization, wherein conquered and conquerors alike would form a single social, economic and spiritual entity under general Roman supervision. But it was clearly impossible to try and reconcile so many different cults within a single religious form, and such attempts as were made merely damaged the prestige of the established Roman religion. Not even the cult of the emperors which could, up to a point, be reconciled with older traditions and was exalted by Virgil and Horace (who compared the Emperor to Hercules, Mercury and Apollo), succeeded in bringing back the Romans to the old beliefs. With the death of Augustus, the artificial syncretism of the Empire was gradually seen to have failed. It had proved impossible to mould so many diverse religious traditions into a single religion, because such a hybrid was incapable of satisfying any real spiritual needs.

So amongst the educated classes, Greek philosophical doctrines, as interpreted by Cicero, Lucretius and Seneca, attracted an enormous number of adherents, whilst the ordinary people found renewed interest in the metaphysical content of the Oriental mysteries. Thracian, Cappadocian and Babylonian gods came to the forefront, displacing the traditional pantheon. In the household shrines of the Romans there were now exotic amulets and sacred objects of the Oriental cults, whilst *tintinnabula*, like those of Herculaneum and Pompeii, adorned house and shop in noisy celebration of the victory of the mystery cults.

Above left:
THE LION
Tintinnabulum. Bronze; length 23 cm
From Herculaneum
(20 May 1740)
1st century B.C.—1st century A.D.
RP, Inv. no. 27835

Above right:
THE MOUSE AND THE TORTOISE
Tintinnabulum. Bronze; length 8.5 cm
From Pompeii
1st century B.C.—1st century A.D.
RP, Inv. no. 27841

THE GLADIATOR
Tintinnabulum. Bronze; height 21 cm
From Herculaneum
(8 February 1740)
1st century B.C.—1st century A.D.
RP, Inv. no. 27853

Page 145:
DIONYSIAC SCENE
Wall-painting; 50 × 50 cm
From Pompeii, *regio* IX, *insula* I, no. 22,
House of Epidius Sabinus *(tablinum)*
Last years of the reign of Nero
RP, Inv. no. 27875

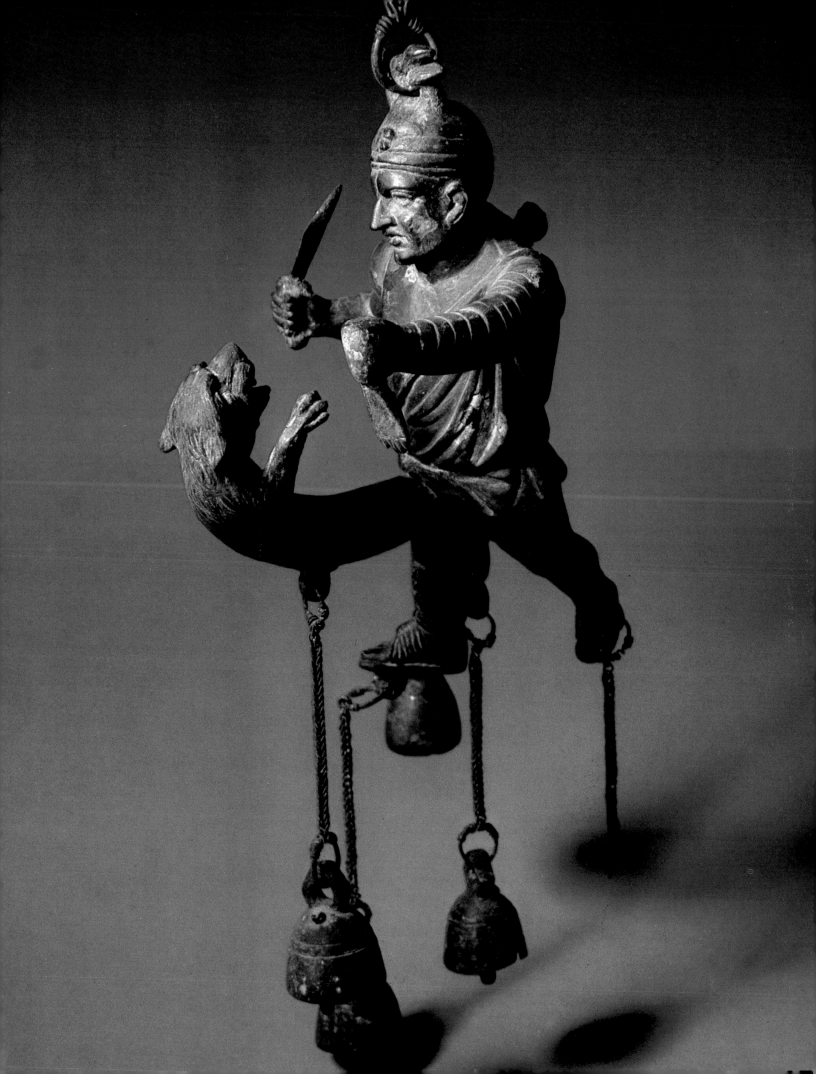

DIONYSIAC SCENE

In this painting, the meaningful gestures of the figures suggest that this is a copy of an *anathema*, an ex-voto offering to Dionysus. It was painted during the first century A.D., and is generally attributed to the 'Theatre Painter', the author of five works showing scenes from the theatrical world which give him his name. This fresco shows his evident liking for solemn and scenographic compositions, with large, somewhat stagey gestures and strong characterization.

The fresco deals with one of the favourite themes of Greco-Roman art. In this variation of the Dionysiac myth, the leading figure is Hermaphroditus; on his left is a bacchante, and behind him a satyr whose beard he clutches. The bacchante is offering him *satyrion*, an aphrodisiac potion, whilst in her other hand she holds the *thyrsus*, a staff crowned with vine leaves and ivy which was the symbol of Dionysus and was used in his rites. A replica of this work, which has probably lost its original religious character and is now just a genre scene, is in the House of the Vettii.

The cult of Hermaphroditus started in Syria and reached Rome via Cyprus and Greece. In Rome he became the object of fervent worship and enjoyed wide popularity, to such an extent that Ovid chose him as one of the more suggestive characters in his *Metamorphoses*.

LEDA AND THE SWAN *p. 146*

The subjects of Pompeian painting are frequently inspired by mythology, but there is no lack of representations of everyday life—scenes from comedies, portraits, landscapes and, above all, *trompe l'oeil* architectural scenes. The fresco shown on page 146 illustrates one of the most beautiful and romantic of the ancient myths. Leda, the wife of King Tyndareus of Sparta, is loved by Zeus, who appears to her in the form of a swan; from their love were born Castor (one of the heavenly twins, or Dioscuri) and his sister Helen. The myth of Leda was mentioned in Homer and depicted many times from at least the end of the fifth century B.C. Amongst the most famous works of the classical period is the sculpture made in 360 B.C. by Timotheos, which survives in copies made by Roman artists. This same theme of the love between Leda and Jupiter in the guise of a swan also recurs in paintings of the Renaissance.

Pompeian painting covers a period from the time of Sulla (c. 80 B.C.) up to the eruption of 79 A.D. In this span of rather less than a hundred years of artistic activity, there is substantial development in technique and form which gives rise to the classification of the paintings into four successive styles. The First Style, also called the 'Incrustation Style', is the oldest and simplest found at Pompeii and consists of plain stucco panels in imitation of marblework. The Second Style (c. 80 B.C.—14 A.D.) introduces pictorial art, with large panels which have architecture that appears functional, landscapes and figures. The Third Style (14–62 A.D.) is ornamental, with architecture that is fanciful and is characterized by minute attention to detail and by a more accentuated use of colour. The Fourth Style (62–79 A.D.), which is the most widespread (because chronologically the most recent), takes up once again the architectural and perspective models of the Second Style, now enlivened with fantastic and unreal motifs and somewhat baroque in character.

The painting shown here, which must have formed the central part of a frescoed wall in the Fourth Style, is probably a copy of a Hellenistic original as reworked by local artists—Leda's hair-style is typical of the Flavian period.

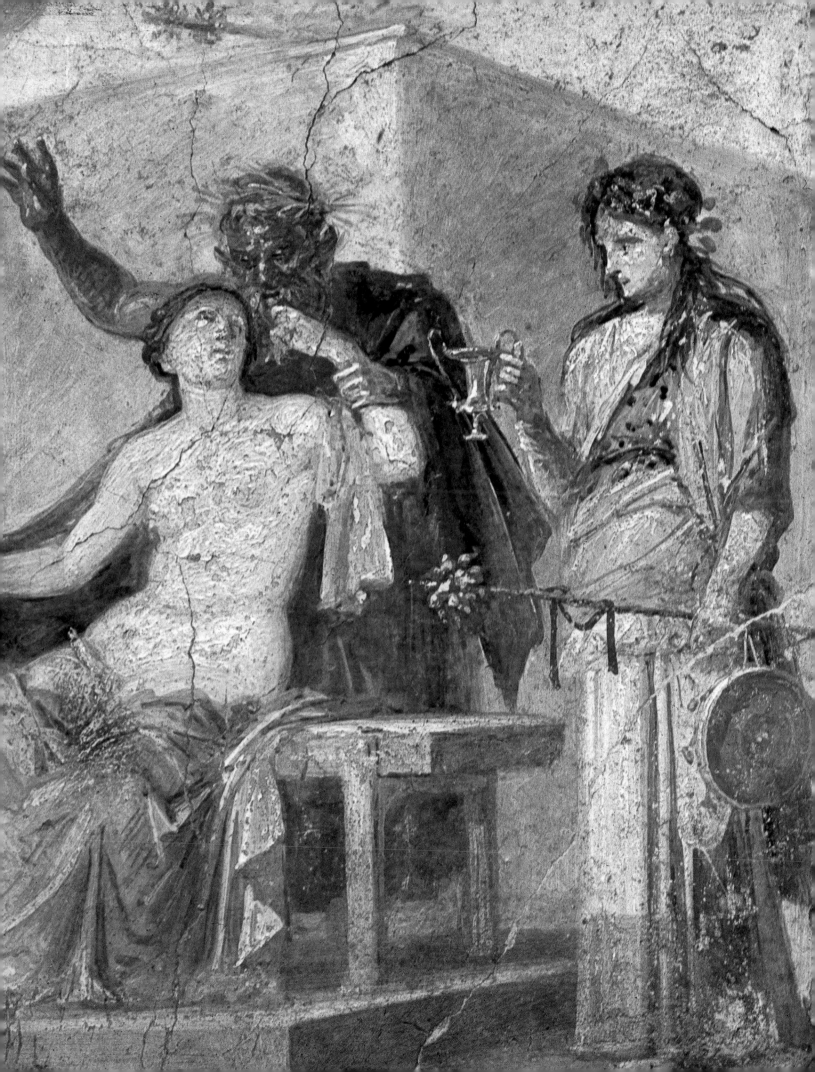

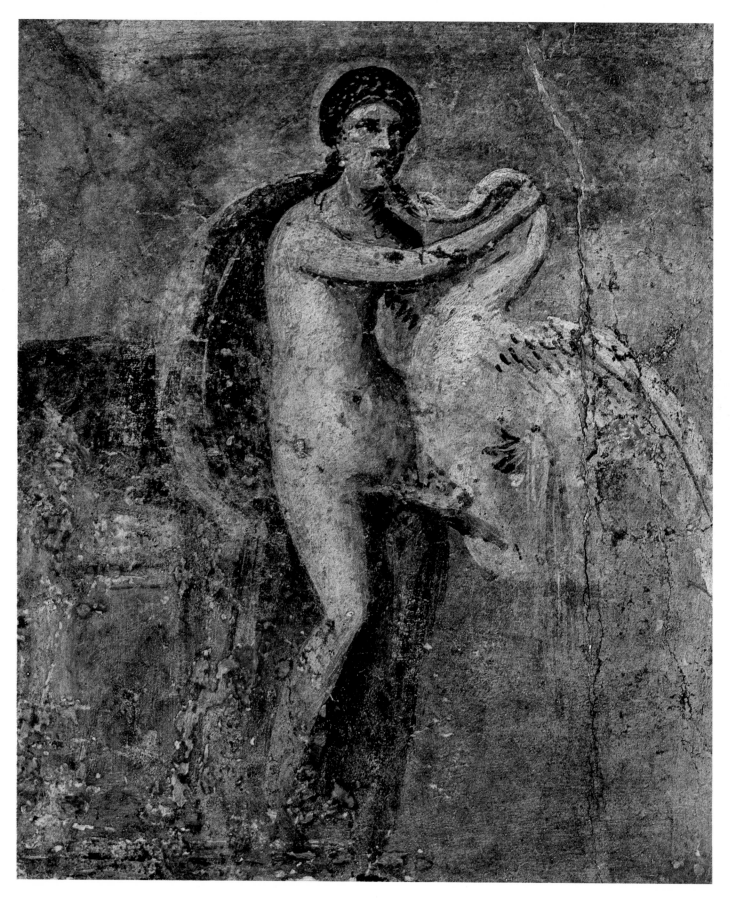

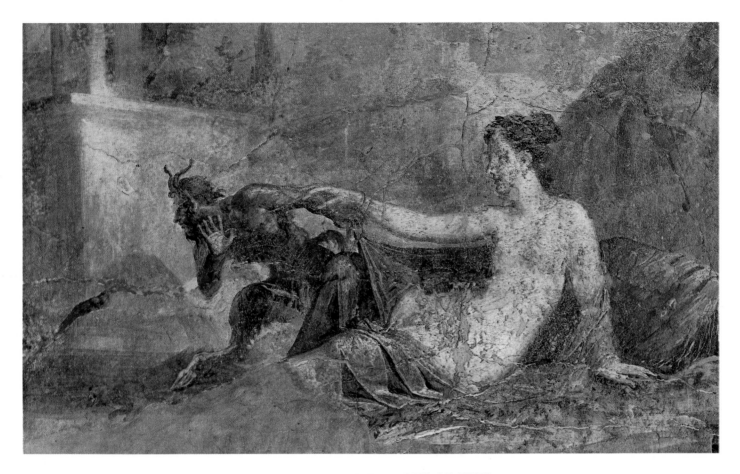

PAN AND HERMAPHRODITUS
Wall-painting; 91 × 143 cm
From Pompeii, *regio* VI, *insula* IX,
nos. 6–7, House of the Dioscuri *(atrium)*
Reign of Nero
RP, Inv. no. 27700

LEDA AND THE SWAN
Wall-painting; 77 × 77 cm
From Herculaneum
Period of Vespasian
RP, Inv. no. 27695

Pages 148–9:
SATYR AND MAENAD
Wall-painting; 39 × 35 cm
From Herculaneum
c. 70 A.D.
RP, Inv. no. 27699

Page 150:
SATYR AND MAENAD
Wall-painting; 56 × 56 cm
From Pompeii
c. 70 A.D.
RP, Inv. no. 27685

PAN AND HERMAPHRODITUS

This delightful fresco was inspired by one of the many adventures of the god of woodlands and flocks, always ready to make insidious overtures to nymphs caught unawares. This time, however, he has made a bad mistake. He has taken Hermaphroditus for a nymph, and is fleeing in disgust from this ambiguous divinity who is a combination of both sexes, whilst Hermaphroditus rather effeminately tries to hold him back. With Pan beating a hasty retreat, and Hermaphroditus so elegantly arranged without a hair out of place, it looks very much as though it was Hermaphroditus who laid a trap for Pan, and not the other way around. The relationship with Hellenistic art, where one of the strong points in mythological parody was the theme of disappointed expectations, is further confirmed by the setting of the Pompeian scene with its hint of architecture and graceful rocky landscape. The painting has the vivacious and refined grace of the Fourth Style and is attributed to the so-called 'painter of Io' (Io was the heifer loved by Zeus) whose activity is witnessed in the House of the Dioscuri, and in many works in the House of Pinarius Cerialis and in the Macellum.

SATYR AND MAENAD *pp. 148–9*

The robust, even lowbrow tone of the final phase of painting at Pompeii is a far cry from the classical composure of the art of the Augustan period. The traditional themes are still used, but the world of myth is now treated with a cool nonchalance. It merely provided an excuse for more exciting treatments of familiar episodes, now shown in a vigorous and dramatic way. Here the stark symbolism of the pale maenad against the dark lustful satyr is tempered by the richly inventive drawing of the figures.

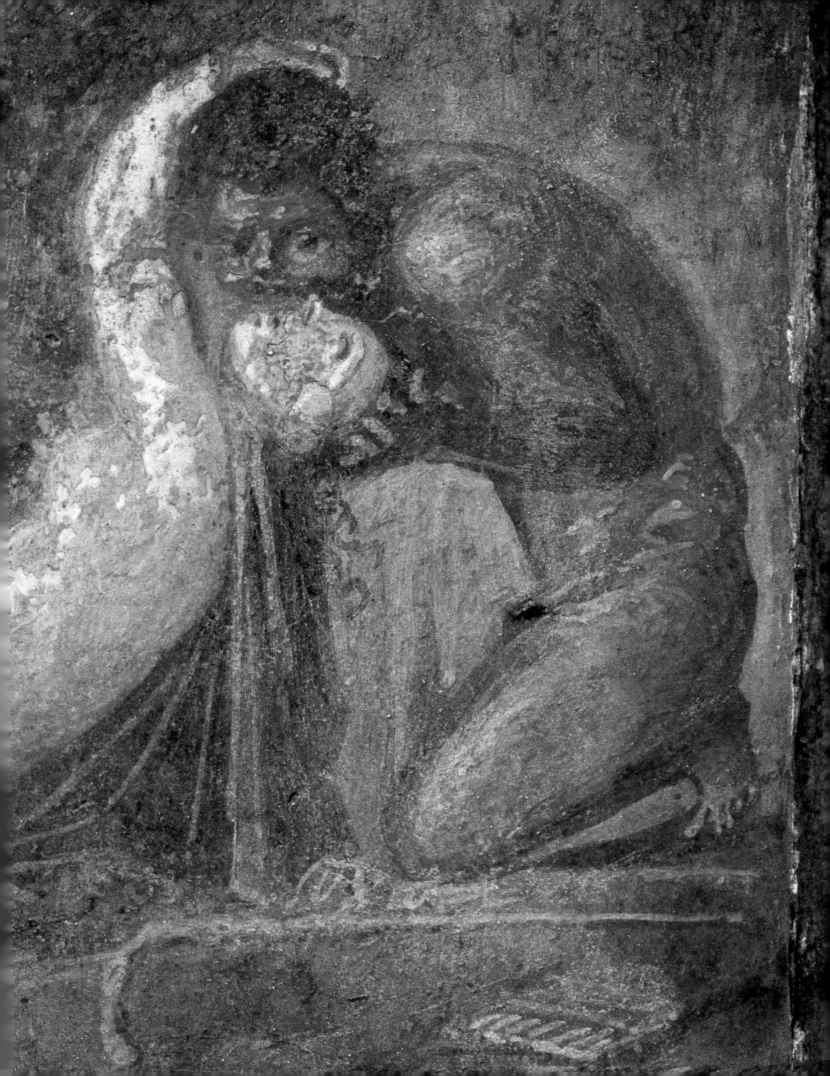

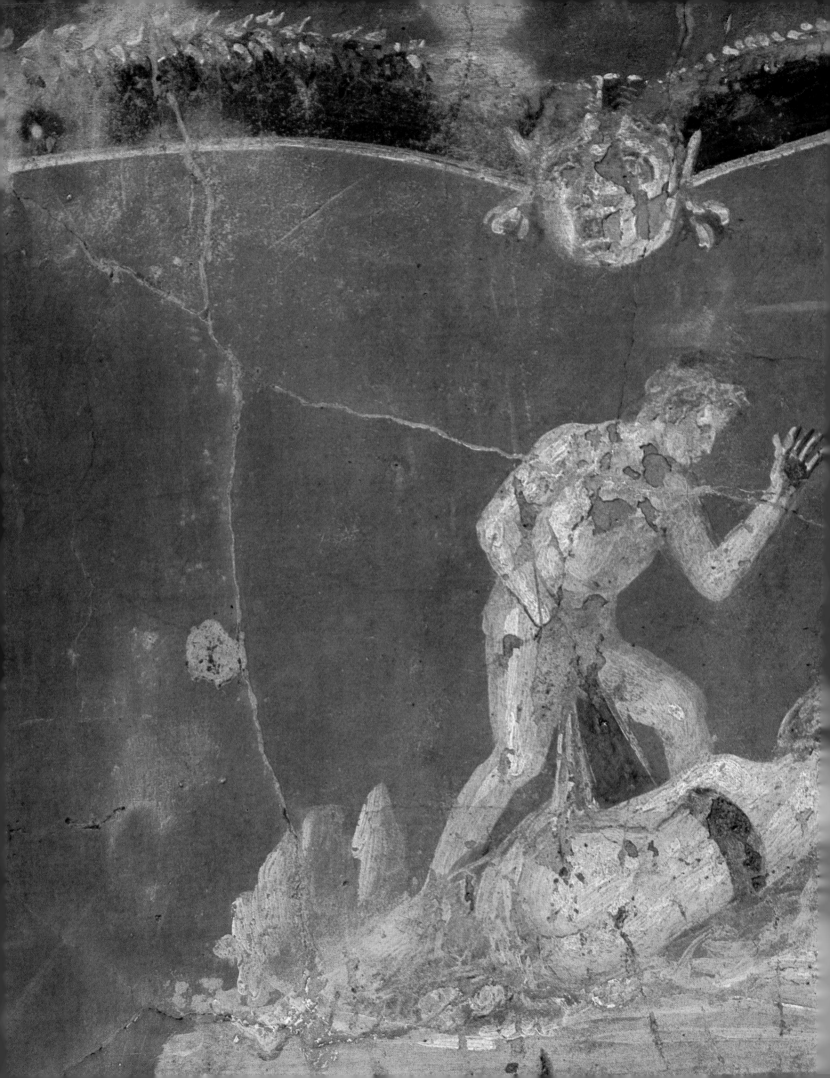

SATYR AND MAENAD

After the violent earthquake of 62 A.D. which destroyed or damaged the majority of their houses, the Pompeians—the population was around twenty thousand—promptly set about the task of rebuilding and restoring the city in the latest style. The fresco illustrated here is in the new Fourth Style of painting. It shows a satyr drawing back the garment of a maenad who is fast asleep among the rocks. The red background is broken up by a mask suspended from a garland, suggesting a theatrical scene.

POLYPHEMUS AND GALATEA *p. 152*

The House of the Ancient Hunt, from which this painting comes, was originally built in the pre-Roman period, but the decoration of the rooms all belongs to the Fourth Style.

There were countless versions of the myth of Polyphemus and Galatea, attesting to its considerable popularity. One tradition told of the happy love story between the nereid (Galatea was the daughter of Nereus and of Doris) and the cyclops Polyphemus. They were supposed to have produced a son, Galas, who became the eponymous ancestor of the Gauls. The painting shown overleaf certainly has its roots in this happier tradition. But the version which had the most success in the Hellenistic period told of Polyphemus's unrequited love for Galatea; this is the version narrated by Theocritus in his Eleventh Idyll, in which the poet adds that the cyclops expressed his frustrated passion by singing his hearbreaking love story from the top of a cliff overlooking the sea. The name of Galatea derives from the Greek *gala*, meaning milk, and this gave rise to the identity of the goddess as protectress of flocks, and her attribute of white sea-foam. Her mythical exploits are illustrated in numerous wall-paintings at Pompeii and Herculaneum, in the House of Livia on the Palatine and on a large number of gems.

WALL-PAINTING WITH EROTIC SCENE *p. 153, above*

This painting, like others from the villas of Pompeii, was inserted as a panel in a wall painted in a monochrome tint, framed with borders in a contrasting colour. Simple both in composition and execution, it does in fact date from the mature phase of the Third Style. Its colours are rather subdued, and in this period, a rather dull-red tonality, called 'Pompeian red', was favoured. The unusual position of the couple finds justification and comment in the following couplet:

> Atalanta extended her legs on the shoulders of Milanio;
> if you have pretty legs this is the way you must make them be admired.
> (Ovid, *Ars Amatoria*, III, 775–6)

WALL-PAINTING WITH EROTIC SCENE *p. 153, below*

Like the previous illustration, this wall-painting has little in the way of artistic pretensions. Its rather summary execution suggests that it owes more to the craftsman's workshop than to the studio. The generous proportions of the lady remind us that quantity, as well as quality, mattered to the Roman male.

> I do not want, O Flaccus, a threadlike
> lover on whose arms you could slip a ring,
> with sharpened buttocks and pointed knees....
> (Martial, *Epigrams*, XI, 100)

151

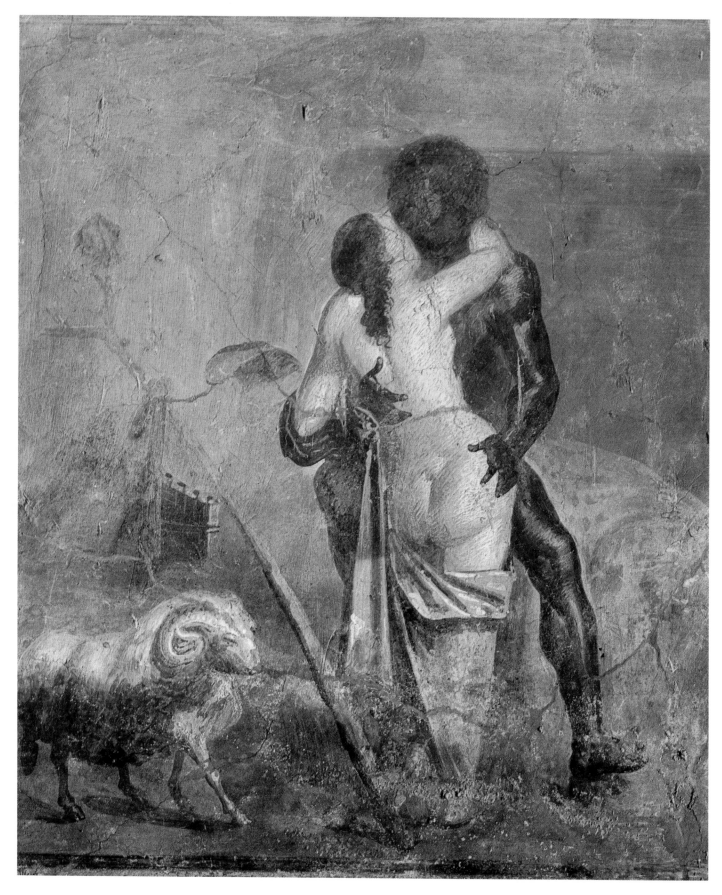

POLYPHEMUS AND GALATEA
Wall-painting; 75 × 82 cm
From Pompeii, *regio* VII, *insula* IV,
no. 48
House of the Ancient Hunt (*exedra*)
Last years of the reign of Nero
RP, Inv. no. 27687

WALL-PAINTING
WITH EROTIC SCENE
37 × 37 cm
From Pompeii
1st century A.D.
RP, Inv. no. 27697

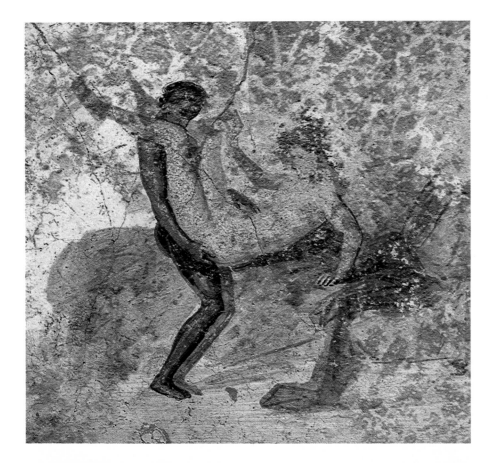

WALL-PAINTING
WITH EROTIC SCENE
41 × 41 cm
From Pompeii
Reign of Nero
RP, Inv. no. 27684

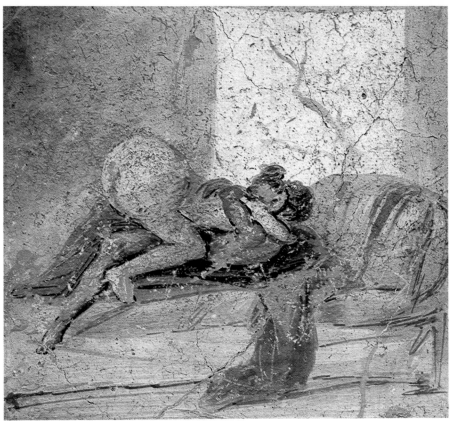

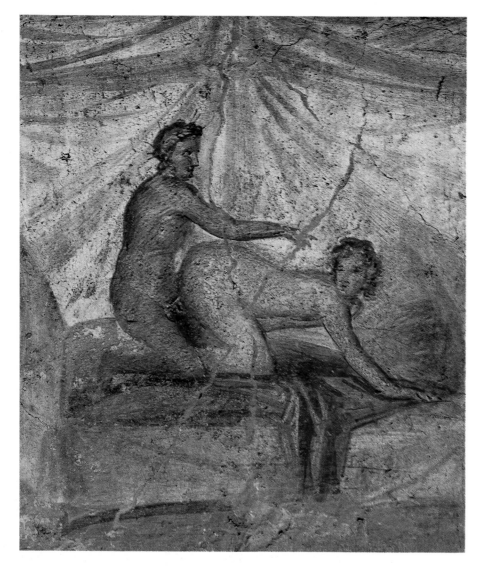

WALL-PAINTING
WITH EROTIC SCENE
51 × 54 cm
From Pompeii
Reign of Vespasian
RP, Inv. no. 27696

WALL-PAINTING WITH EROTIC SCENE

The need to regularly rework his figurative repertoire led the Pompeian artist on a restless search for new ideas. Constant reference to the real world paved the way for improvements in technique. Carefully detailed brushwork gave way to rapid splashes of colour, used in a way which can justifiably be termed impressionistic.

But what was the purpose of these little vignettes? They can certainly be explained in terms of Hellenistic traditions. *Pornographi* of this kind are attested in literature, and other internal features suggest a relationship to genre miniatures of Hellenistic origin. But in a more specific sense, these little paintings may have functioned as a sort of figurative grammar of love, and may have been intended as visual enticements to make love. Many have in fact been found not only in brothels but also in the bedrooms of private houses, as if they were private collections of erotic art. Ovid seems to refer to this in passages such as the following:

> [Mature women] lend themselves to love in a thousand positions
> which in no collection of paintings can be found;
> in them voluptuousness is provoked without artifice.
> (Ovid, *Ars Amatoria*, II, 679–681)

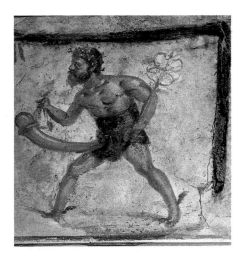

MERCURY
Wall-painting; 80 × 72 cm
From Pompeii (?)
Reign of Nero
RP, s.n.

WALL-PAINTING
WITH EROTIC SCENE
41 × 44 cm
From Pompeii
c. 70 A.D.
RP, Inv. no. 27686

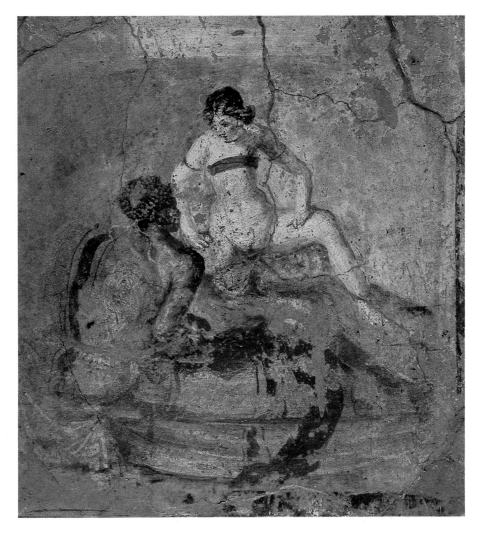

Page 157:
WALL-PAINTING WITH EROTIC
SCENE
44 × 52 cm
From Pompeii, *regio* V, *insula* I, no. 26
House of Caecillius Iucundus
Reign of Nero
RP, Inv. no. 110569

MERCURY

Mercury was the protector not only of traders but also of thieves, one of the more ironic contradictions of Graeco-Roman mythology. The ithyphallic Mercury portrayed here has winged feet, symbolizing his speed of movement. The *caduceus* with its two little snakes is the symbol of peace, and the bag which the god is holding in his right hand refers to profit in trade. He was frequently portrayed in the company of the goddess Fortuna on shop signs, as an auspicious symbol.

WALL-PAINTING WITH EROTIC SCENE

The garland of rose petals (the *corona sutilis*) round the head of the man portrayed in this painting, together with the *strophium* (a sort of bikini top) and the *armilla* or bracelet worn by his female companion, all suggest that the couple have just come back from a banquet. This scene brings to mind some verses from Ovid's *Amores*, a collection of elegies in which the poet narrates his amorous adventures, some of which are true and some invented:

Night, love and wine advise against half measures:
night frees men from modesty, wine and love from fear.
(Ovid, *Amores*, I, VI, 59–60)

WALL-PAINTING WITH EROTIC SCENE

There have been some 226 years of excavations at Pompeii. For more than a century work has been carried out in accordance with the scientific principles of modern archaeological technique. This has involved innumerable operations of preservation and restoration, and it is now possible to reconstruct something of the civilization of Roman Pompeii in all its aspects, with details of social and economic life, cultural history and even building activity. The work of excavating private houses is one of the most difficult and complex operations but the results are striking, and illustrated here is a painting from one of the richest houses so far brought to light in Pompeii.

In this house a cashbox was discovered, and the decipherment of the tablets contained in it suggest that its owner, Caecilius Iucundus, was a prosperous banker. The splendour of his house confirms this. The painting shown here, with its frame of white and brown borders, is certainly one of the finest works of its kind. The two figures in the foreground are foreshortened to set them at a distance from a third figure, barely visible in the background. The person who is just hinted at with light hazy brushwork is almost certainly the *cubicularius*, a slave whose task it was to serve in the bedroom (*cubiculum*). He was also on call in the antechamber when his master and mistress withdrew to the bedroom. We thus glimpse him hovering dutifully in the background of this amorous encounter. The painter has endowed the moment of intimacy with a gentle and calm sensuality. The perspective in the spatial layout, the extremely delicate play of colour against more sombre tones and the skilful use of shading all make this enchanting picture a little masterpiece, in which the erotic element is more suggested than declared, more understood than expressed.

> Having put off her veils she stood before me;
> She was beautiful and her body without defect.
> What shoulders and arms I saw and touched!
> And the shape of her breasts so suited to be caressed!
> And under her breast, perfect and smooth was her belly,
> And rich and large her thighs! Fresh with youth her legs!
> Why tell all? I saw nothing that was not so praiseworthy,
> And naked I clasped her to me.
> Who cannot guess the rest?
> Both tired, we rested.
>
> (Ovid, *Amores*, I, V, 17–25)

SATYR TAKING A MAENAD BY SURPRISE p. 158

The Hellenistic world saw the break-up of the political system based on the city-state, or *polis*. The ties that bound a man to city were loosened, and the practice of using art in the service of the city, as an expression of religious and civic values, declined. Hellenistic artists were thus free to portray realistic or mythical themes without labouring under the burden of producing official or religious art. The portrayals of satyrs and maenads which are so frequent in the Roman world and which derive from Hellenistic works are part of this new secular trend. The other chief ingredient of scenes like the one shown here is again of Hellenistic origin: the elaboration of bucolic and pastoral themes goes back to the poets Anyte and Theocritus. Scenes such as this one give a new dimension to the traditional representations of mythical figures and demi-gods by emphasizing their very human weaknesses.

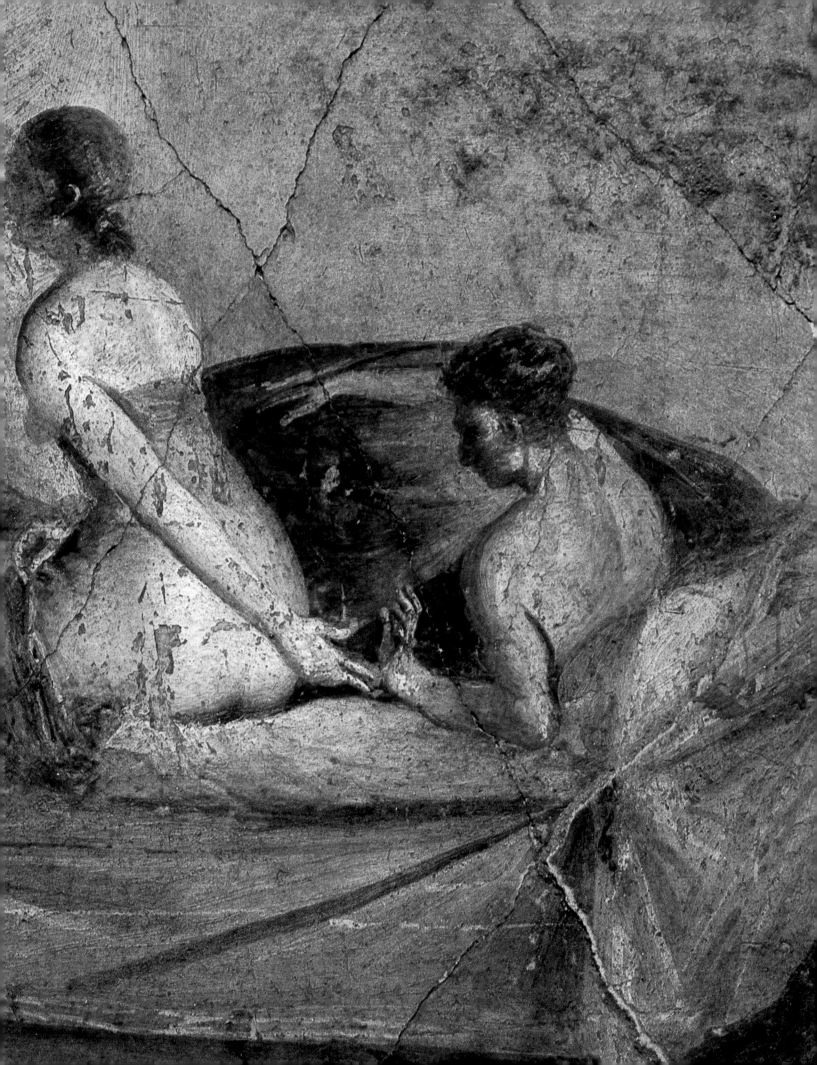

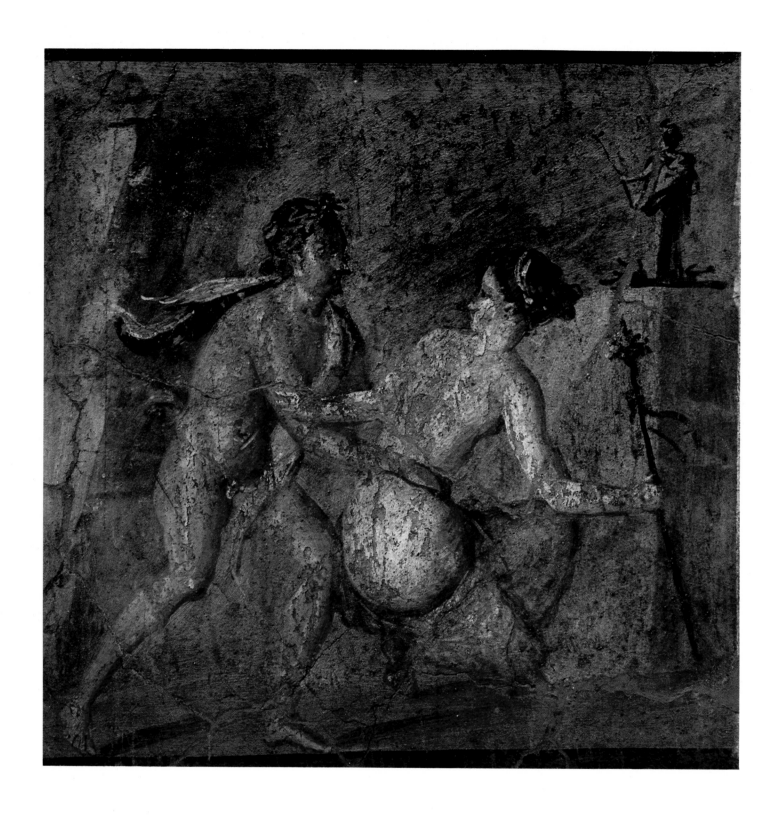

HERMAPHRODITUS STRUGGLING WITH A SATYR *p. 159*

The lively use of colour and careful attention to detail suggest that this painting is work of the Third Style with a date which is probably not later than 62–63 A.D.

Painted with great care and suffused with gentle light, this work is modelled on a celebrated Hellenistic sculpture of the second or first century

SATYR TAKING A MAENAD
BY SURPRISE

Wall-painting; 48 × 48 cm
From Pompeii
Reign of Vespasian
RP, Inv. no. 27693

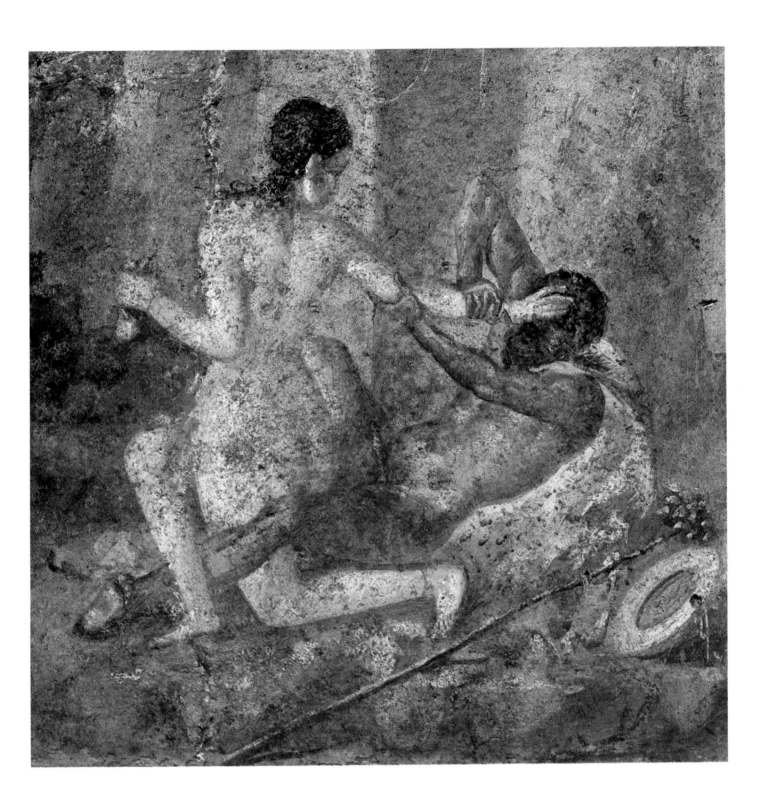

**HERMAPHRODITUS
STRUGGLING WITH A SATYR**
Wall-painting; 51 × 56 cm
From Pompeii
Reign of Nero
RP, Inv. no. 110878

B.C. so that the figure struggling with the satyr can be identified as Hermaphroditus rather than as a nymph.

The composition is roughly quadrangular in form, anticipating the late Hellenistic preference for frontal views. The main features of this type of painting are rapid brushwork and an evocative quality. Many versions of this work are known, all deriving from the Hellenistic original.

159

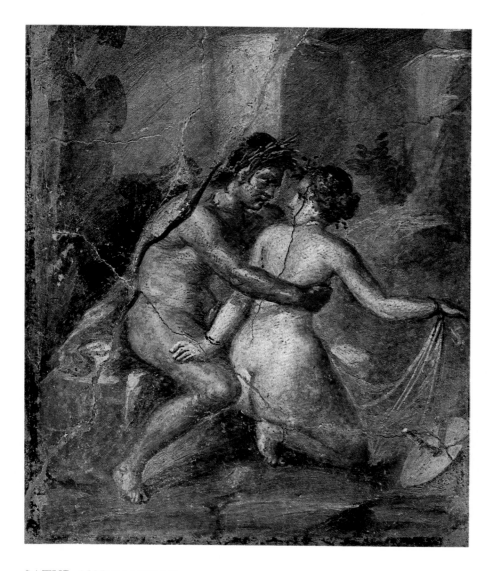

SATYR AND MAENAD
Wall-painting; 37 × 44 cm
From Pompeii, *regio* V, *insula* I, no. 18
House of the Epigrams (peristyle)
Reign of Nero
RP, Inv. no. 27705

SATYR AND MAENAD

This painting is another harmonious composition which deliberately indulges in a degree of mannerism. The use of both strong tones and a hazy luminosity combine to create a powerfully illusionist image. The graceful encounter of the lovers is well expressed.

WALL-PAINTING WITH EROTIC SCENE

This little picture is an example of work by a local craftsman which is an offshoot of the highly developed work of more skilled artists. It is mainly of documentary interest, for it is from these local imitations of more sophisticated painting that one can gain some idea of the native tradition of folk art.

Of particular interest is the writing which can just be read in the background: 'LENTE IMPELLE' ('Enter slowly'). The hairstyle of the woman was fashionable in the Flavian period, which makes it possible to date the painting to the last years of Pompeii. Dating on stylistic grounds is not possible because of the local character of the work.

SATYR DISCOVERING MAENAD *p.162*

This painting is a treatment of one of the most widely used themes of Hel-

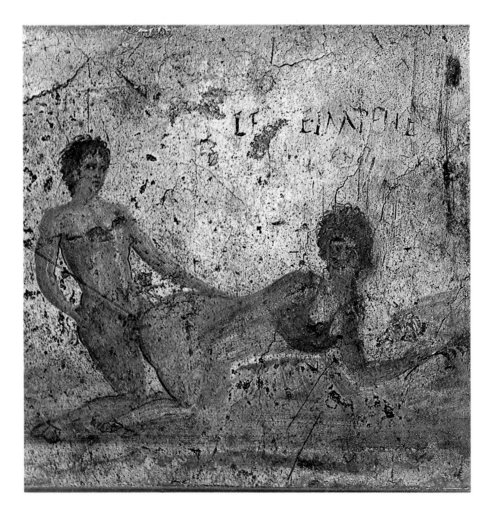

lenistic iconography, the myths of Dionysus and Pan. Despite its bad state of preservation, it reveals a controlled use of polychromy and an expressive quality, particularly in the satyr's eloquent gesture of wonder at the sleeping girl.

The Romans never really solved many of the technical problems of painting. Both Pliny and Vitruvius discuss the various techniques available for the preparation of the plaster ground for painting, giving us technical information of enormous interest. There were two main procedures. Fresco painting was carried out on plaster which was still damp, and the methods and materials used varied over the course of time, with the Romans making some improvements in technique. Encaustic painting involved the application of the pigments with hot wax, and this technique has in fact been rediscovered on the basis of Pliny's description.

FAUN AND HERMAPHRODITUS *p.163*
The details of this mural are rather difficult to make out because of its poor state of preservation, but the painting makes a strong statement in the bold contrast between the dark brown of the faun and the white limbs of Hermaphroditus. The two bodies are intertwined in an ambiguous pose that suggests both repulsion and attraction, yet another improvisation on a favourite theme in the Hellenistic repertoire. Nonetheless the artist succeeds in infusing new strength into the well-worn motif by his expressive treatment of form.

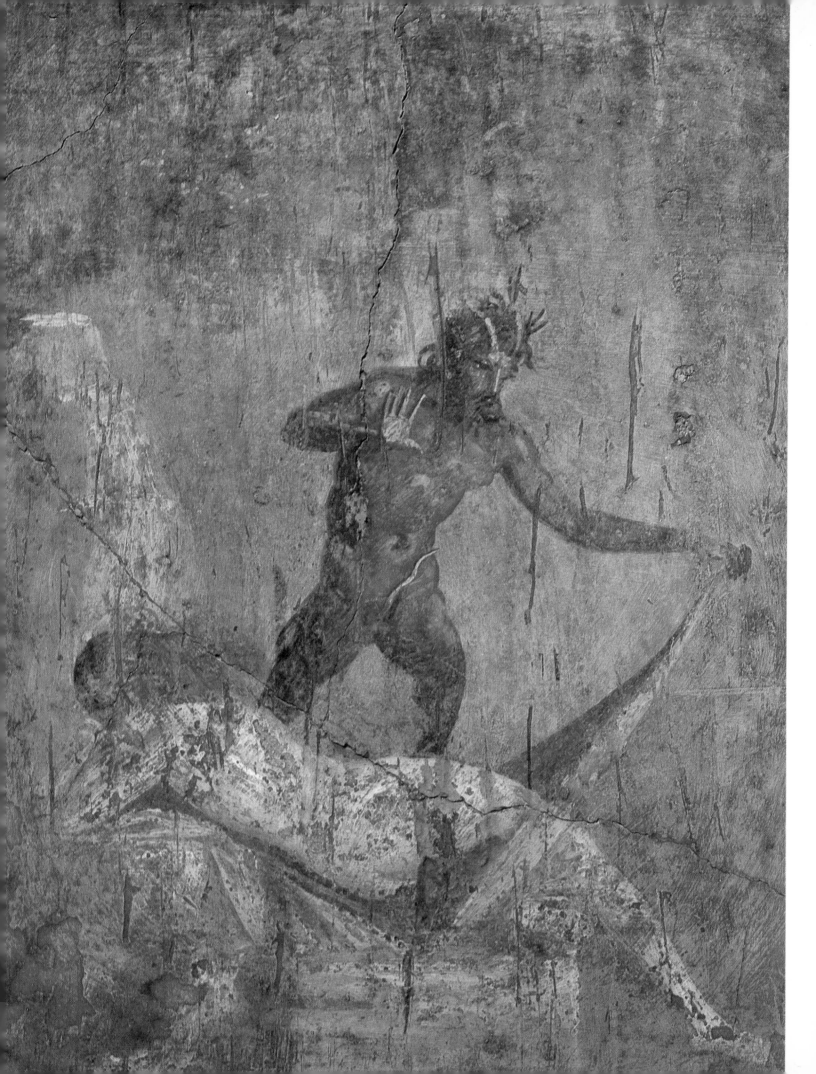

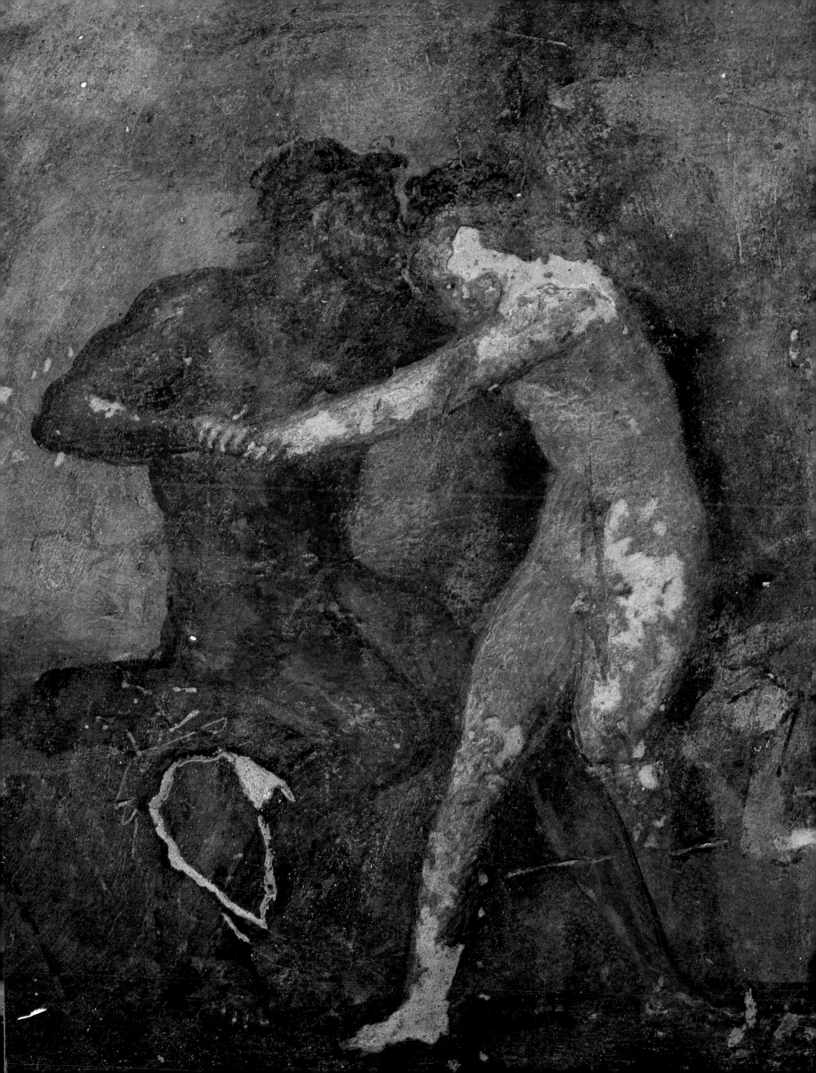

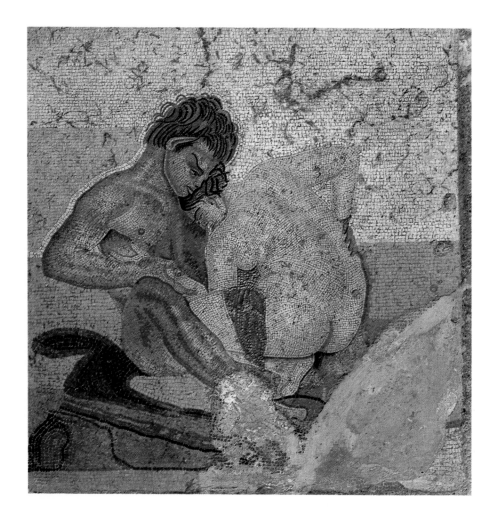

SATYR AND MAENAD
Mosaic; 37 × 39 cm
From Pompeii, *regio* VI, *insula* XII,
nos. 2–5, House of the Faun
2nd century B.C.
RP, Inv. no. 2770
Opposite page: a detail

SATYR AND MAENAD

The art of the mosaic spread to Italy during the Hellenistic period, probably brought in by specialized Greek craftsmen. It was the Greeks who had developed the technique of making the polychrome figured mosaics which are so minutely described by Vitruvius and by Pliny the Elder.

Pompeii and Herculaneum provide us with the best view of Roman mosaic work during the Imperial period, and also during its earlier development. The earliest Pompeian mosaics were made with river or sea pebbles. The House of the Faun has a whole sequence of mosaic works that in themselves provide a continuous dossier on the development of the art form from the Republican period onwards. The extremely beautiful mosaic in the illustration is an *emblema* or panel inserted in the centre of a mosaic. It is in *opus vermiculatum* (inlaid work which resembles the tracks of a worm [*vermiculus*]), done with extremely tiny tesserae which enabled the artists to model the contours of the figures with clarity. The Pompeian artist has rendered the delicate chromatic variations with great sensitivity, giving the figures a tactile quality.

The *emblema* comes from a pavement in one of the chambers off the entrance to the House of the Faun, one of many mosaic treasures found there. The most important of these is undoubtedly the great panel depicting the *Battle of the Issus* between Alexander the Great and the Persian king Darius. It is based on a lost original by the great painter Philoxenus of Eretria, and is thus one of the most precious mosaics to survive from antiquity.

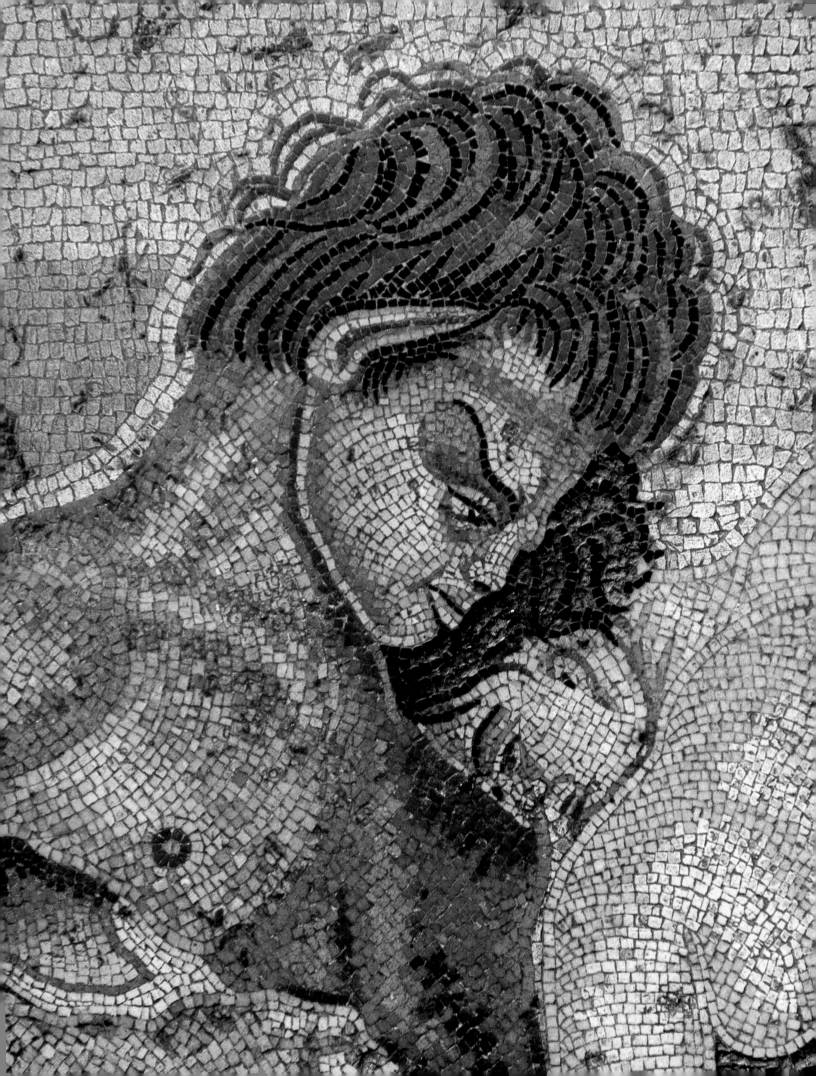

PAN AND HAMADRYAD
Mosaic; 25 × 27 cm
From the Museum of Noja
Late 2nd—early 1st century B.C.
RP, Inv. no. 27708

PAN AND HAMADRYAD—MOSAIC

This mythological scene represents the shepherd god Pan vainly attempting
to seduce a young and beautiful hamadryad who is about to turn into a tree.
Pan, the protector of woodlands and flocks, was one of the most widely
worshipped divinities in Greece, and in the Hellenistic age his cult spread
over the Near East and to Southern Italy. Portrayed with goatlike attri-
butes, he appears frequently in sculptured groups, in bas-reliefs, in Pompeian
paintings and on gems and coins. He also figures in works by the bucolic
poets who use him as an embodiment of Nature.

The hamadryads (the word is formed by the Greek *hama* meaning 'together'
and *drys*, 'oak' or, more broadly, 'tree') were tree-nymphs. Their name
suggests the interdependence between the tree and the nymph, between the
vegetable element and its animate form. They relate to the wider Greek
concept of Nature as a complete entity of body and spirit in which man him-
self is also included. The hamadryads are thus the trees personified; their
blood is sap, the rustling of leaves their voice. Only as they grow up do they
take on a fuller human aspect and develop the ability to enter and leave the
tree over which they exercise their divine protection.

The scene in the mosaic represents this second stage in the myth. The hama-
dryad has been caught unawares by the god Pan as he is wandering through
the woods. She is trying to escape his unwanted attentions by returning into
the tree.

166

The History of the Museum
and the Collection

Antonio De Simone

The long history of this collection starts in 1763, with the beginning of the systematic excavation of the ancient city of Pompeii which had been located under a thick layer of volcanic debris. Charles VII of Bourbon had long been fascinated by the archaeological finds which were frequently made around Vesuvius and had engaged the engineer Roque de Alcubierre to undertake the job of excavating some fifteen years earlier.

Charles VII's ambition was to make Naples the artistic capital of Italy, and to this end he had the treasures of the rich Farnese collection transferred from Rome and Parma. These formed part of his inheritance as he was the son of Elisabetta, the last descendant of the Farnese family. The collection, which had been started by Alessandro Farnese (Pope from 1534 to 1549 under the name of Paul III), had over the years become one of the most splendid in Europe. After being transported with great difficulty to Naples, it was housed in the palace of Capodimonte and in the museum at Portici. Paintings and miscellaneous objects of archaeological interest were housed in the palace. The finds arriving from Herculaneum and Pompeii became more numerous as excavation work progressed, and they were placed in the museum. Soon the volume of treasures unearthed by the excavators made it imperative to find yet another building to house the archaeological finds.

In 1585 the Viceroy of Naples had decided to provide better accommodation for the Cavalry Corps, and had a new barracks built outside the Constantinople gate, fairly close to the royal palace. But when the building was finished it turned out to be quite unsuitable for the housing of cavalry. It was subsequently modified and incorporated in a new building erected in 1616 by the Viceroy Don Pedro Fernandez de Castro to house the university. The architect, Giulio Cesare Fontana, worked in conjunction with the sculptors Finelli and Fanzago who where responsible for much of the decoration of the building.

In July 1773, Pope Clement XIV dissolved the Society of Jesus, 'its posts, its property, its institutions', as a sequel to the expulsion of the Jesuits in 1767. Charles VII's successor, Ferdinand IV, was thus given the opportunity to confiscate the property of the Jesuits and transfer the university to their former college. This solved the problem of finding a suitably prestigious building for the nascent Academy of Science and Letters, with large rooms in which to exhibit numerous objets d'art.

During the period when the Kingdom of Naples was under French rule, the Raccolta Palatina (Palatine Collection) was assembled through the agency of the French Queen, Caroline Murat. Some of these treasures were carried off to France on the return of the Bourbons, but over the years other acquisitions continued to augment the royal collection. Finally, in 1822, the works were transferred to their new home and visitors came to know and admire them, though occasionally they misunderstood their meaning. In 1819 Francis I, Duke of Calabria and future King of Naples, visited the museum with his daughter. He suggested to Arditi, the curator of the museum, that it would be better to restrict those items which dealt with erotic subjects to a single room, so that access could be limited to 'persons of mature age and of proven morality'. Arditi immediately took up this suggestion and isolated a total of 102 objects which might cause offence to the prevailing moral sentiments of the times, setting up the 'Gabinetto degli oggetti osceni' *('Cabinet of Obscene Objects'). In 1823 the name of this collection was changed to* 'Gabinetto degli oggetti riservati' *('Cabinet of Restricted, or Secret, Objects'), a euphemism which reflected the political realism of the time. The works could, in fact, be shown to persons who had a valid royal permit. The situation did not improve with the advent of political changes. After the nationalist uprisings of 1848, even greater restrictions were imposed as steps were taken to restore law and order throughout the kingdom. In 1849 the doors of the collection were closed to everyone, after other nude sculptures and paintings had been added. Three years later the entire collection was transferred to a remote corner of the museum, as if to remove all trace of it.*

In 1860 things changed for the better. When Giuseppe Garibaldi proclaimed himself dictator, he declared the museum to be national property. He named Alexandre Dumas

(Dumas père, who had followed him in the Expedition of the Thousand) as its curator. The new curator's approach was progressive and thorough: the collection was accurately checked and catalogued. It was renamed the 'Raccolta Pornografica' ('Pornographic Collection'), the title by which it is still known today. Many objects were once again exhibited in the public galleries, and all those which had been found after 1849, and had been put to one side without even being inventoried, were catalogued. In 1866, Fiorelli, curator since 1863, listed some 206 works belonging to the collection. Subsequent changes in taste and conventions meant that the collection had its ups and downs. More works were placed on show, and permission to view the special collection was granted by the directors of the museum to those who applied for a permit. Casual curiosity was thus discouraged. These controls were strictly applied during the Fascist dictatorship, as can be seen from the permits still filed at the superintendent's office. The threat of total closure never disappeared. In 1931 the government did order the collection to be closed, but the ban was ignored and the authorities began to employ less severe restrictions. In August 1934, the Office of the High Commissioner for Naples and the Province of Naples ordered that 'this upper room, for reasons of morality, may be visited only by artists bearing valid documents testifying to their profession and, as the occasion arises, by personnel on official visits who shall make application'.

Since the end of the war, work has been in progress at the Museum as a whole to re-organize the storerooms, to check and catalogue existing material and to increase the number of galleries open to the public. The collection, which now includes more than 250 works, is also undergoing revision. There is every reason to hope that new regulations will permit the complete and permanent exhibition of these works to the public. They are part of Italy's cultural inheritance, and are a unique testimony to the life of an ancient city.

BIBLIOGRAPHY

Avino, M., *The Women of Pompeii*, Naples, 1967

Balsdon, J. P. V. D., *Roman Women*, London, 1962

Barré, M. L., *Herculaneum et Pompéi, Recueil Général*, Vol. VIII (Musée Secret), Paris, 1862

Becatti, G., *Pitture murali campane*, Florence, 1955

Brion, M., *Pompeii and Herculaneum: the Glory and the Grief*, London, 1960

van Buren, A. W., *A Companion to the Study of Pompeii and Herculaneum*, 2nd ed., Rome, 1938

Carcopino, J., *La vie quotidienne à Rome à l'apogée de l'empire*, Paris, 1938 (English ed.: *Daily Life in Ancient Rome*, London, 1962)

Carrington, R.C., *Pompeii*, Oxford, 1936

Ciprotti, P., *Conoscere Pompei*, Rome, 1959

della Corte, M., *Case ed abitanti di Pompei*, 2nd ed., Rome, 1965

Corti, E. C., *Untergang und Auferstehung von Pompeji und Herculaneum*, 6th ed., Munich, 1944 (English ed.: *The Death and Resurrection of Herculaneum and Pompeii*, London, 1951)

Diehl, E., *Pompejanische Wandinschriften*, 2nd ed., Berlin, 1930

Etienne, R., *La vie quotidienne à Pompéi*, Paris, 1966

Fiorelli, G., *Catalogo della Raccolta Pornografica*, Naples, 1866

de Franciscis, A., *Il Museo Nazionale di Napoli*, Cava dei Terreni, 1963

Gabriel, M.M., *Masters of Campanian Painting*, New York, 1952

Grant, M., *Cities of Vesuvius*, London and New York, 1971, 1974

Grant, M., *Gladiators*, London and New York, 1967

Grant, M., *Nero*, London and New York, 1970

Grimal, P., *Les jardins romains de la fin de la République aux deux premières siècles de l' Empire*, Paris, 1943

Harter, H., in Pauly-Wissowa-Kroll, *Realencyclopädie der classischen Altertumswissenschaften*, XIX, 2 (1938), cols 1681–1784, s.v. Phallos

Jashemski, S.A. and W.F., *Pompeii*, New York, 1965

Kiefer, O., *Kulturgeschichte Roms unter besonderer Rucksichtigung der römischen Sitten* English ed., translated by G. & H. Highet: *Sexual Life in Ancient Rome*, London, 1934)

Lafeye, G., in Daremberg-Saglio-Pottier, *Dictionnaire des antiquités*, II, 2 (1896), pp. 983–7, s.v. Fascinum

Leppmann, W., *Pompeji: Eine Stadt in Literatur und Leben* (English ed.: *Pompeii in Fact and Fiction*, London, 1968)

Lindsay, J., *The Writing on the Wall*, London, 1960

Lullies, R. B., in Pauly-Wissowa-Kroll, XXII, 2 (1954), cols 1914–42, s.v. Priapos

Maiuri, A., *Pompei ed Ercolano: tra case e abitanti*, Padua, 1951, Milan, 1958

Marcadé, A., *Roma Amor*, Geneva, 1961

Marini, G. L., *Il Gabinetto Segreto del Museo Nazionale di Napoli*, Turin, 1971

Mau, A., *Pompeji in Leben und Kunst*, Leipzig (English ed.: *Pompeii: Its Life and Art*, New York and London, 1899)

Menzel, H., *Antike Lampen*, Mainz, 1969

Le Musée Secret de Naples, Paris, 1906

Onorato, G.G., *Iscrizioni pompeiane*, Florence, 1957–8

Pernice, E., *Die Hellenistische Kunst in Pompeji*, IV *(Gefässe und Geräte aus Bronze)*, Berlin-Leipzig, 1925

Ragghianti, G.L., *Pittori di Pompei*, Milan, 1963

Schefold, K., *Pompejanische Malerei: Sinn und Ideengeschichte*, Basle, 1952

Sergejenko, M.L., *Pompeji*, 3rd ed., Leipzig, 1955

Tanzer, H.H., *The Common People of Pompeii* (Johns Hopkins University Studies in Archaeology, No. 29), Baltimore, 1939

Zunz, G., *On the Dionysiac Fresco in the Villa dei Misteri* (Proceedings of the British Academy, No. 49), Oxford, 1963

Grateful acknowledgement is due to the Superintendents of the Monuments of Campania for permission to photograph objects from the Secret Collection, and in particular to Professor Alfonso de Franciscis for his assistance.

The photograph on page 10 was supplied by the Istituto Fotografico Editoriale Scala, Florence. The photographs on pages 46–7, 54, 55, 146 and 147 were supplied by Signore Fabrizio Parisio of Naples.

The publishers are grateful to the following for permission to reproduce the extracts quoted in the text:

The Loeb Classical Library (Harvard University Press; William Heinemann) for the extract from Dio Classius, *Roman History;* Penguin Books Ltd for the extract from *The Letters of the Younger Pliny*, translated by Betty Radice; George Weidenfeld & Nicolson Limited and Macmillan & Co., New York, for the extract from *The Cities of Vesuvius* by Michael Grant (Copyright © 1971 by Michael Grant Publications Ltd).

The author would like to express his thanks to Mrs Patsy Vanags for checking and editing the English edition of 'The Secret Collection' and 'The History of the Museum and the Collection'.